ONE DAY IN THE LIFE OF
ROBERT WILSON'S
THE LIFE AND DEATH OF MARINA ABRAMOVIC

JULY 6TH 2011 MANCHESTER U.K.

TIM HAILAND
WITH JORN WEISBRODT ANTONY
ROBERT WILSON AND WILLEM DAFOE

Four years ago Marina Abramovic called me and told me she wanted Bob Wilson to direct her biography, a rather startling and unusual request from one artist to another. This was not the first time that she had done this - more than 10 years ago Marina staged her biography herself, then she asked the Belgian theater director Michael Laub to interpret her life, but the third time would be he ultimate. As she explained to me, it was because she wants to be buried in three different places so nobody will know where the real Marina is. She had planned her funeral already, the music, the coffin, everything. She would put a binder together with all her work, her life, and show it to Bob Wilson to convince him to stage it. She explained that as an artist she has total control over her work, but she wanted no control over her life.

A few months later, Robert Wilson and I went to Marina's sparse and beautiful loft in New York's SoHo. Marina explodes on the inside with ideas, thoughts, and emotions, so she tries to keep the outside very simple and empty. There couldn't be two more different artists in the same room than there was on that afternoon. Robert Wilson, the "cold-passioned" Texan for whom silence is the most elegant form of communication, and Marina Abramovic, the "hot, sensual" Serbian who exhales words with every breath she takes. The two artists had met in 1968 in Belgrade at the beginning of each other's careers and now, almost 50 years and two huge and extreme careers in their respective artistic fields later, as related to each other as prison cells but also as separated from each other.

Marina and Bob sat down and she handed him the folder with her life in it and a letter explaining her great wish. She tried to let him read the letter but her excitement was so big that she took it out of his hands and read it aloud. She wanted to have no control, he could do with her life whatever he wanted to do. He has total control was basically what the letter in her hands said.

And then she went through the folder with him, images of her work, Marina sitting on a white horse, Marina in a burning star, Marina brushing her hair, stories of her childhood, her artist manifesto, Marina crying with onions, et cetera. She wanted to have a Russian army chorus, she explained, the opening scene would have to be her suspended from a cross with a snake around her neck because her other two biographies opened like that. Maybe Ulay's son could re-perform her and Ulay's pieces on stage with her. She wanted Serbian music, knew who should design her costumes, and much more. Wilson was too polite to say anything. I said, "Marina, you want to give up control?"

And finally she did. It took a few years and the combined efforts of Alex Poots of the Manchester International Festival and Gerard Mortier of Madrid's Teatro Real, who lead the way as co-commissioners of the piece, and the many others who followed.It also took a few years to develop the piece. Wilson chooses to stage her funeral as the first scene, there is no army chorus (it was too expensive and Wilson did not really want it), no re-performances or images of her past work - he was absolutely focused on her life, not her oeuvre. Antony performs his music himself and has never looked more beautiful on stage, thanks to Jacques Reynaud's stunning costumes, Willem Dafoe shows that great actors can even be greater, and, most importantly, Marina plays the role of her life: her mother. The Life and Death of Marina Abramovic became, with Wilson's and Philip Glass's Einstein on the Beach, probably one of the most unusual collaborations between two great artists. It is a theater piece that is almost addictive, it starts so good and gets better and better and after three hours of sheer theatrical bliss you wish you could start all over again, like the famous Wagner soprano who said of her first Isolde that it was better than an orgasm and she could have started from the top again. As you leaf through this beautiful book, you run through the day of the dress rehearsal of The Life and Death of Marina Abramovic with Robert Wilson himself, and then can start at the top over and over again to see how this incredible work of art came to life.

An afterthought: I do not know if the piece resolves the dichotomy between performance art and theater - the real blood against the fake blood - but it does show the differences and definitions do not matter at all when you are in the presence of painful and sheer beauty. It does, though, break down the common ground from which we set up these definitions in the first place. It is the real and the fake blood that pumps in our cultural hearts.

JORN WEISBRODT MONTAUK NOVEMBER 2011

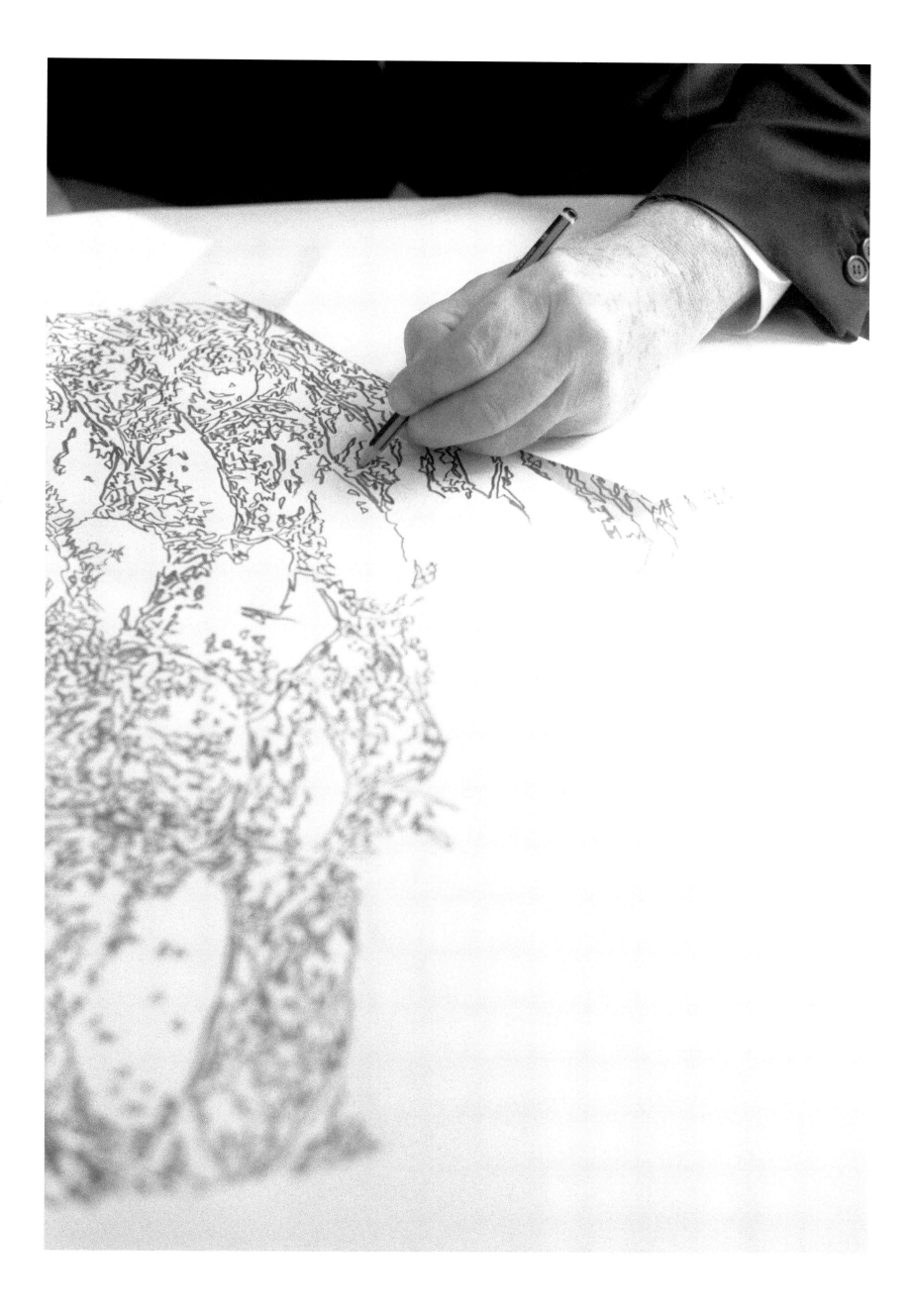

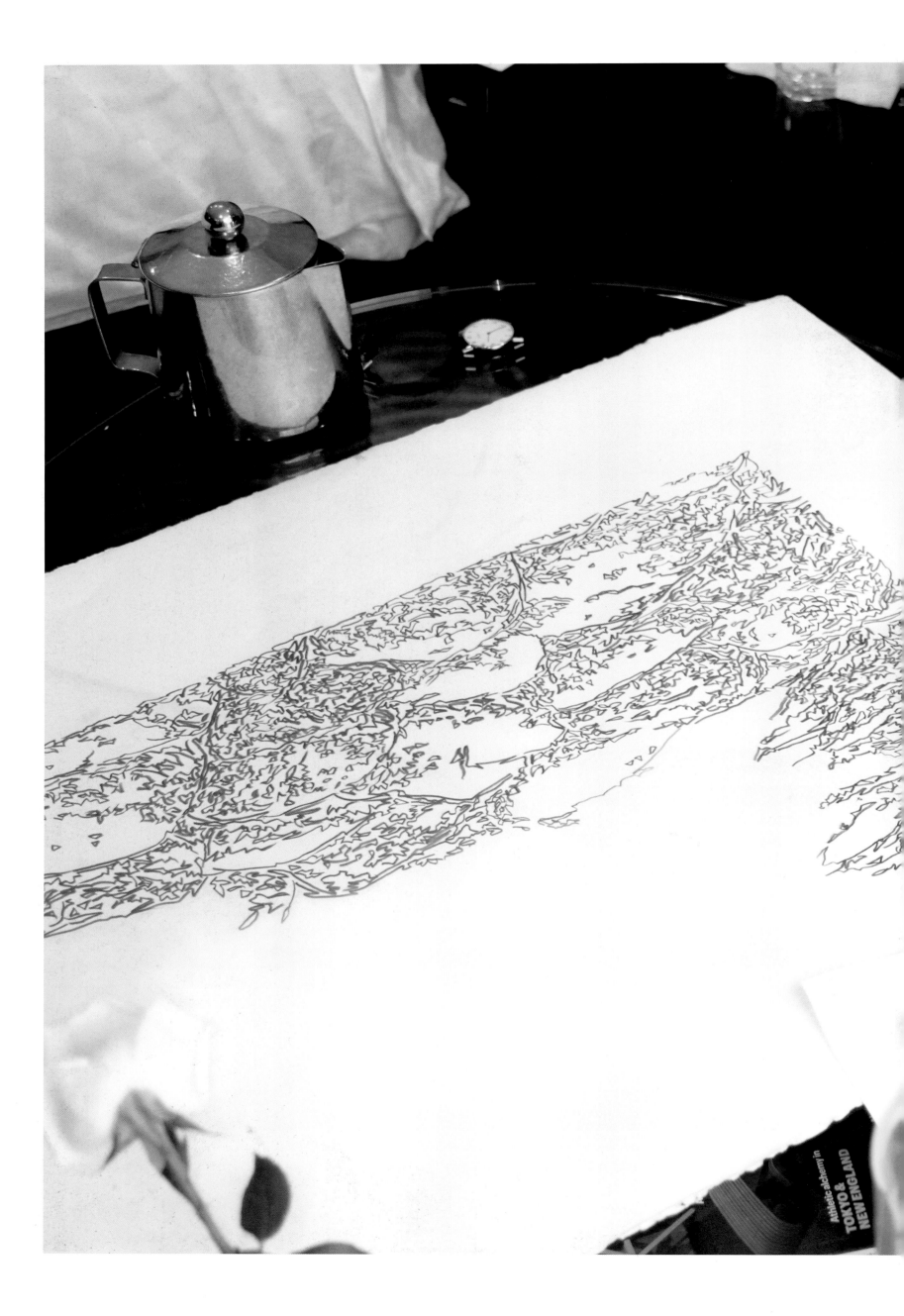

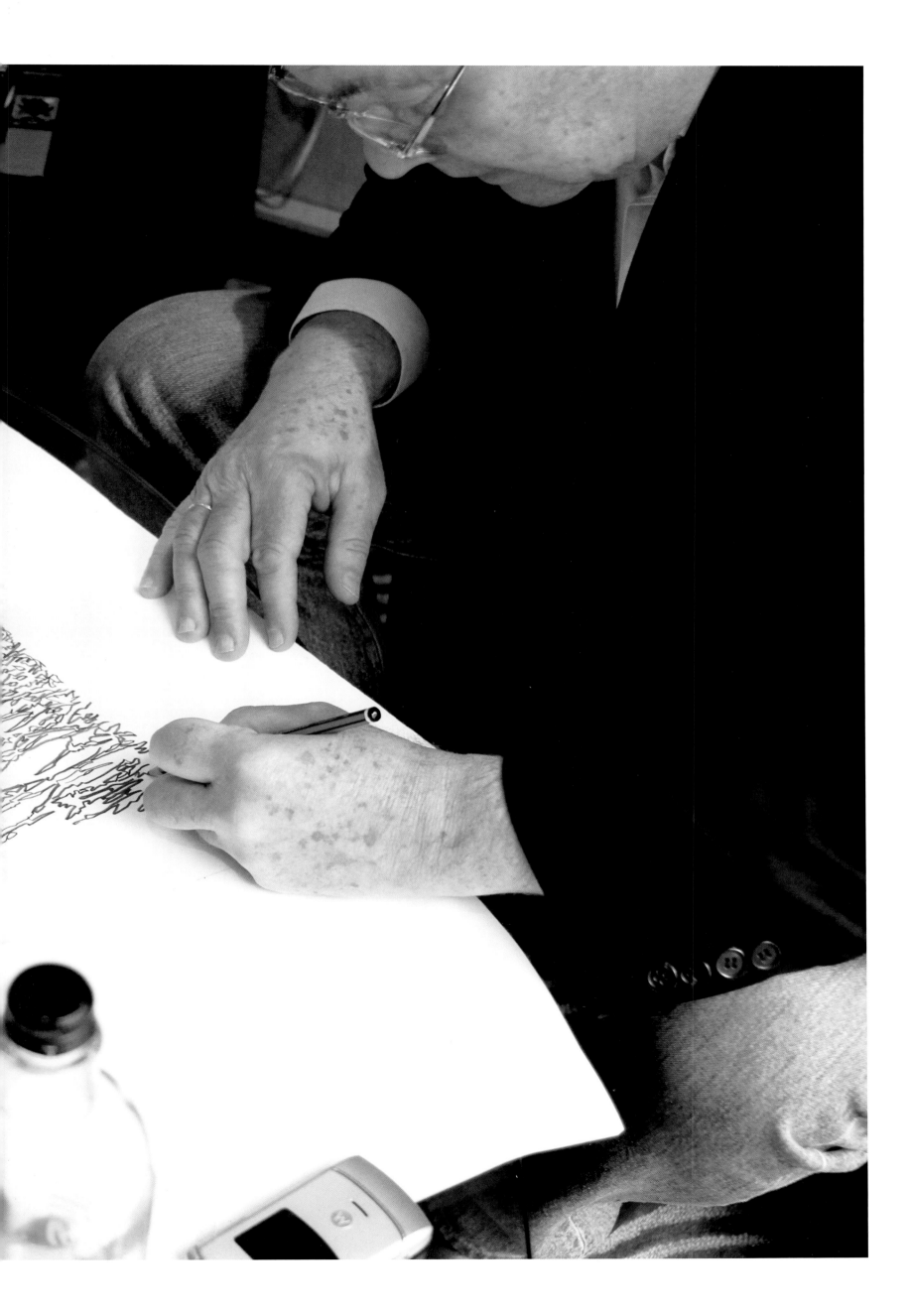

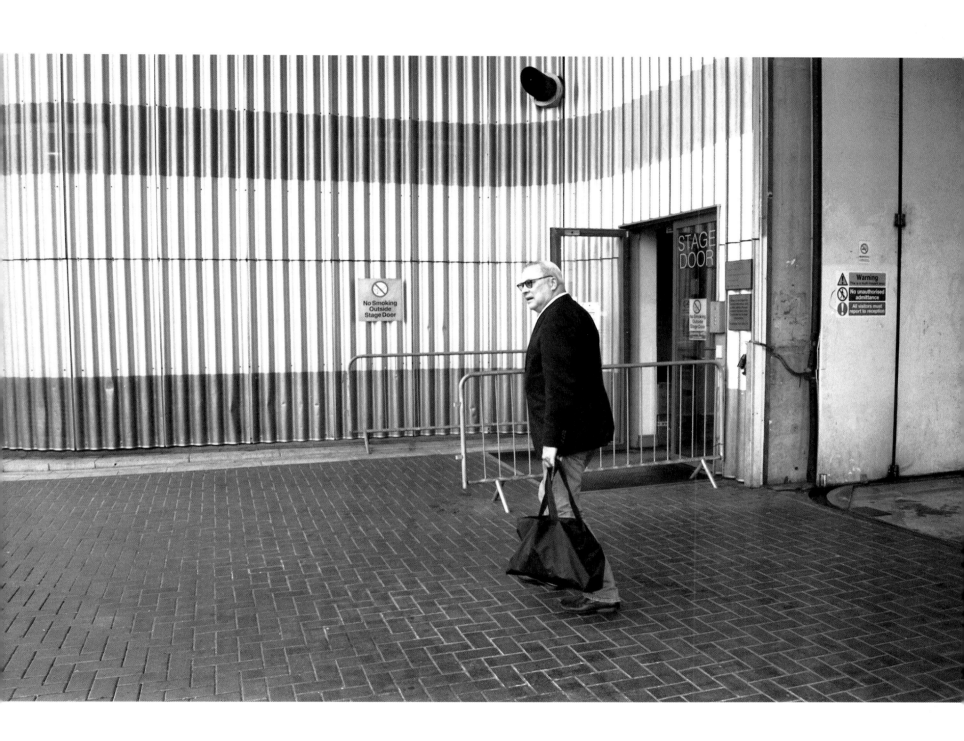

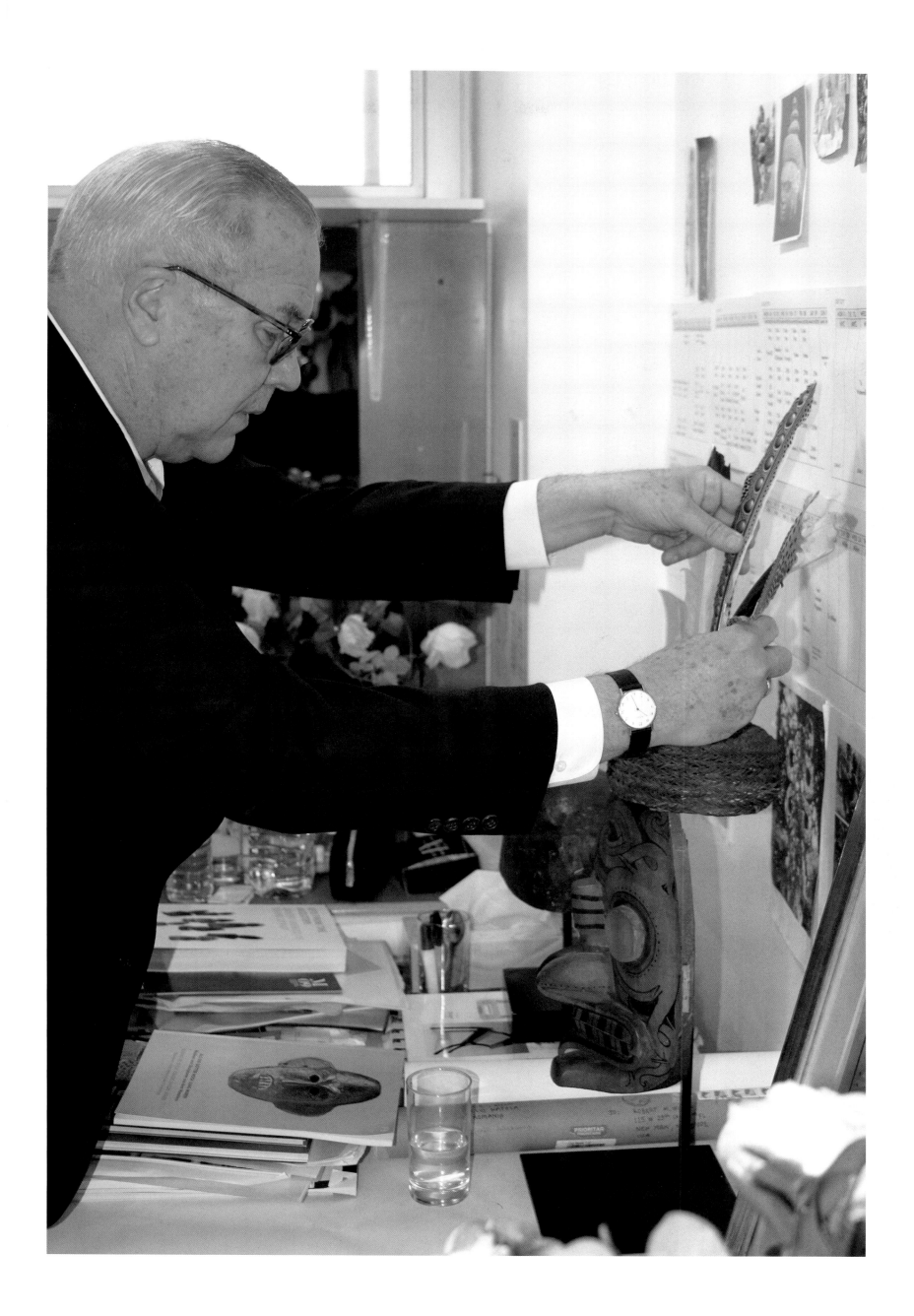

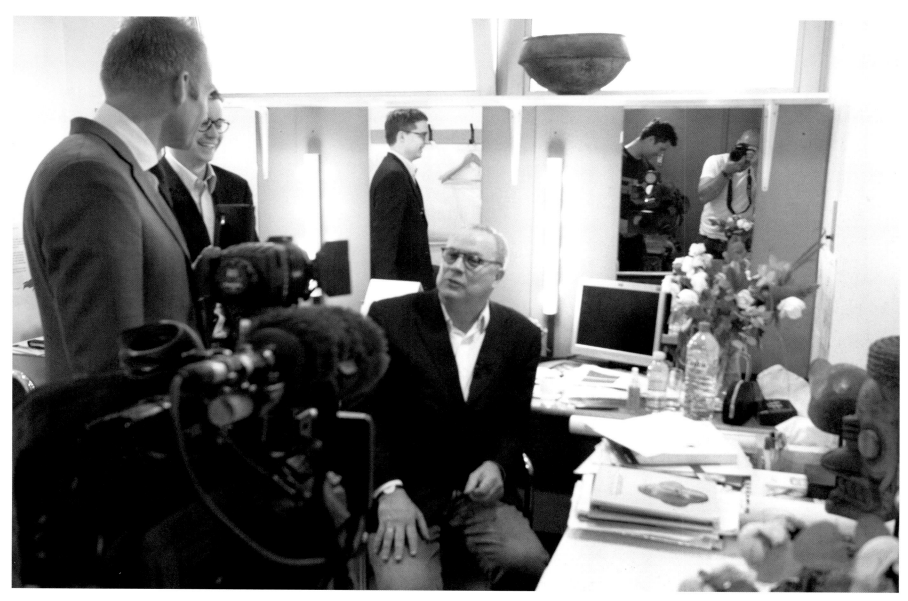

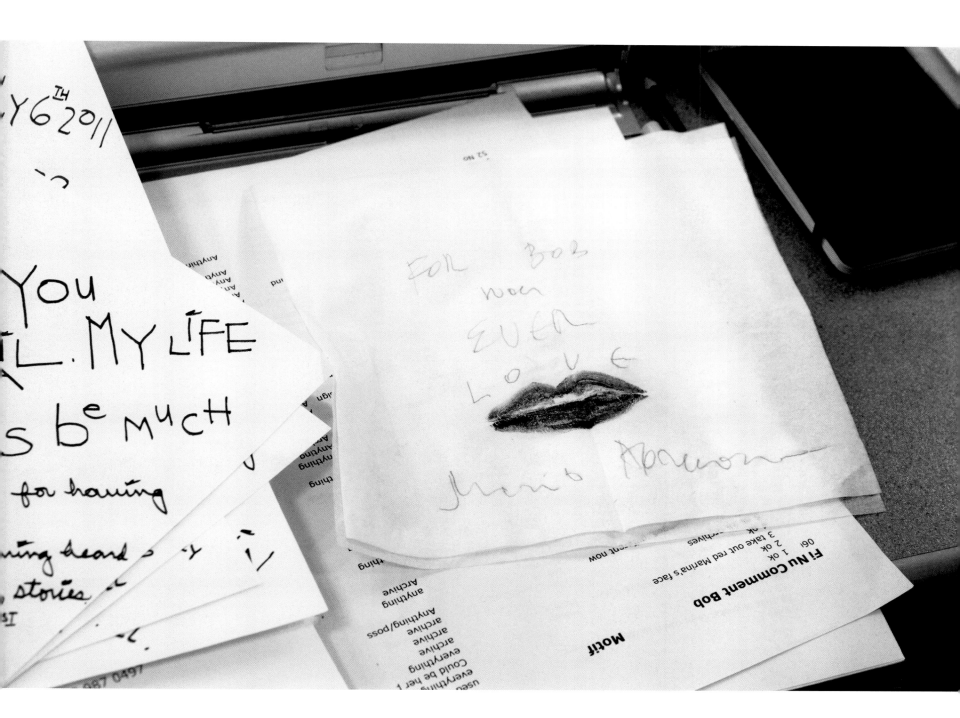

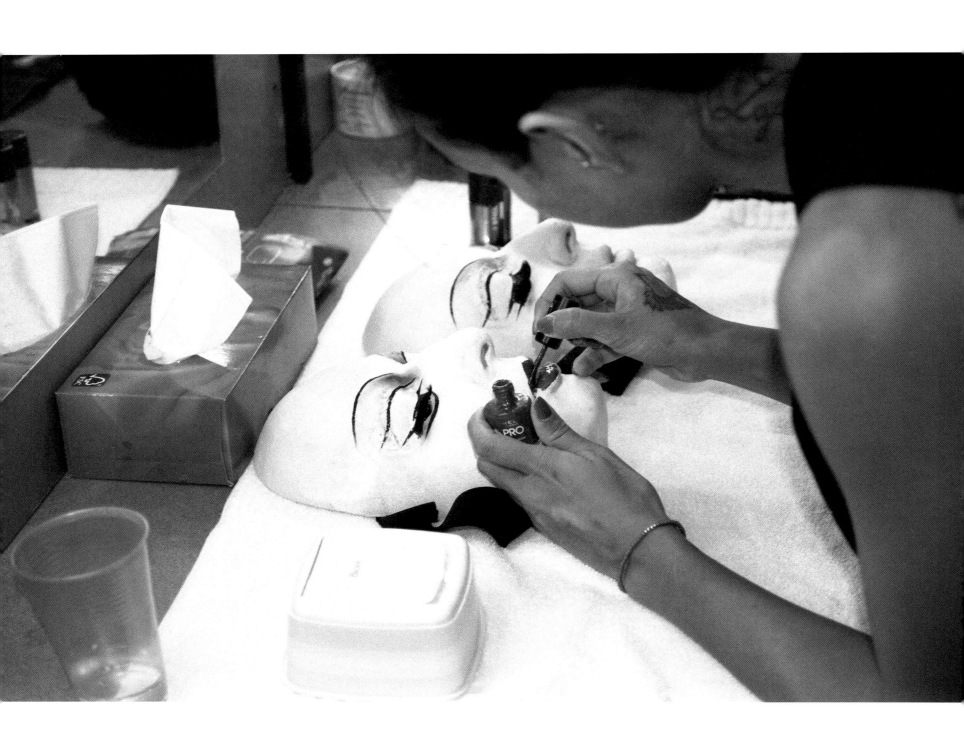

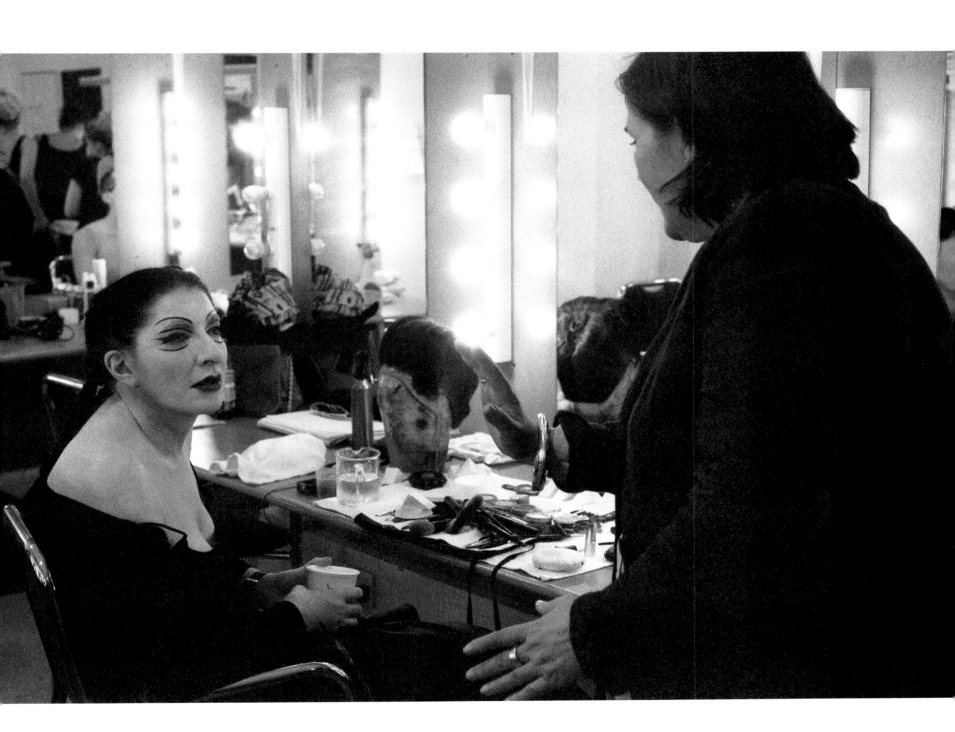

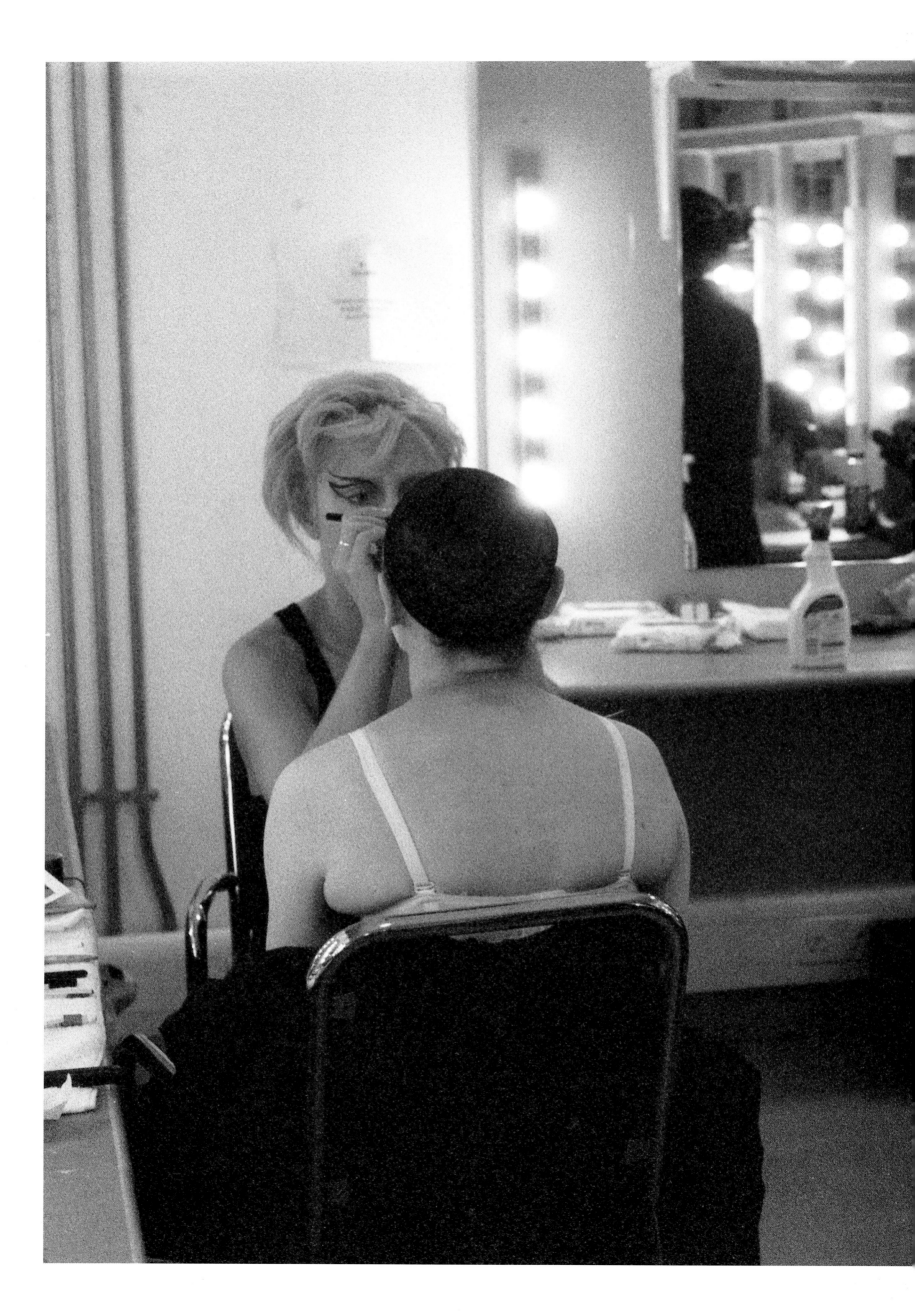

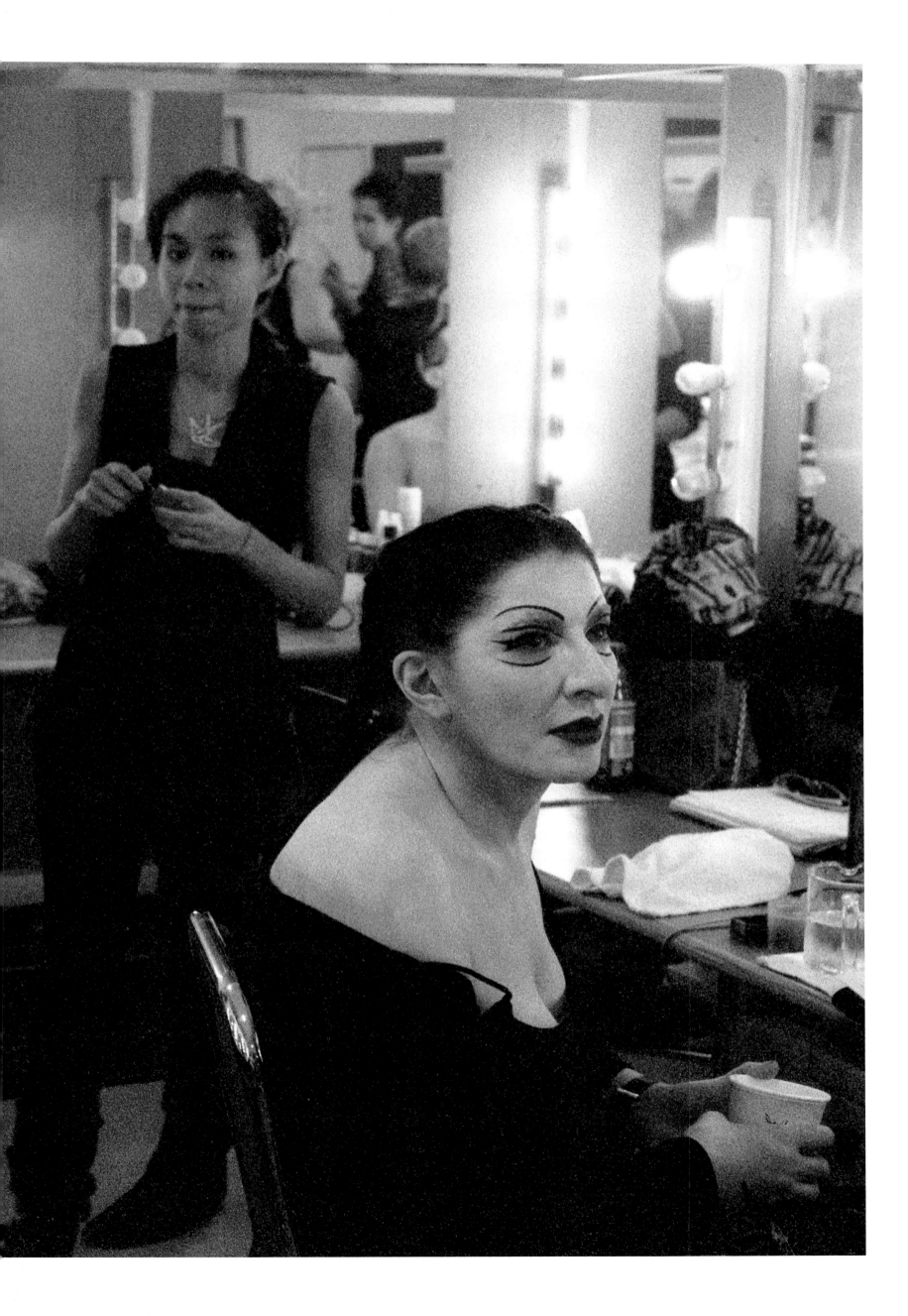

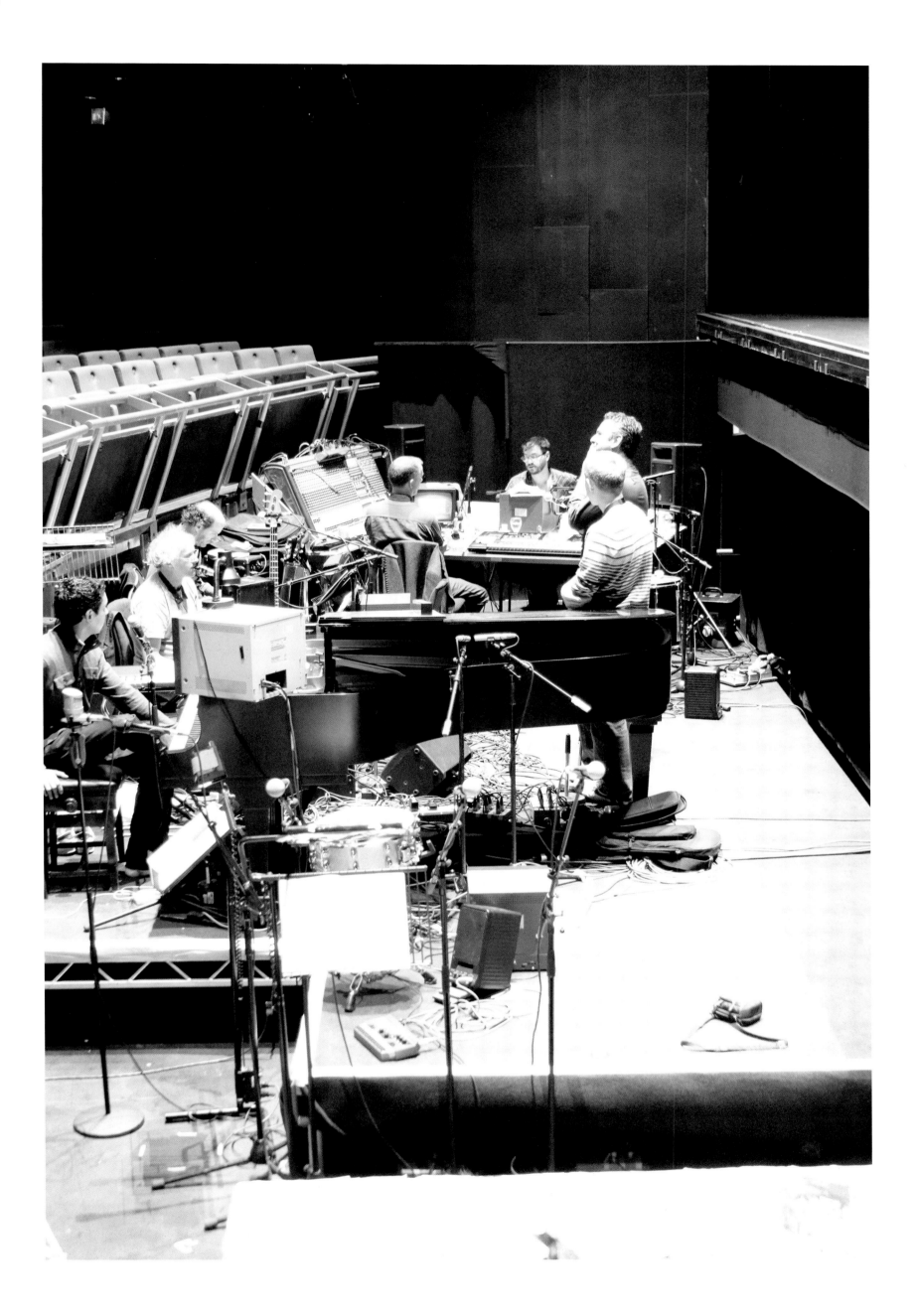

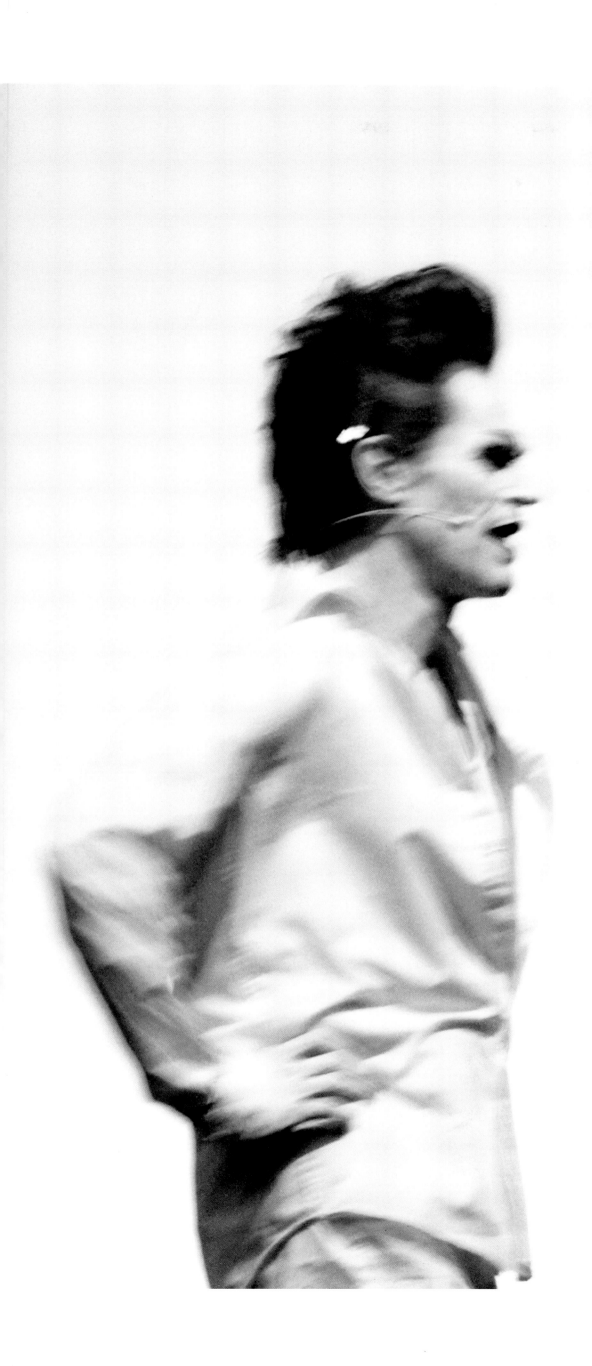

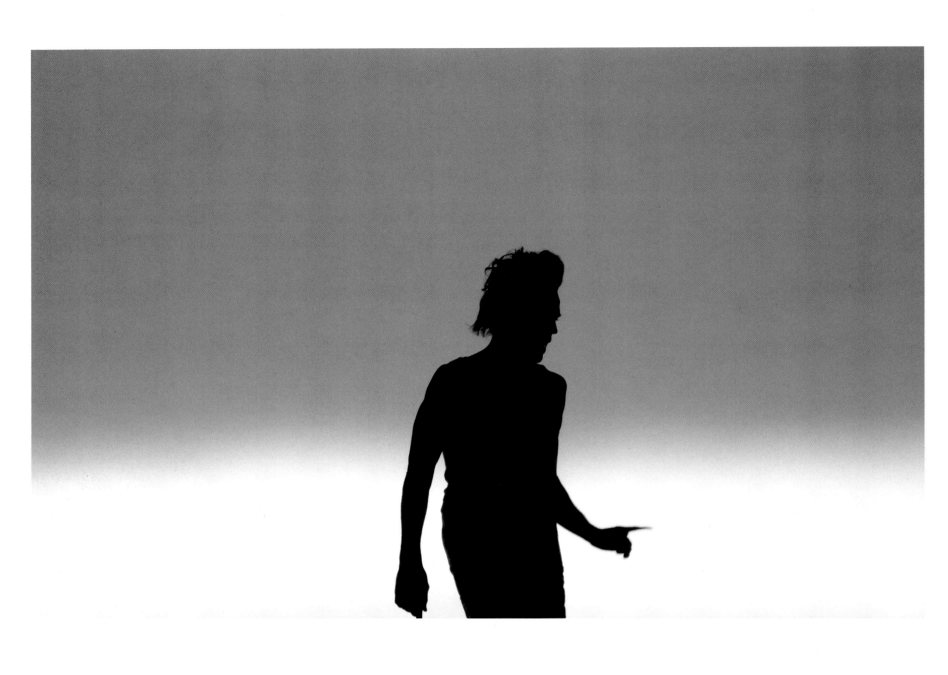

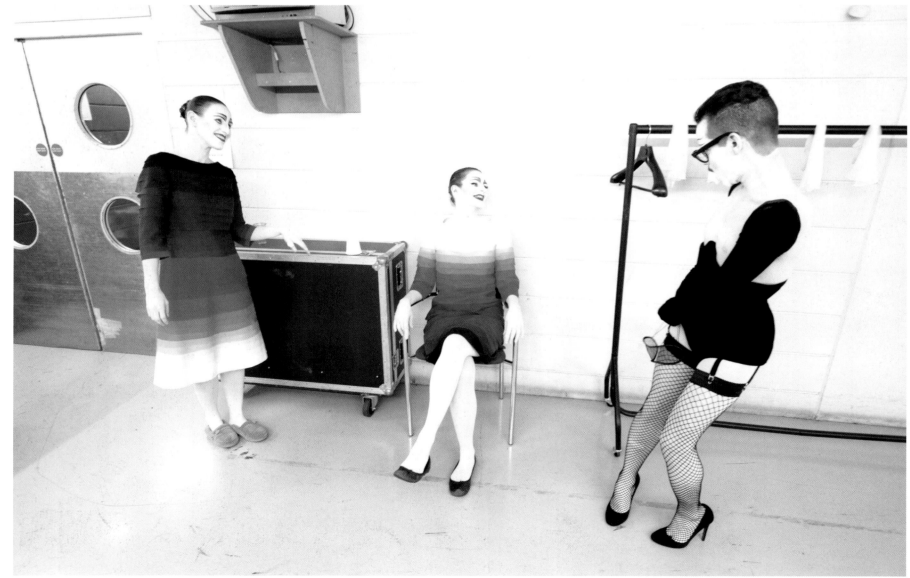

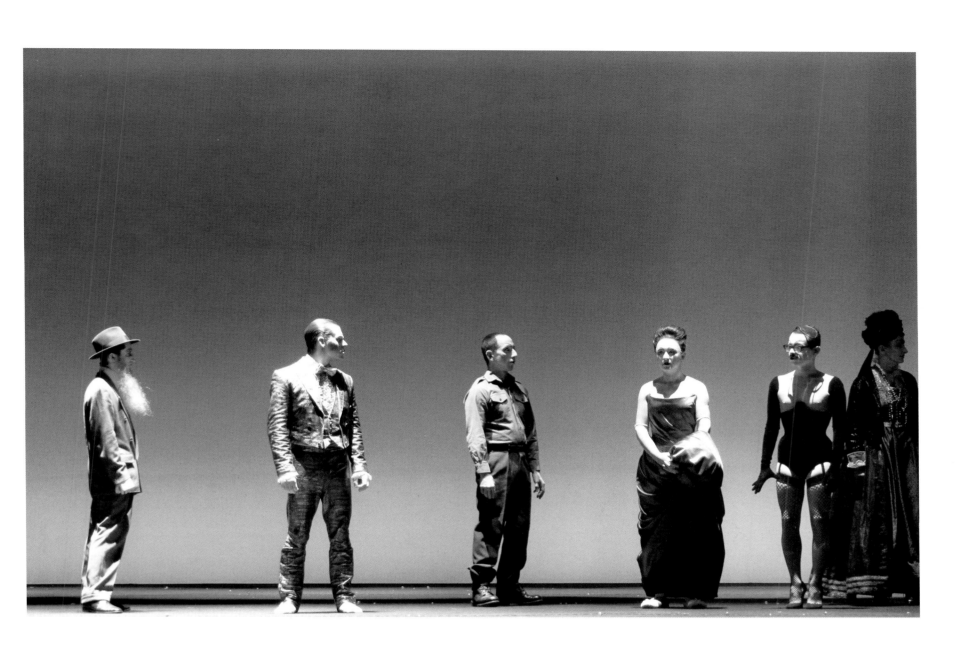

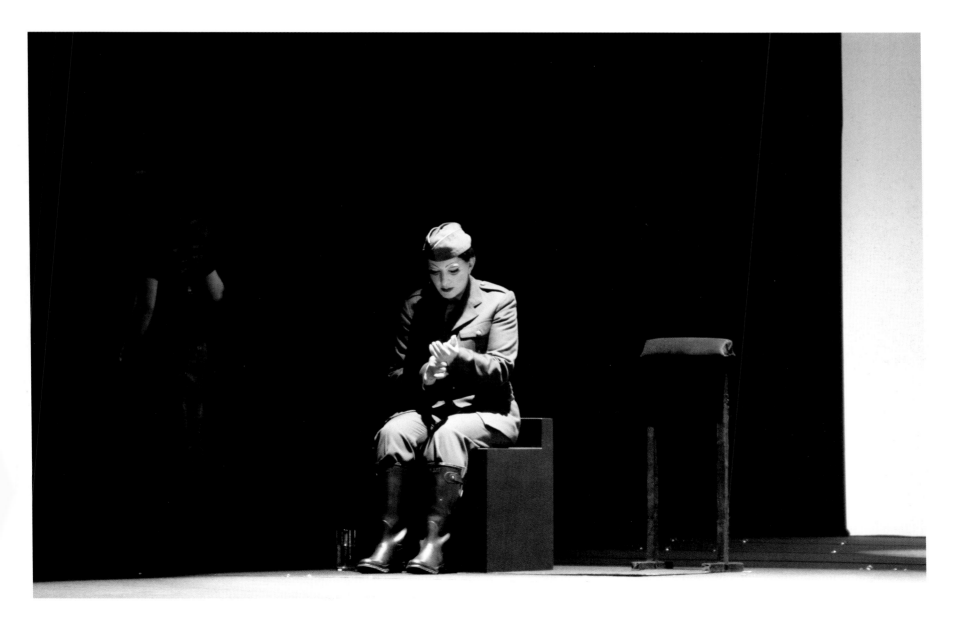

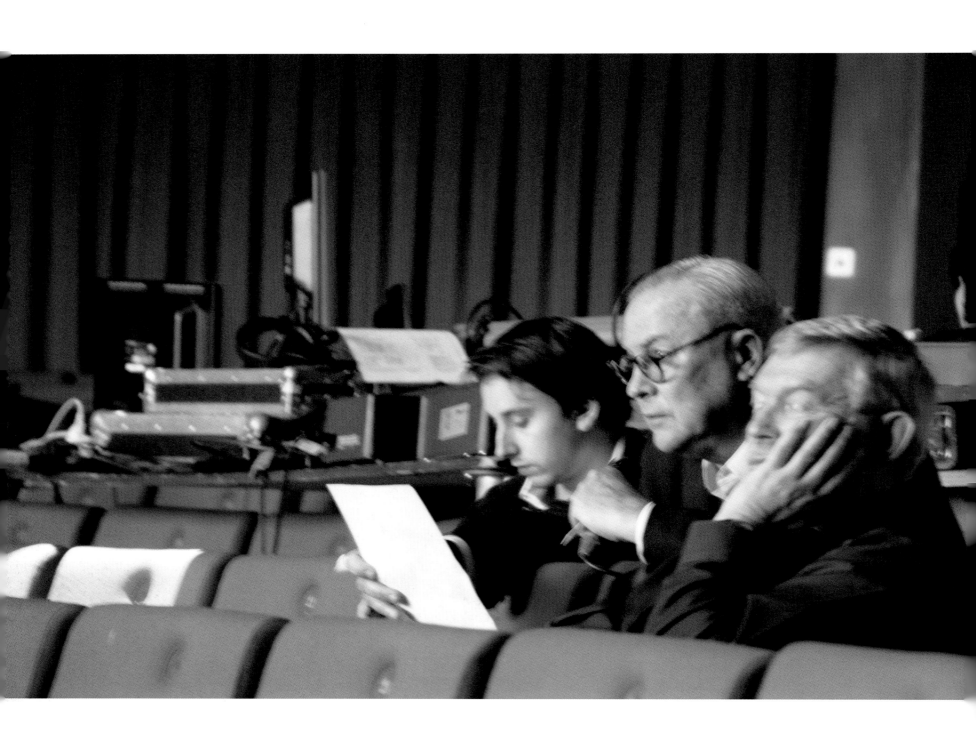

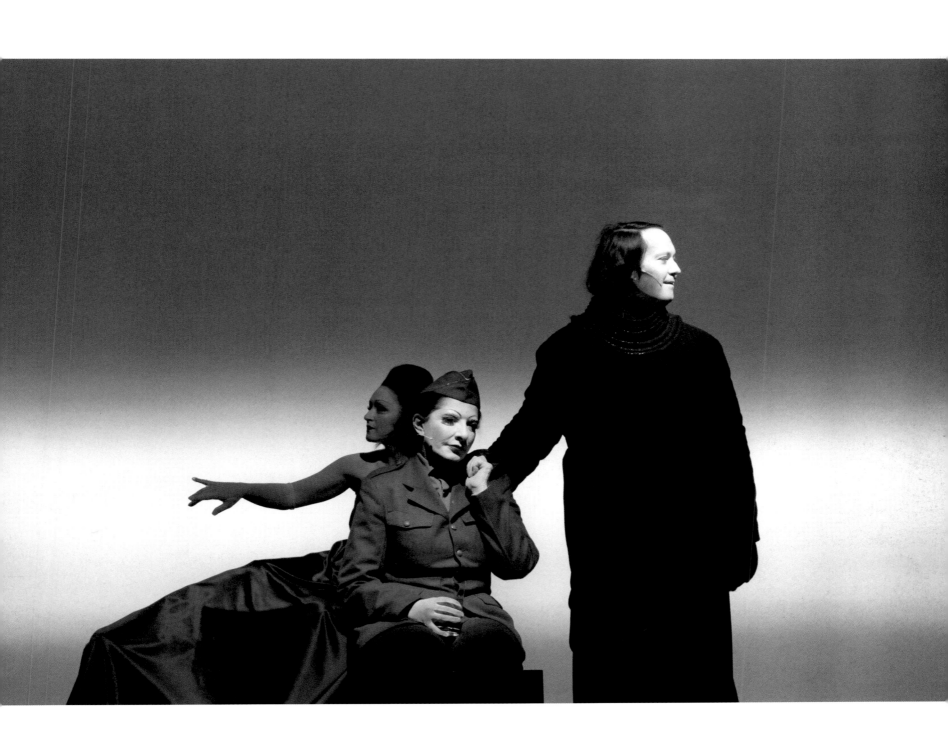

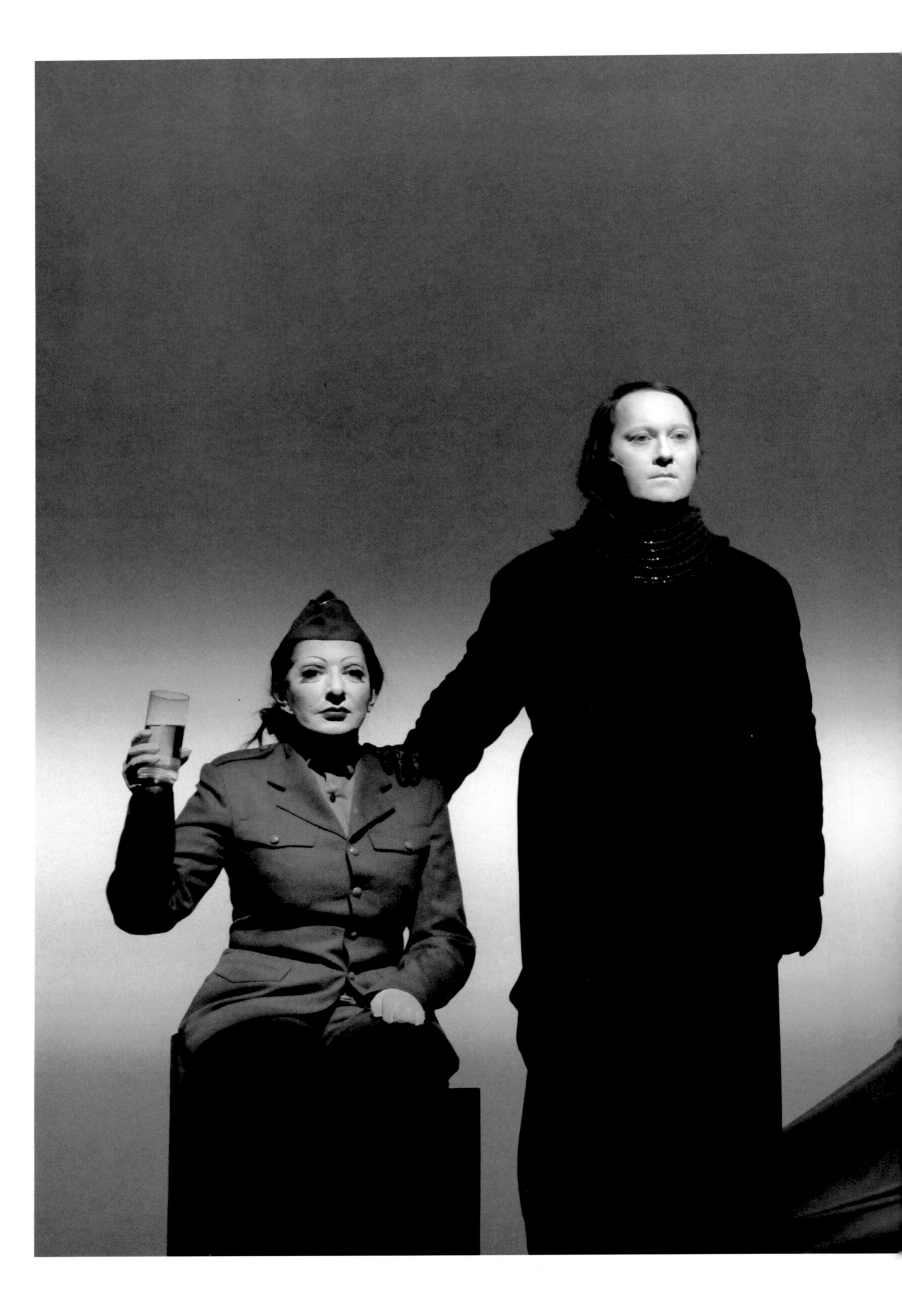

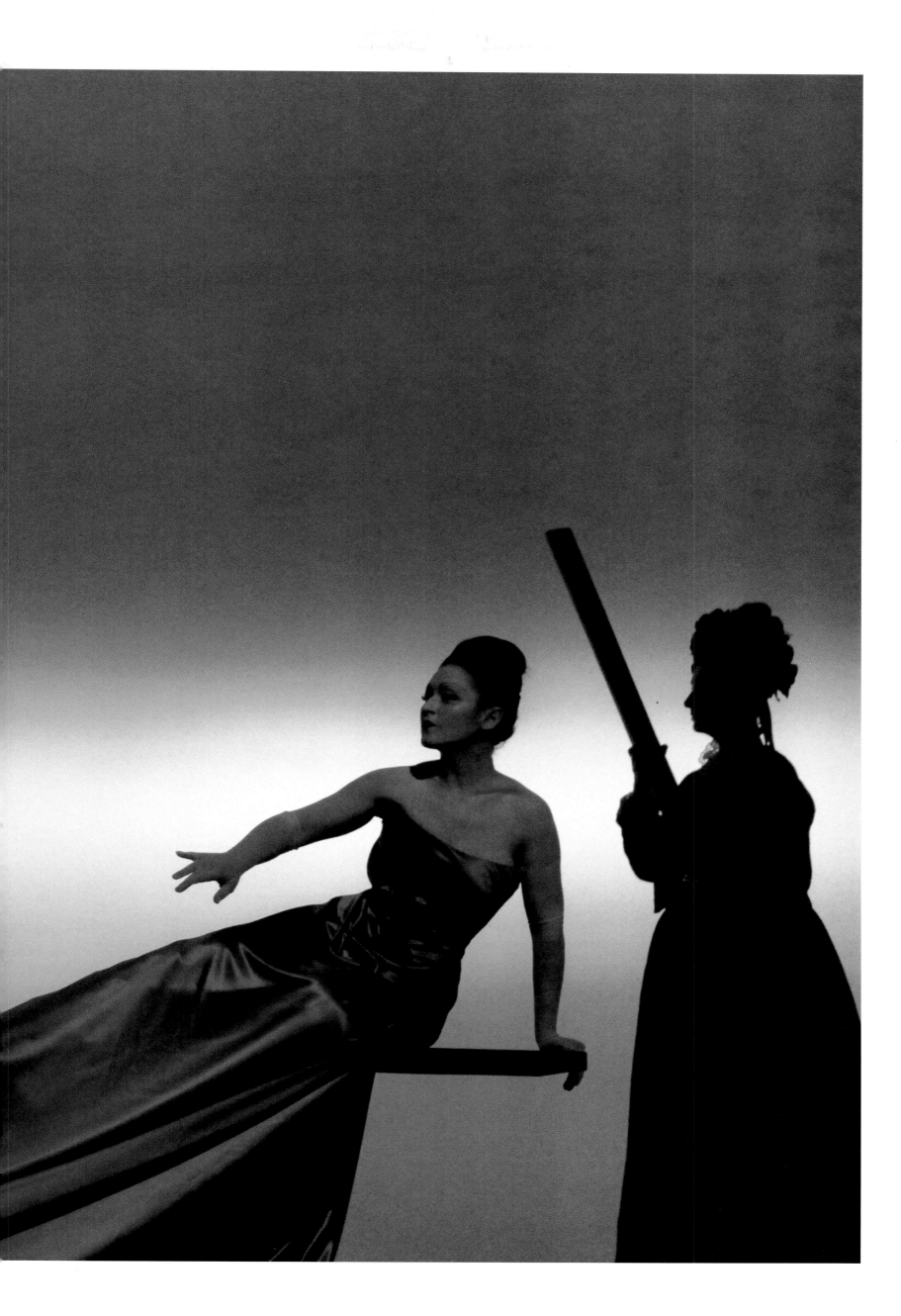

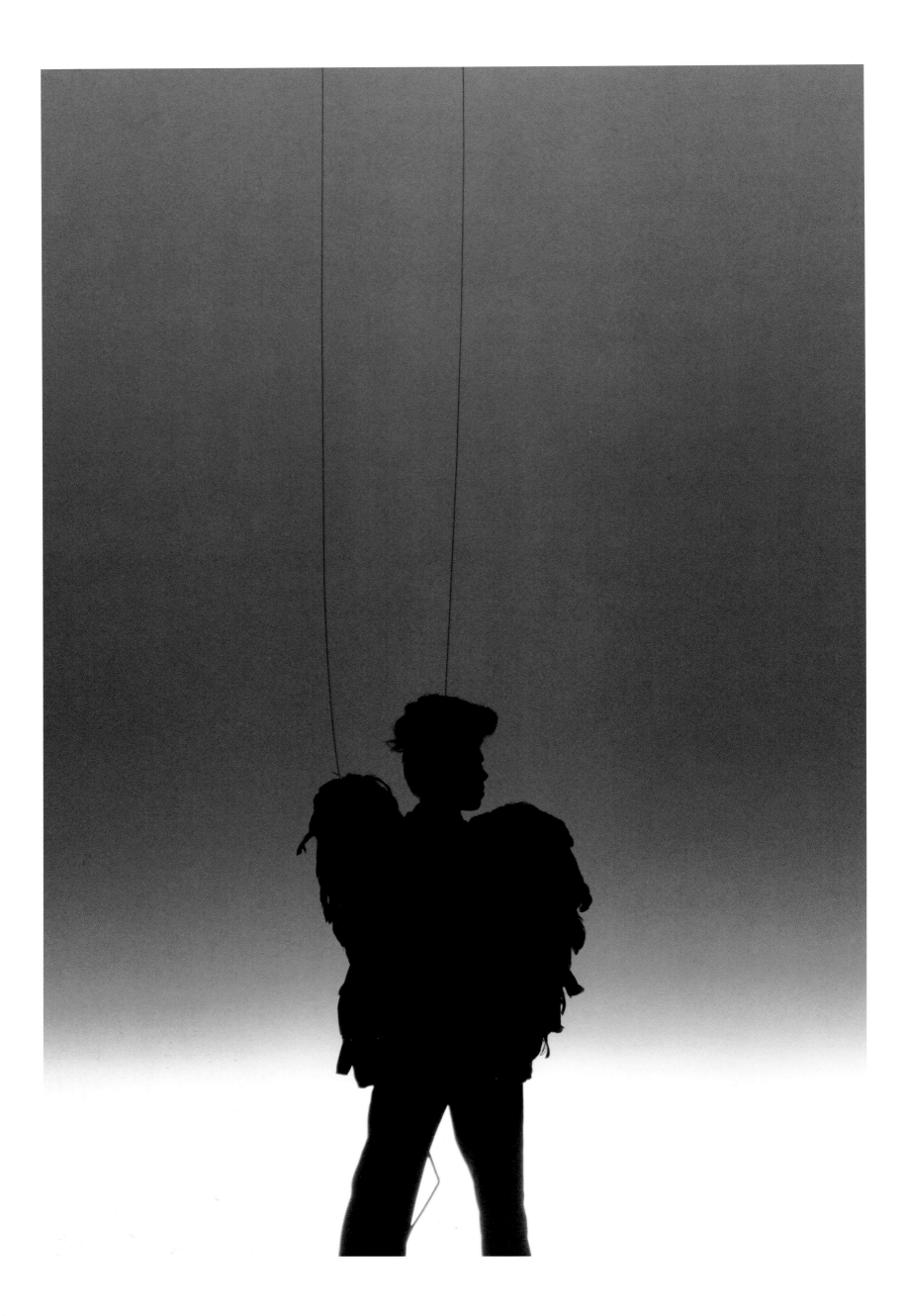

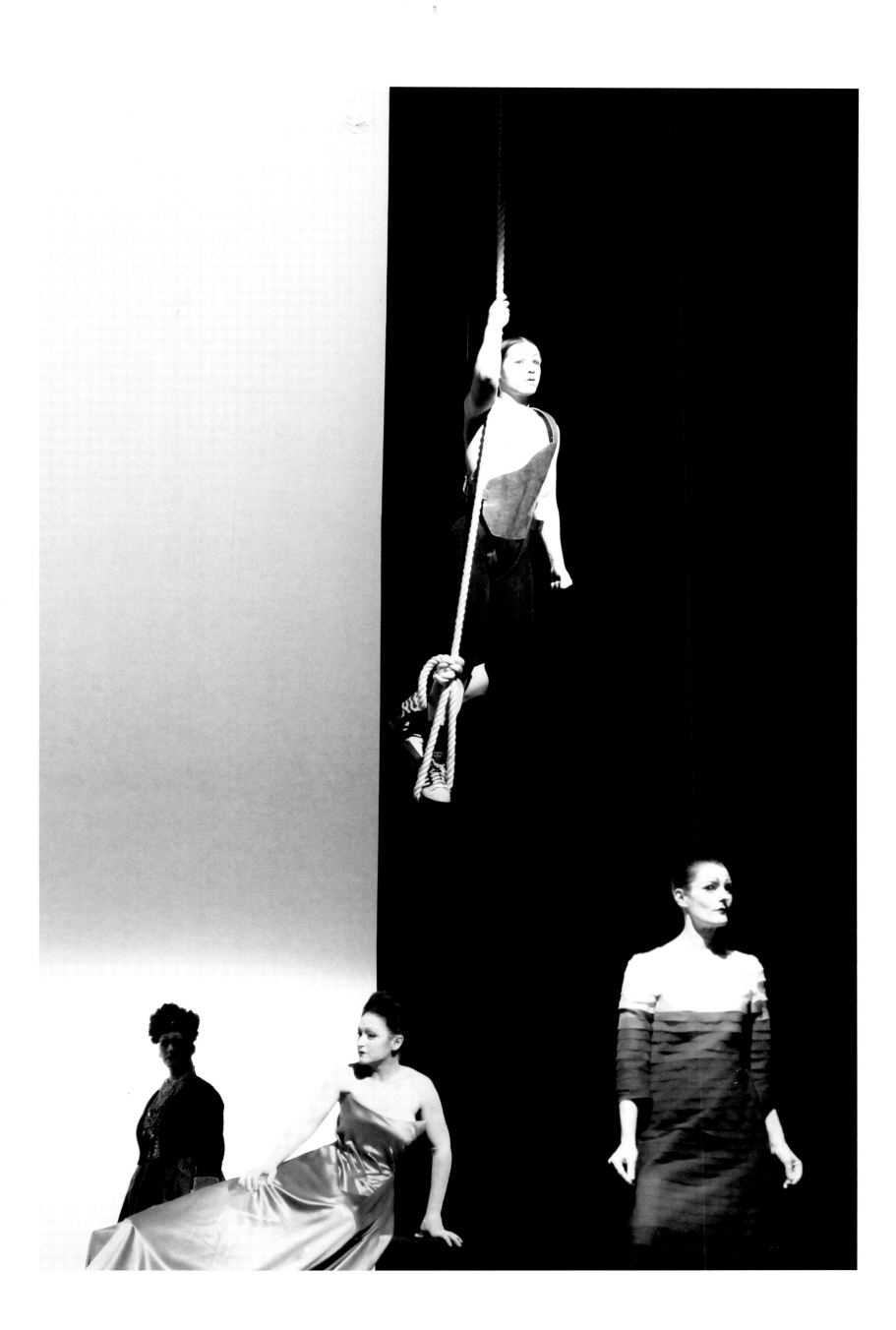

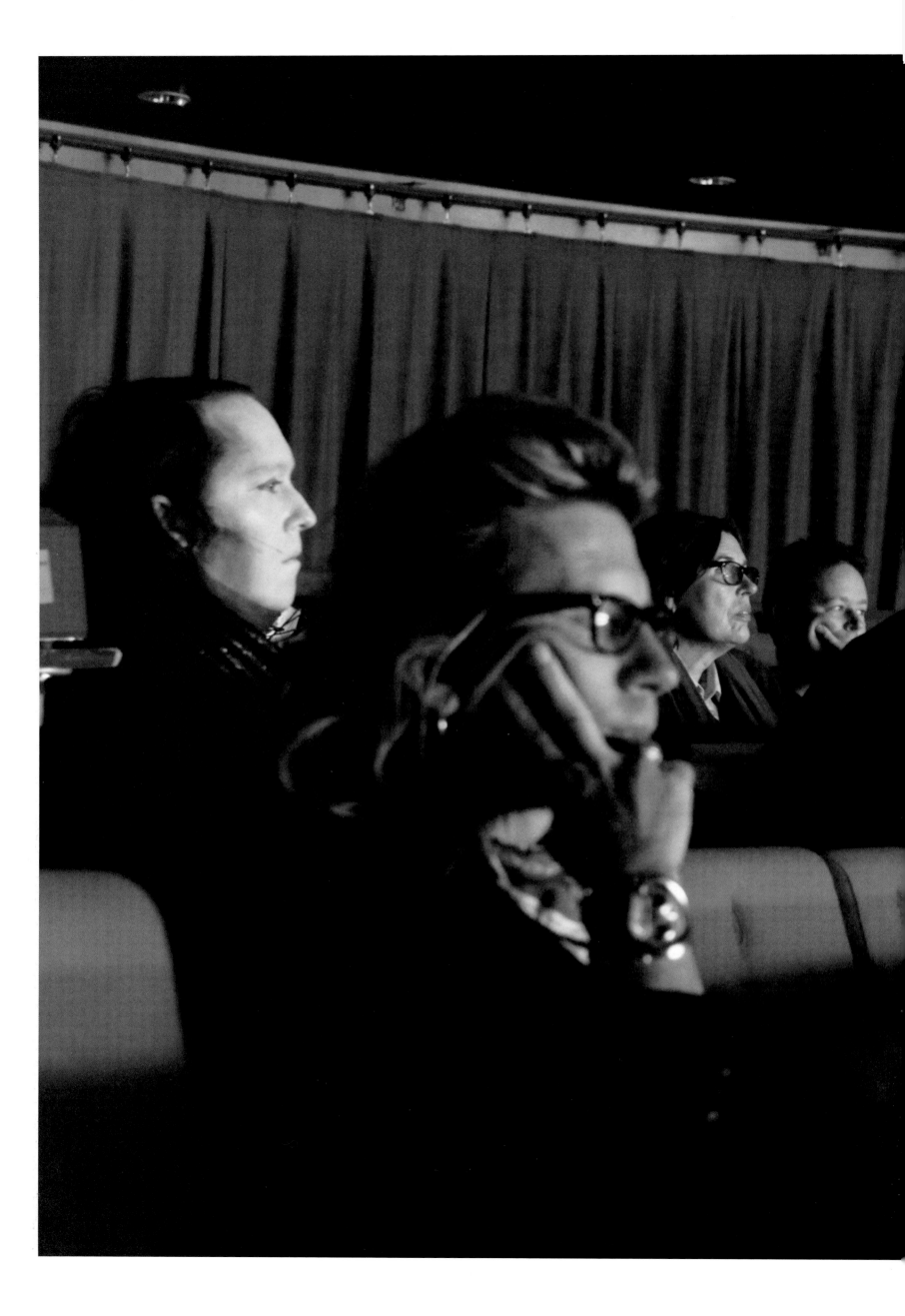

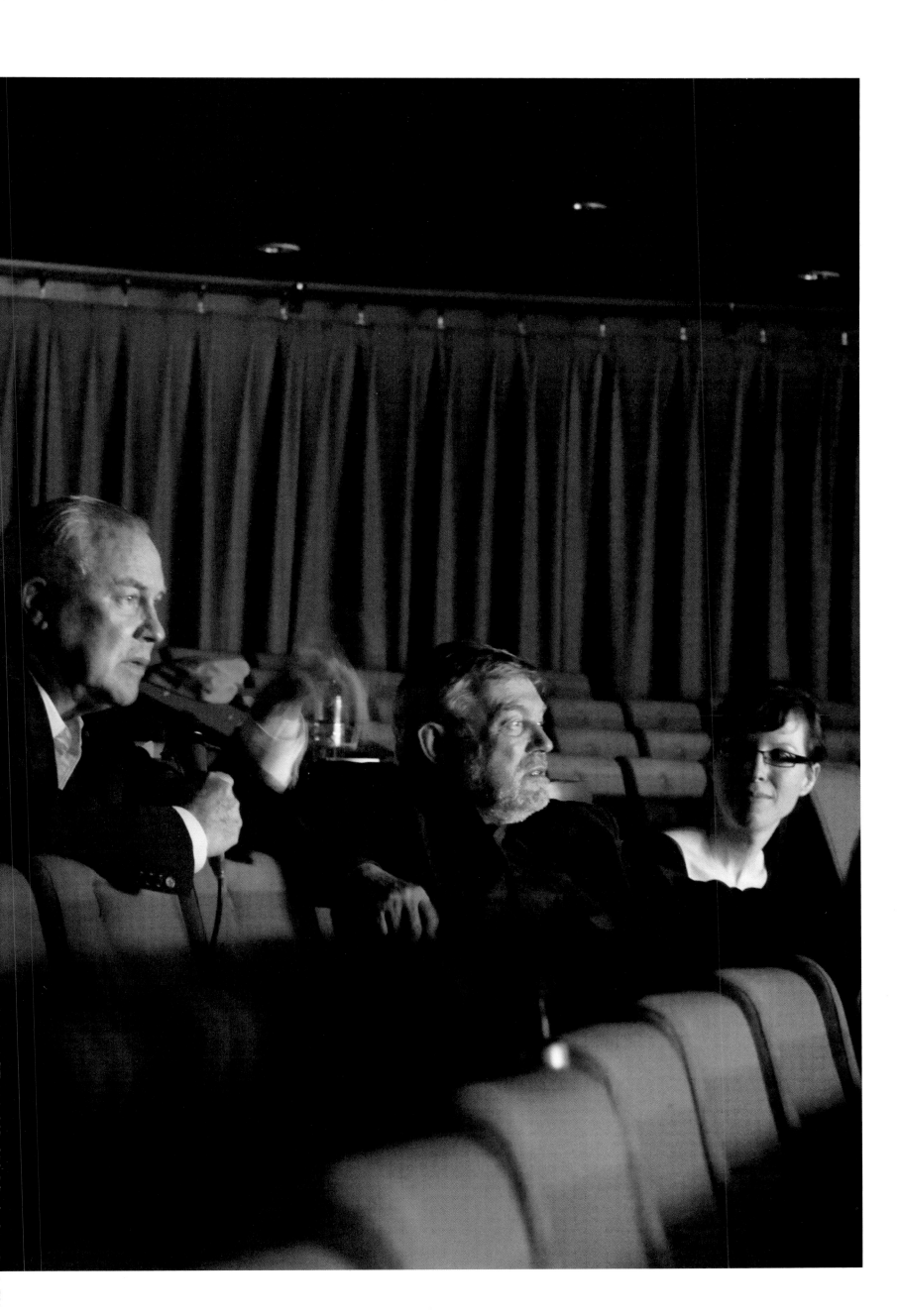

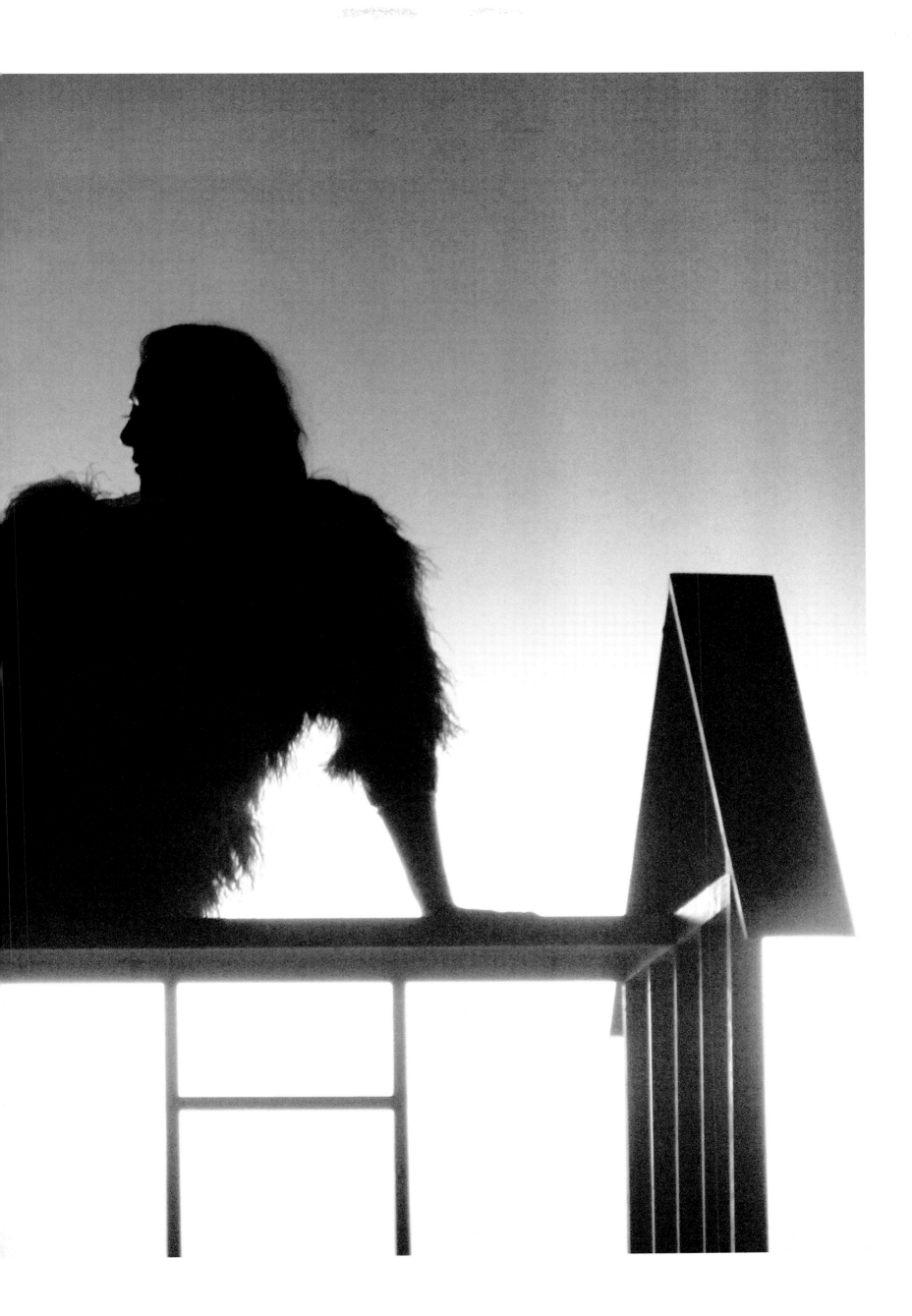

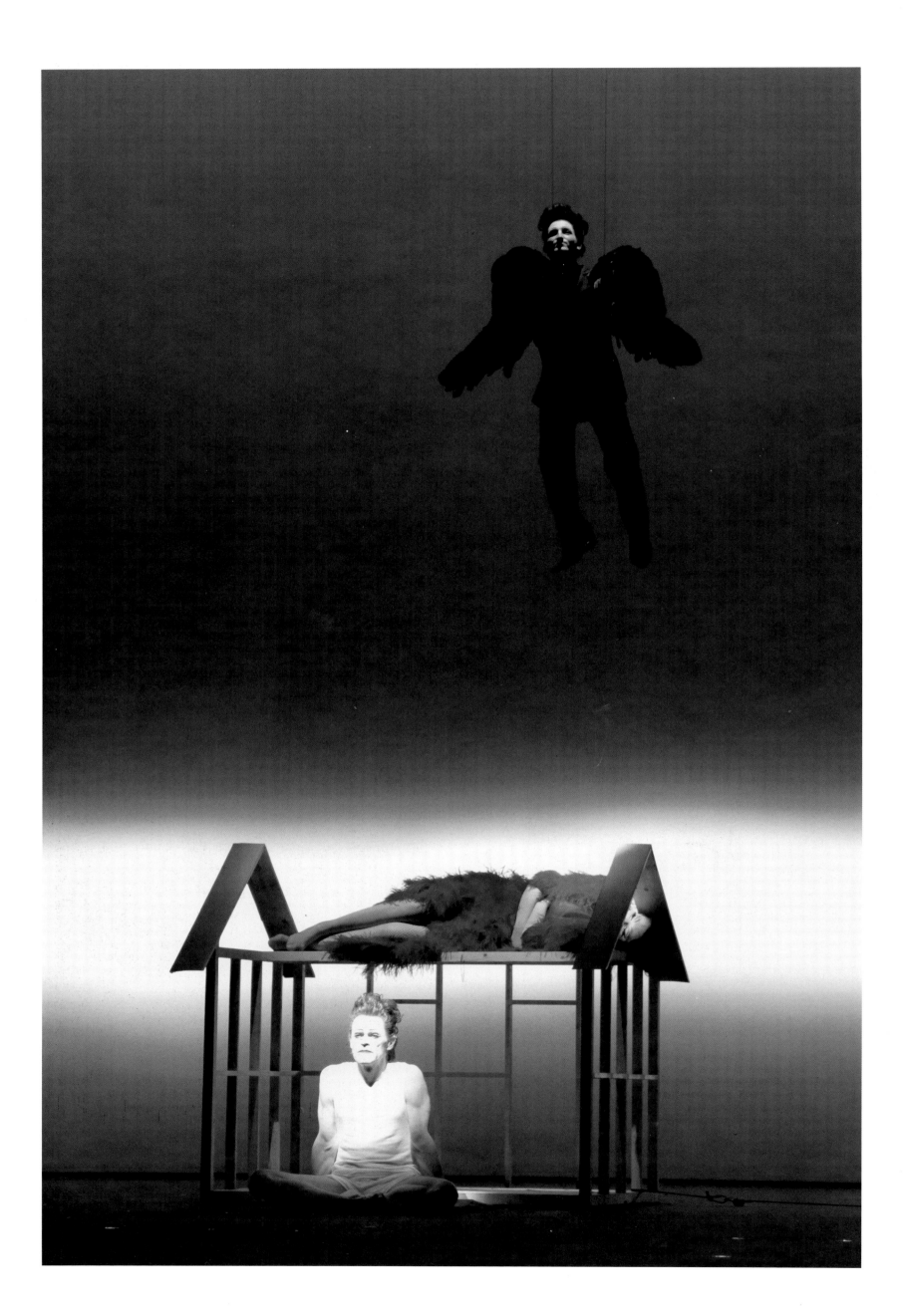

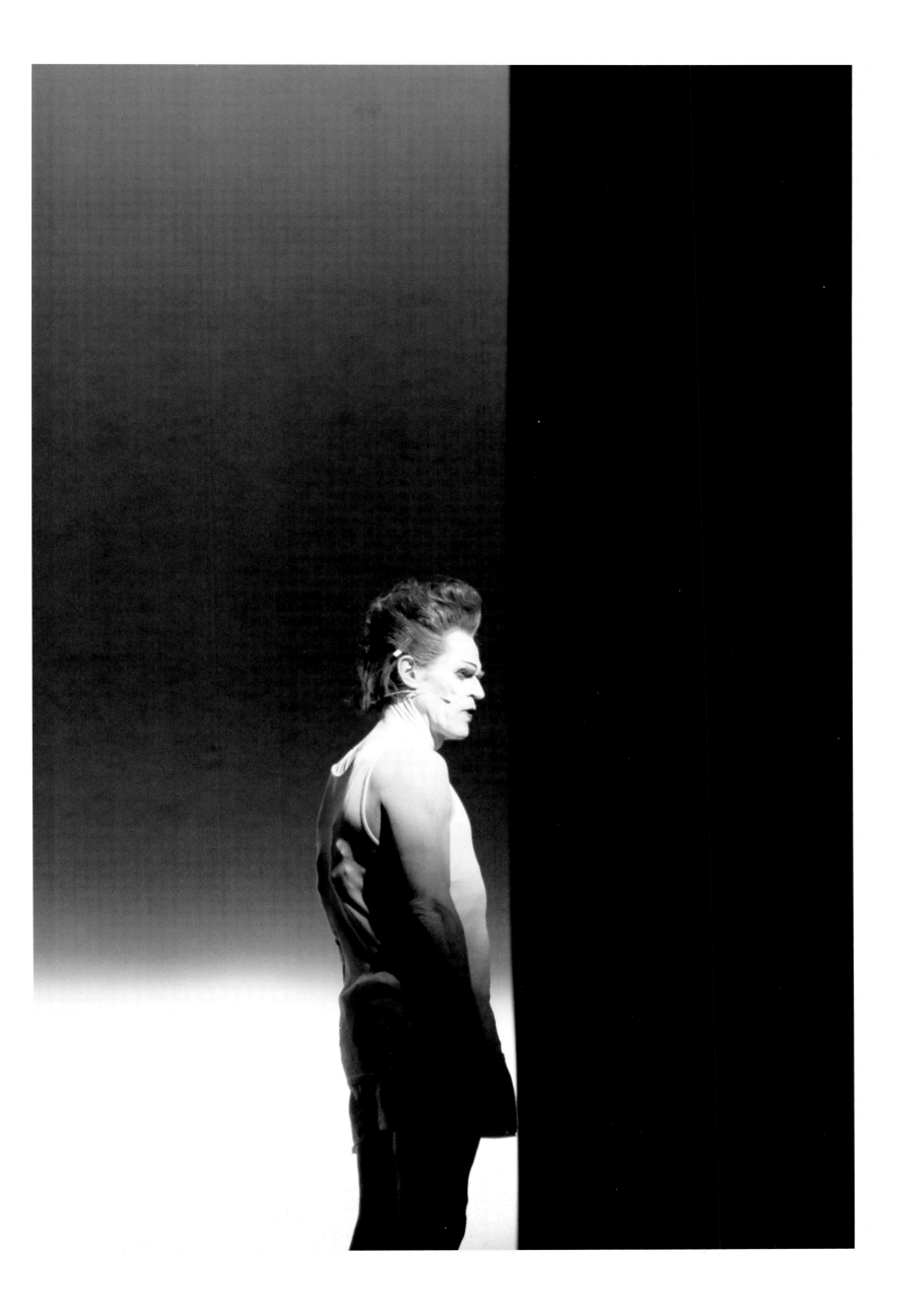

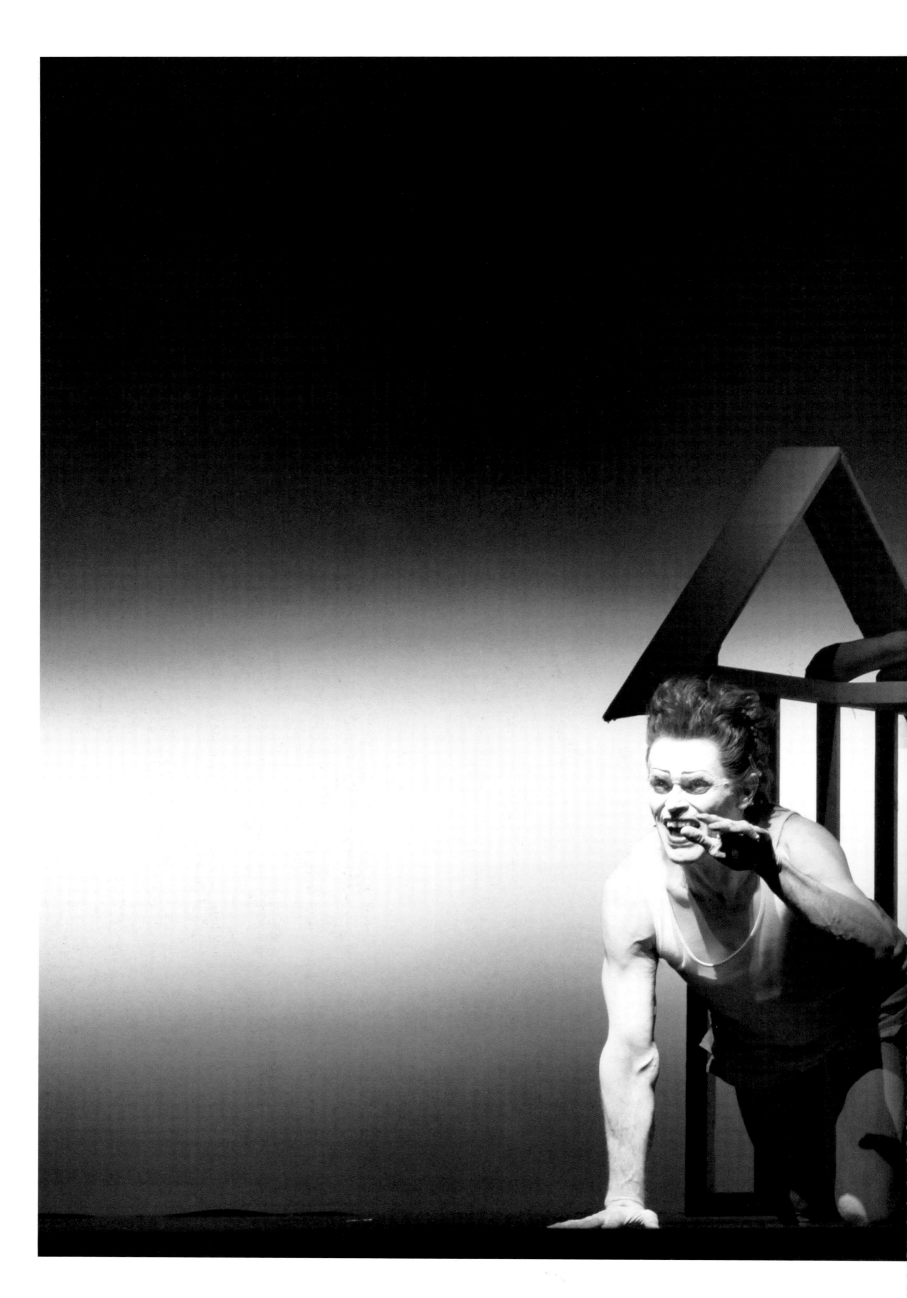

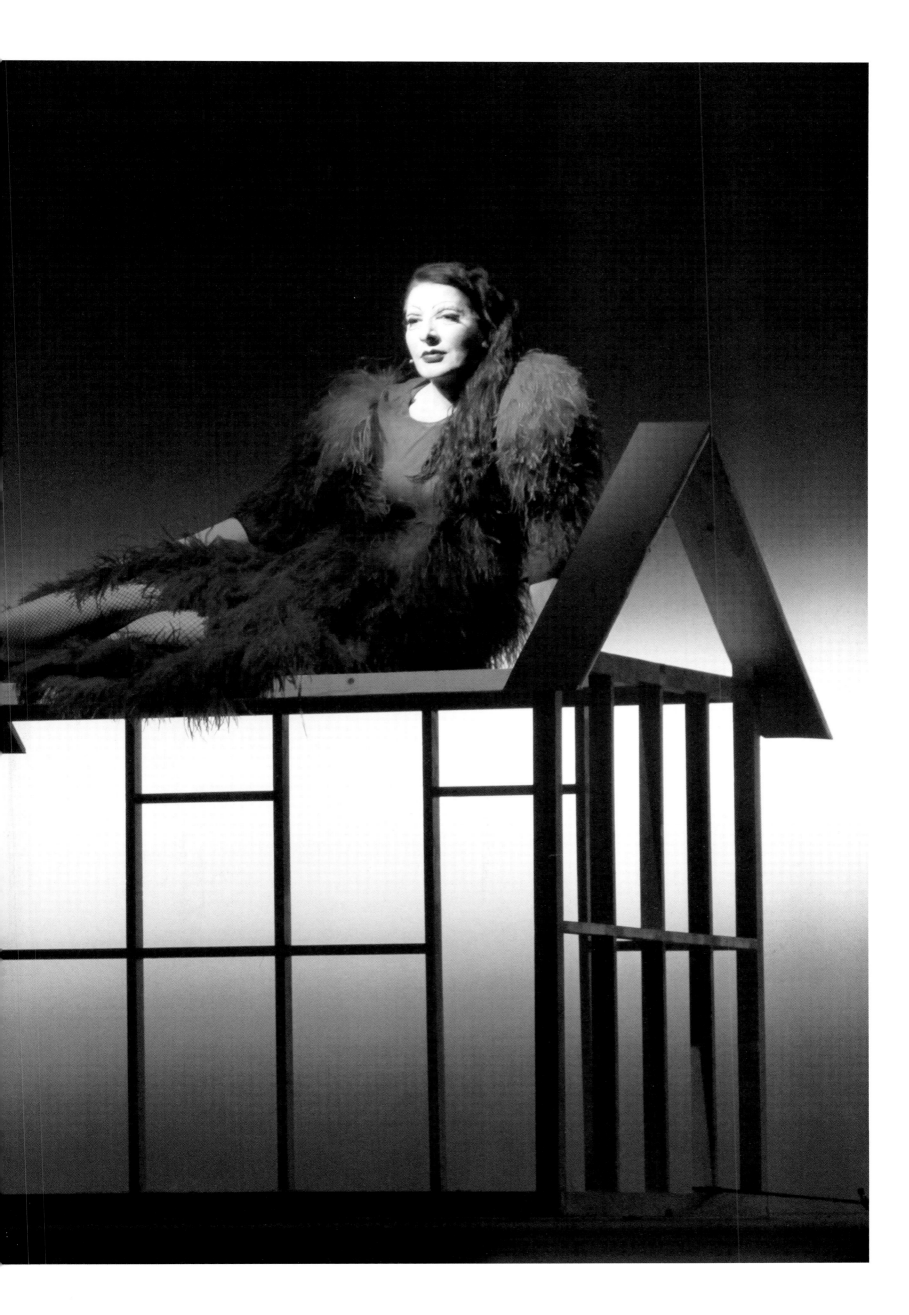

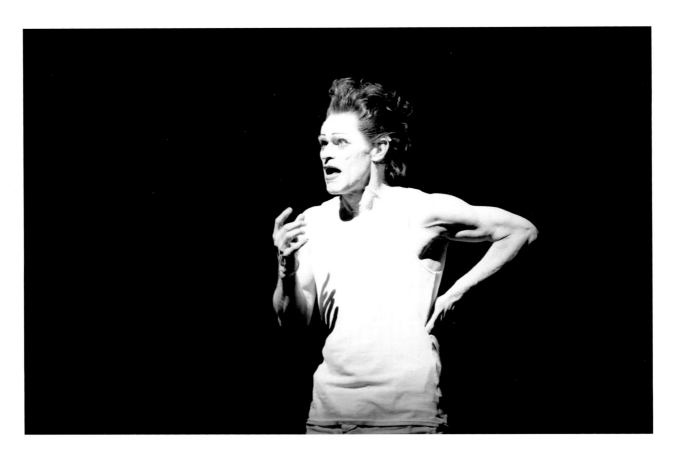

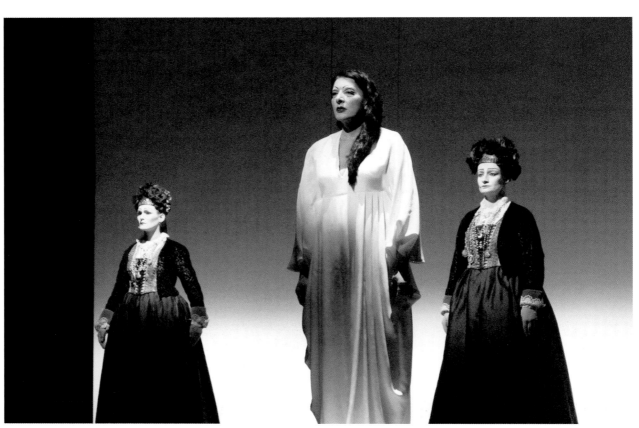

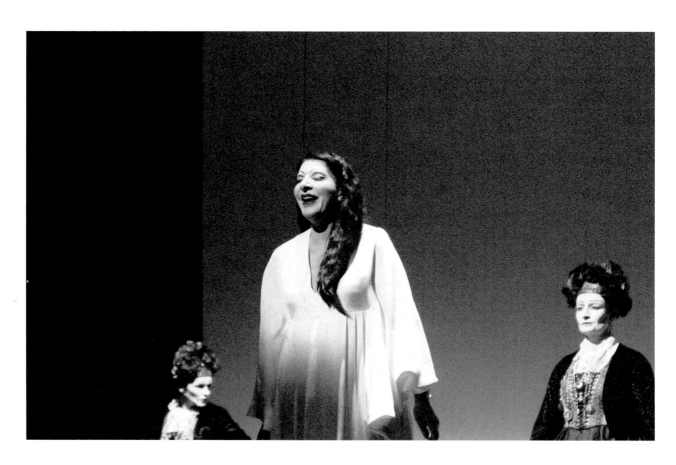

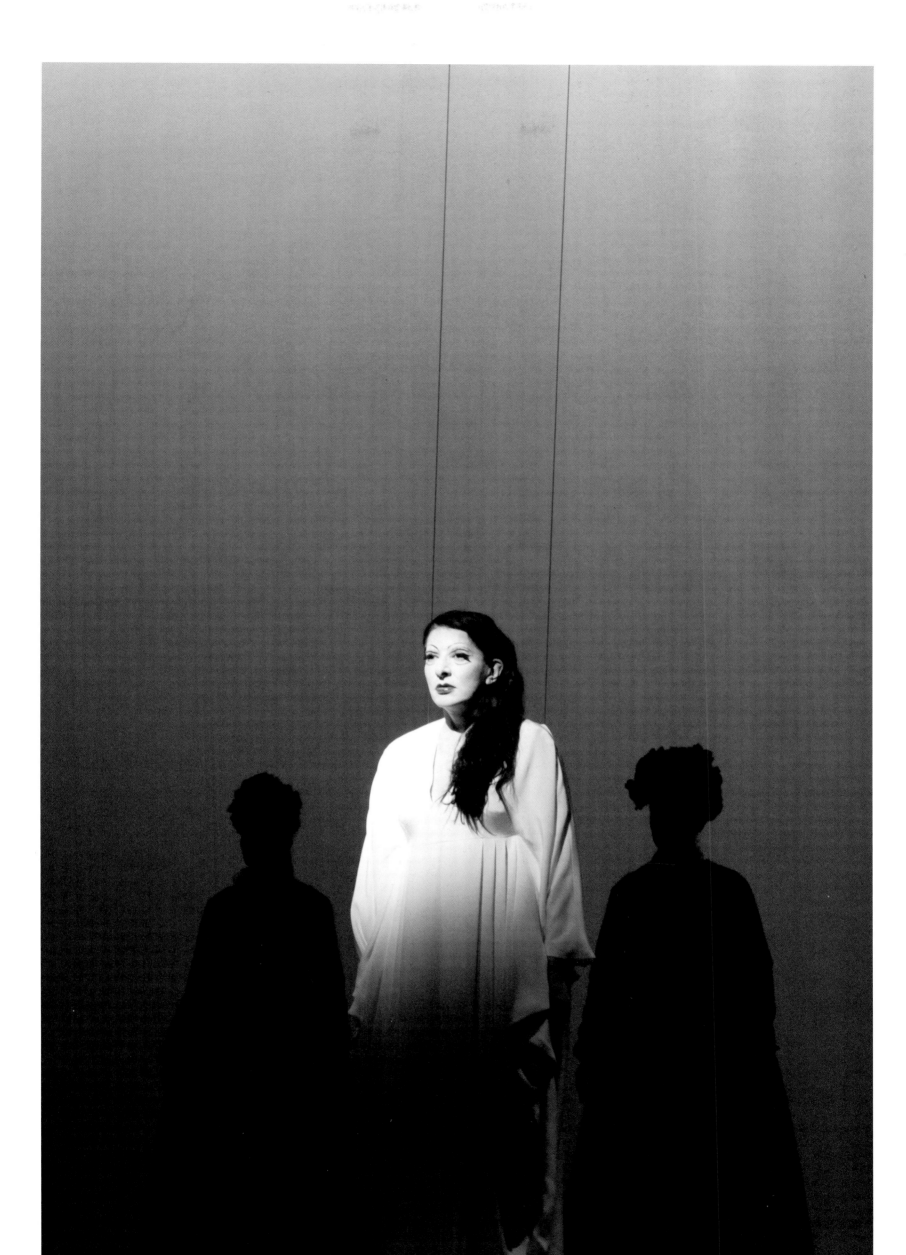

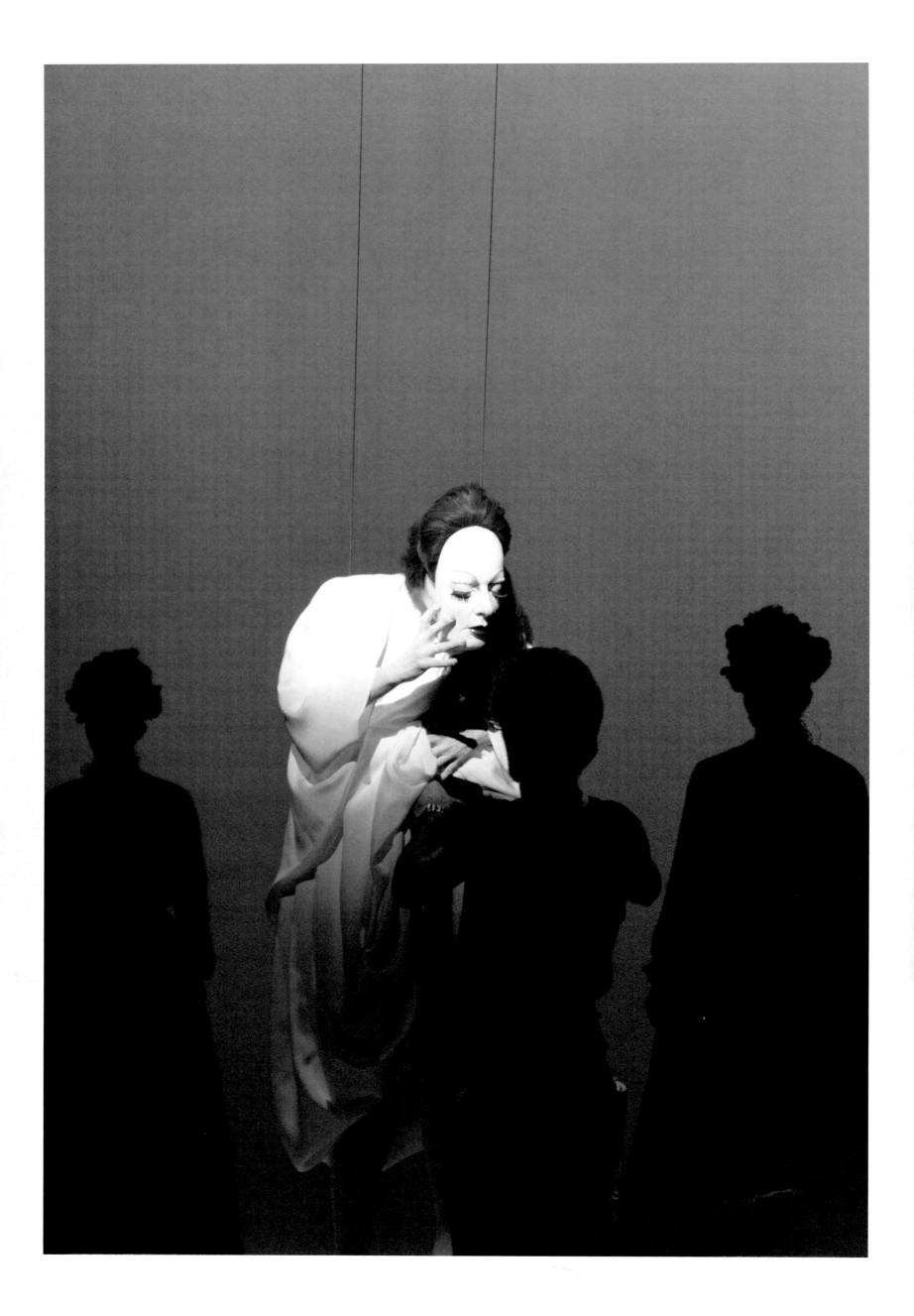

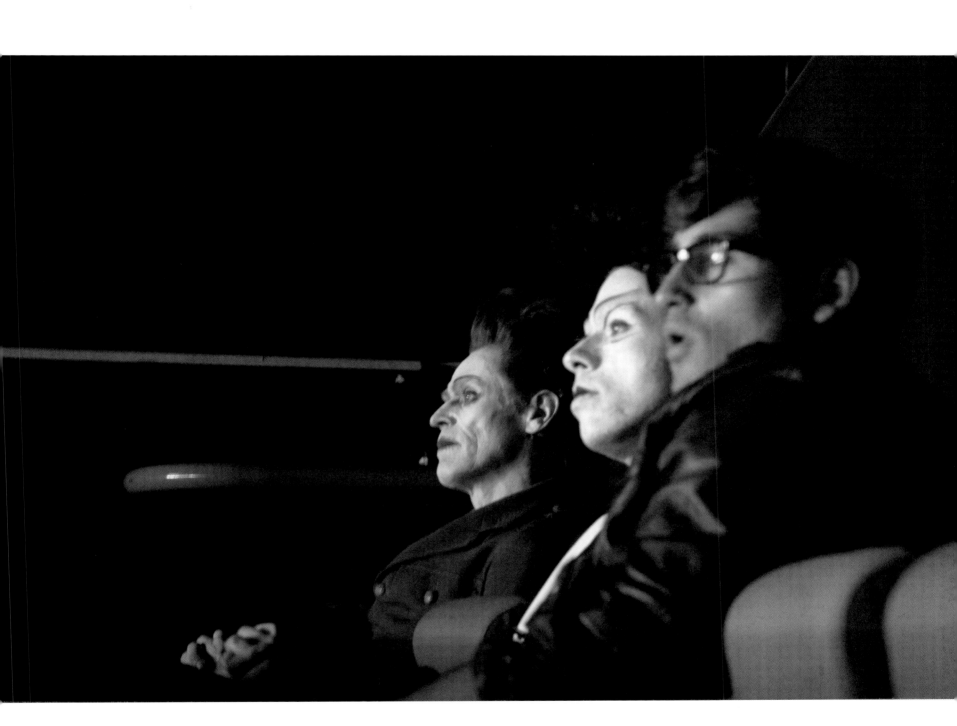

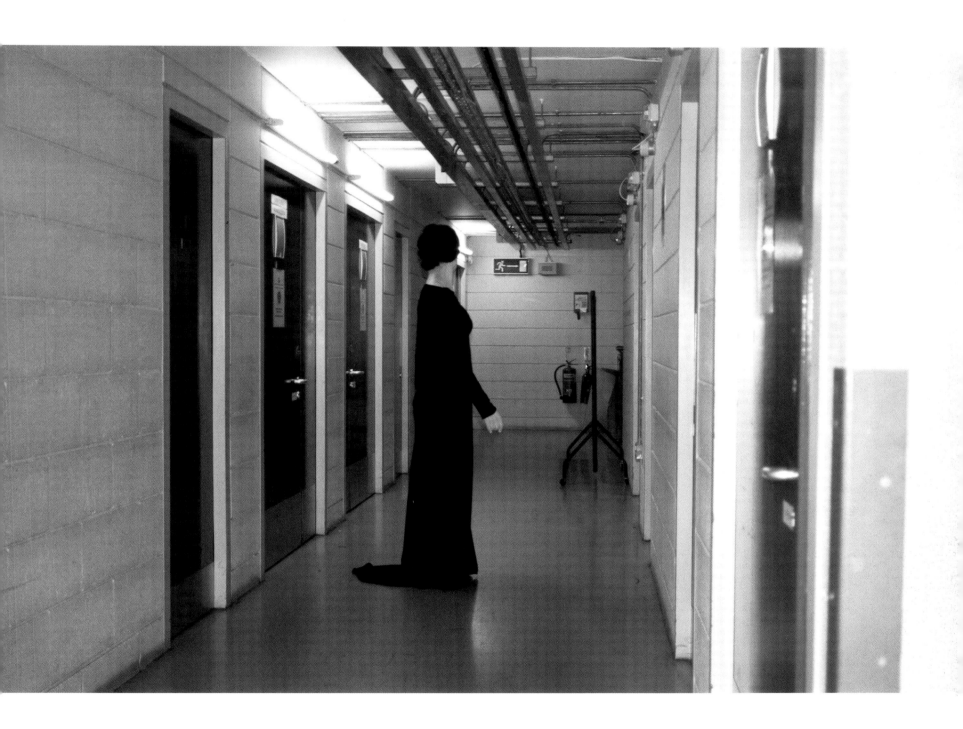

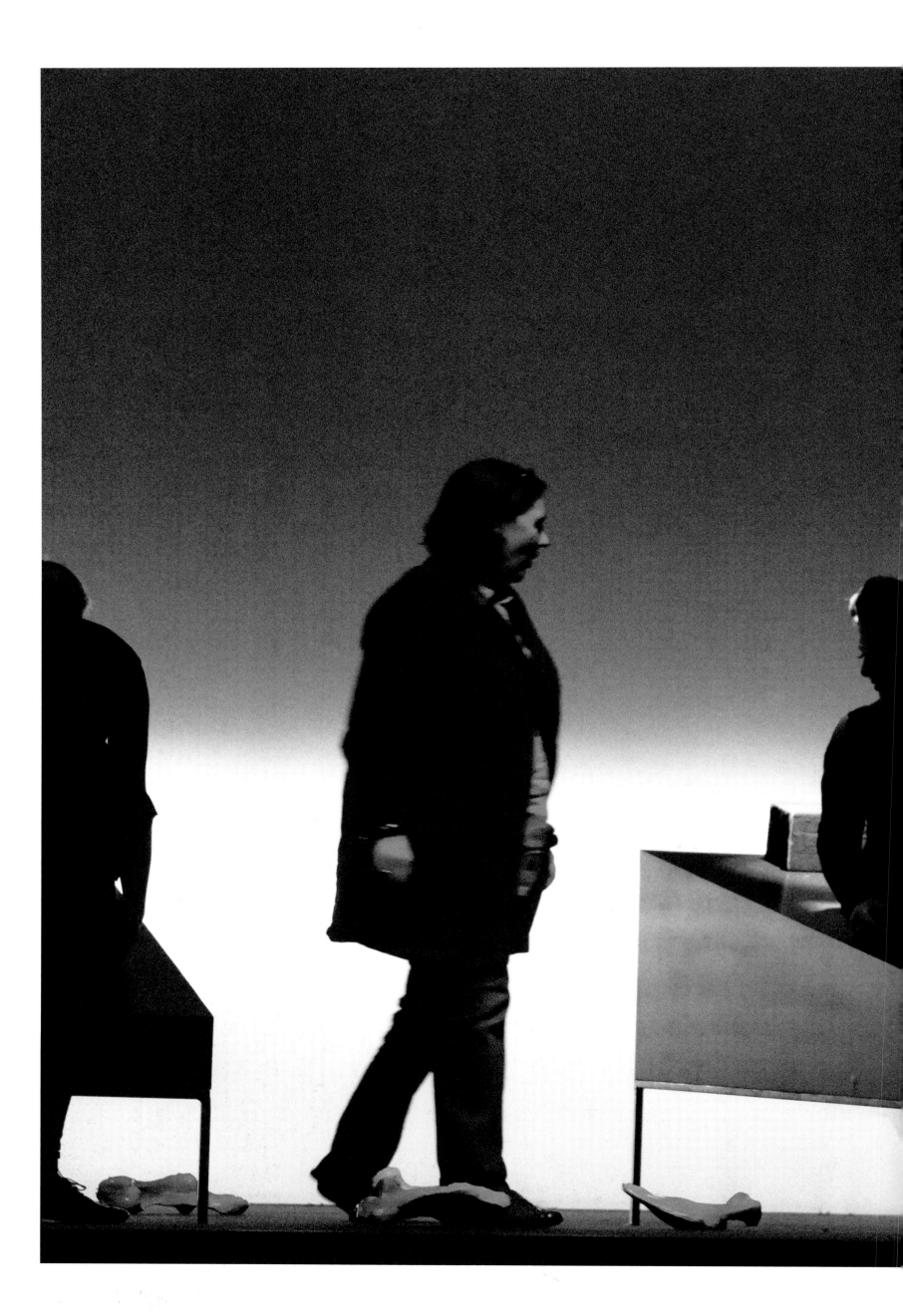

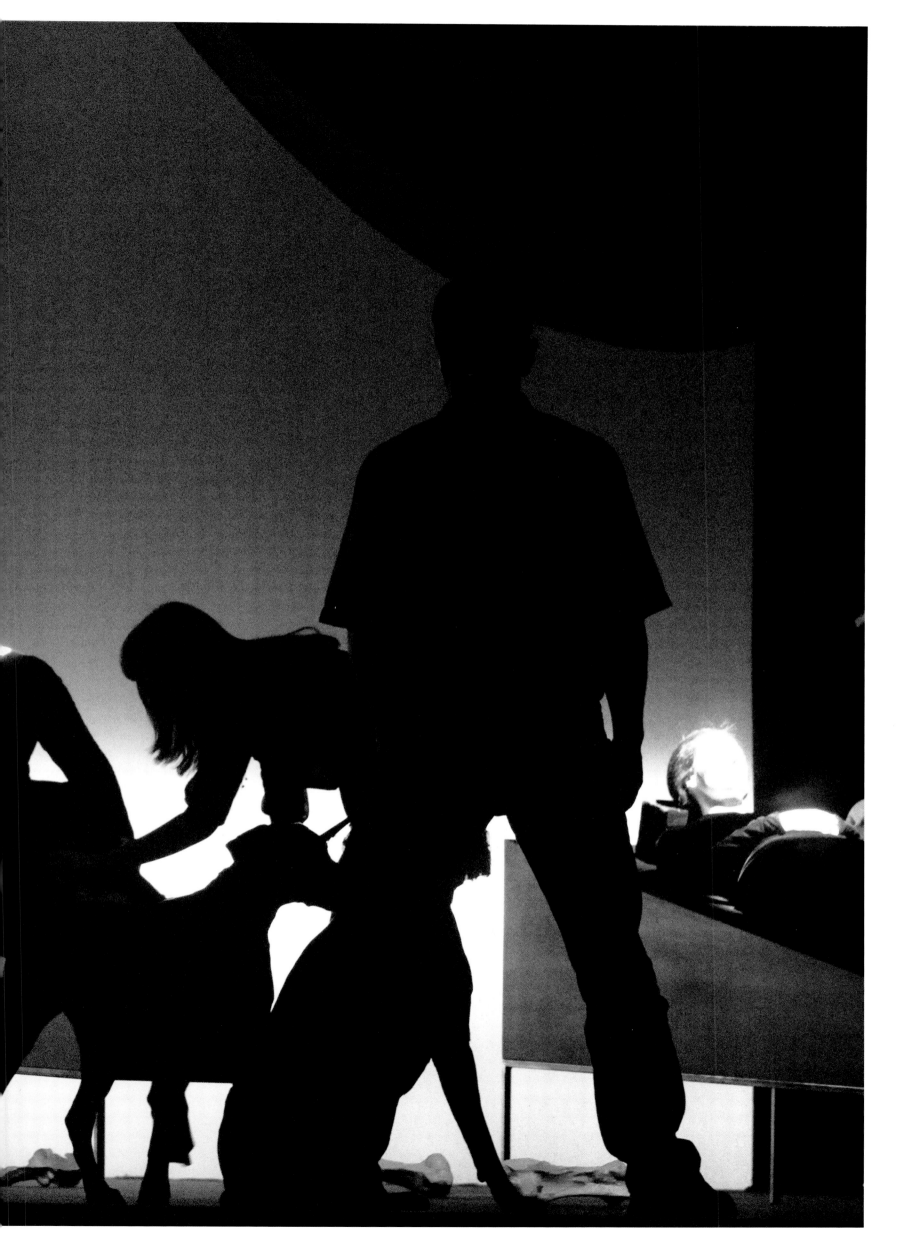

ACT 1

1946	Born in Belgrade Mother and father partisans
1947	Talking like singing "Give me a glass of water"
1948	Refuses to walk
1950	Scared of dark bedrooms
1951	Watching father sleeping with a pistol
1952	Birth of brother Velamer
1953	First jealousy attack
1961	Menstruation Painting her dreams
1962	First exhibition
1963	Mother writes: "My dear little girl, Your paintings have got nice frames."
1964	Drinking vodka
	Sleeping in the snow
	First kiss
1965	Father gives her a pistol for her birthday and teaches her how to shoot
	Games with knives
1966	Joining the Communist Party
	Painting truck accidents
1967	Father writes: "My dear little puppy dog,Today is Saturday and I am thinking of you"
	Learning French
	Music teacher says to Mother:
	"I'm taking your money for nothing, she doesn't have an ear for music"
1968	Discovering Zen Buddhism
1969	Doesn't remember
1970	Sound installations: putting speakers on a bridge in Belgrade with the sound of
	the bridge falling down
1971	Realizing that kitchen of grandmother is center of her world
1972	Starts using her body as material
	Blood
	Pain
	Watching major operations in hospitals
	Pushing her body to physical and mental limits
1973	Burning her hair
	Cutting a star on her stomach with a razor blade

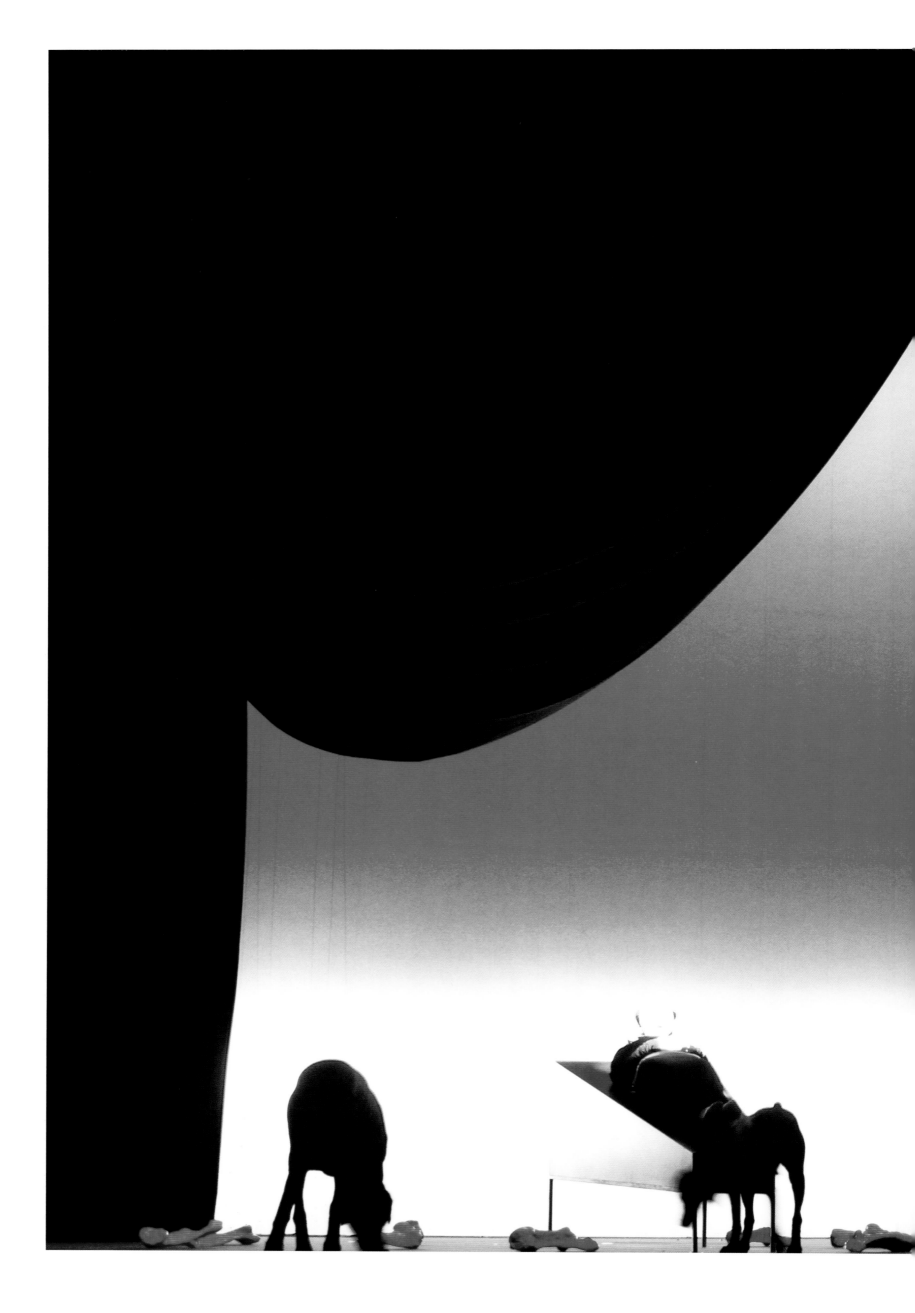

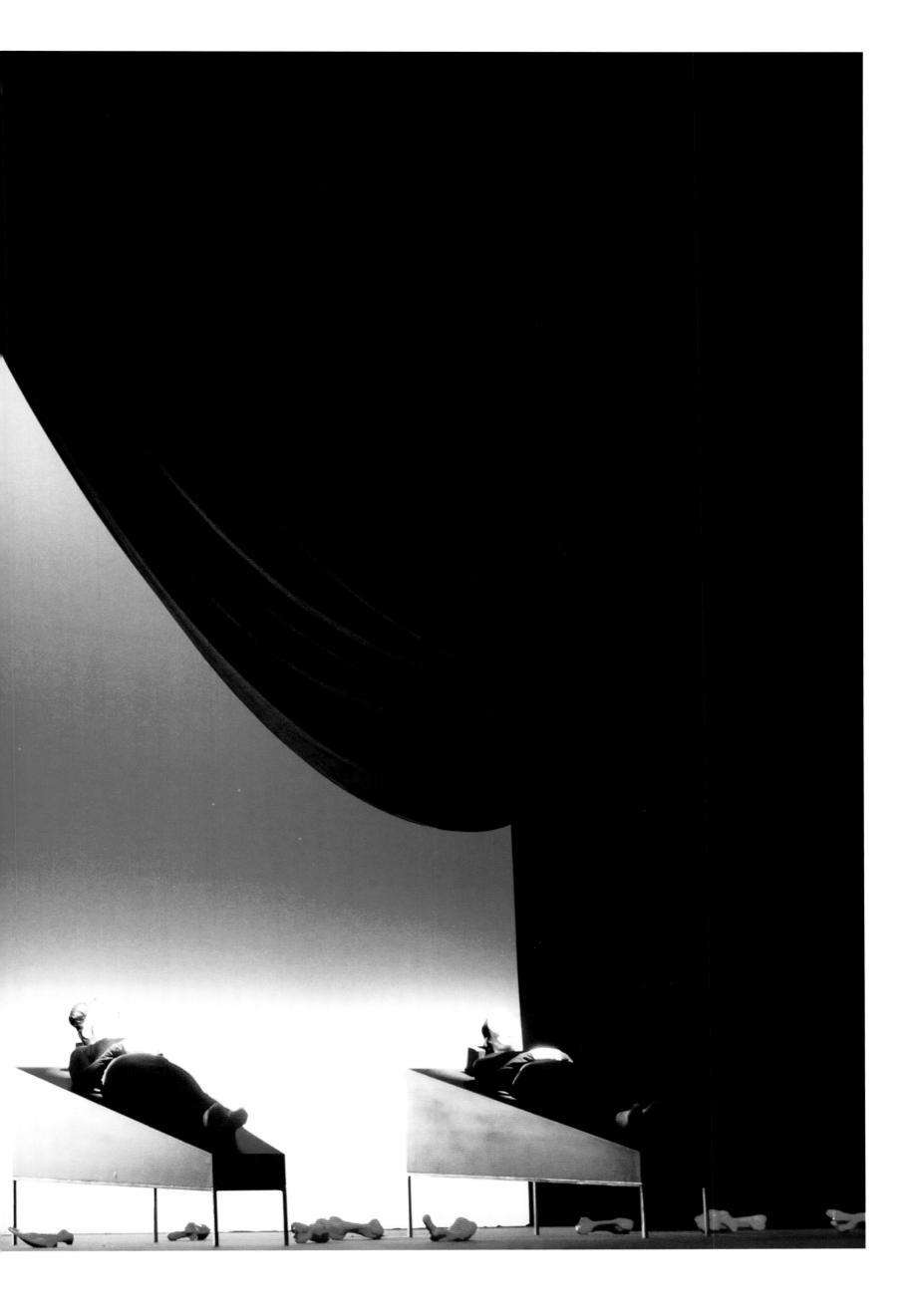

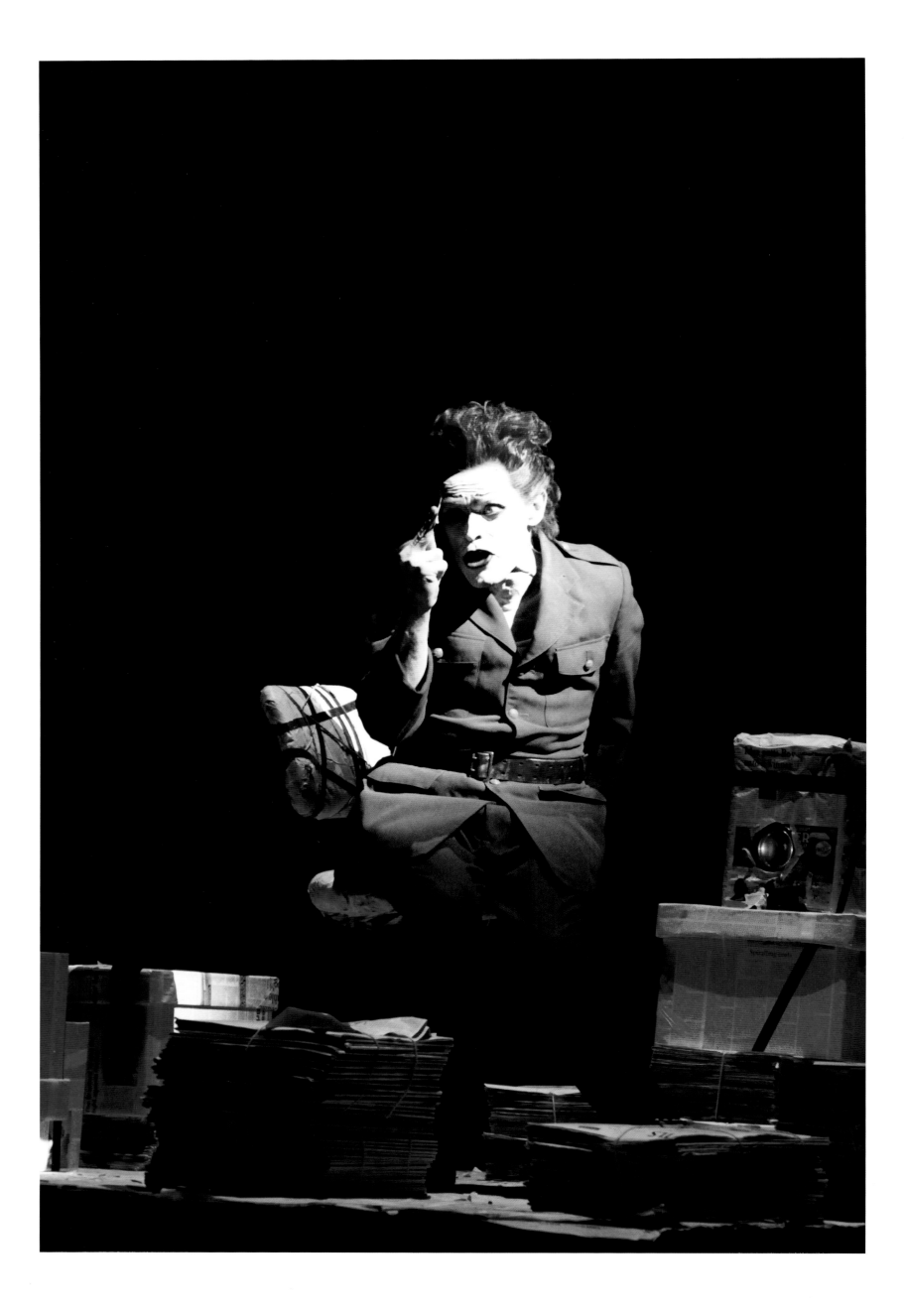

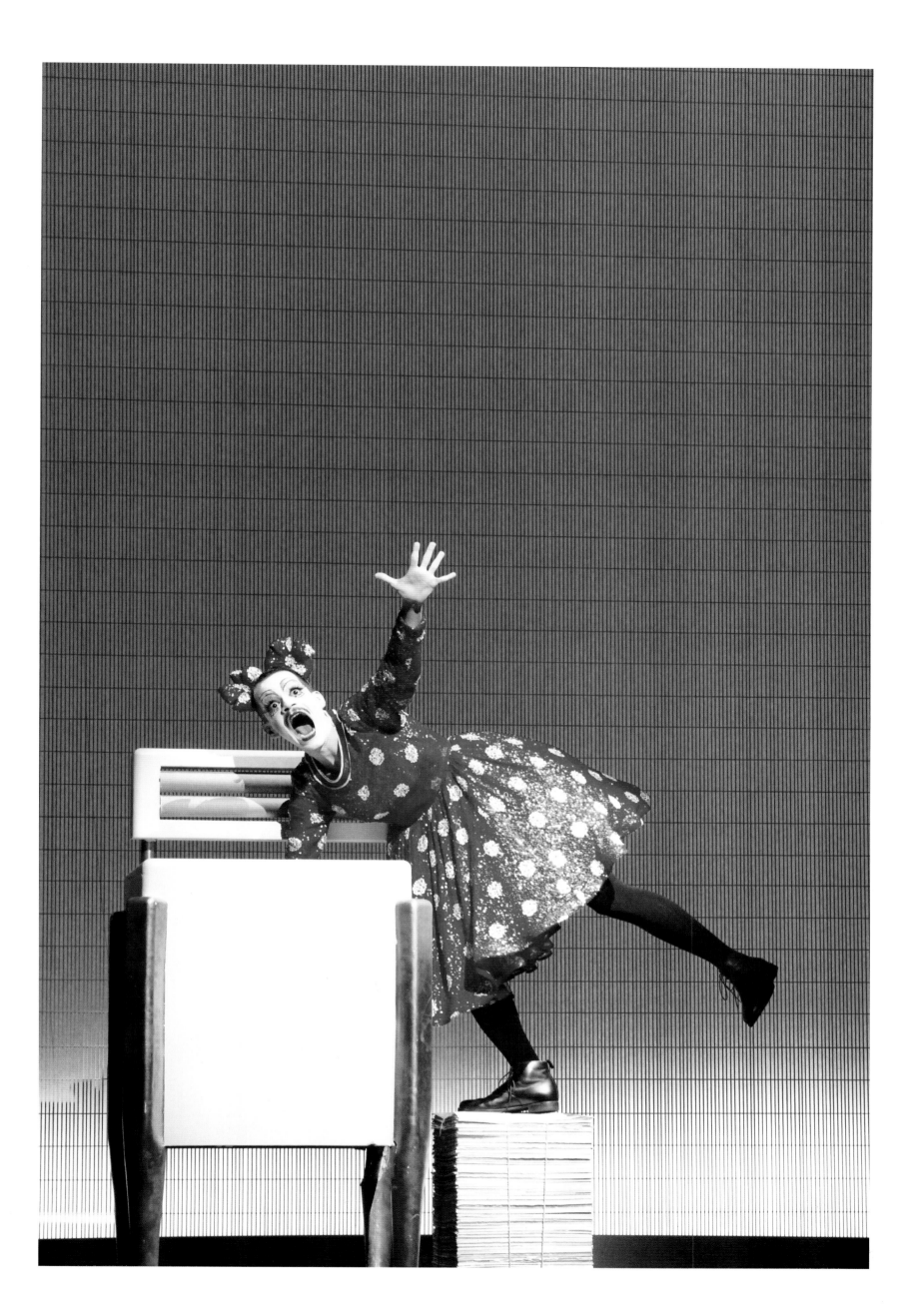

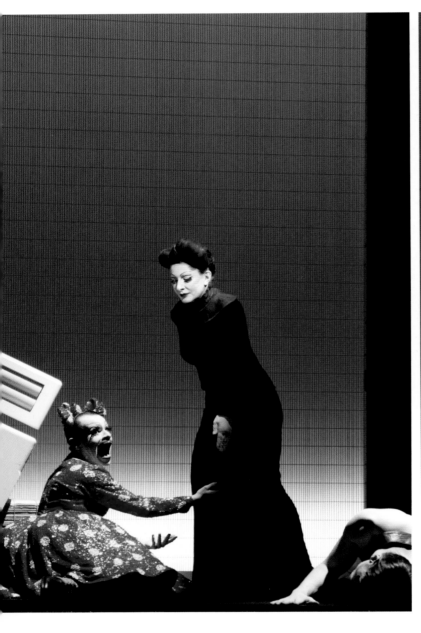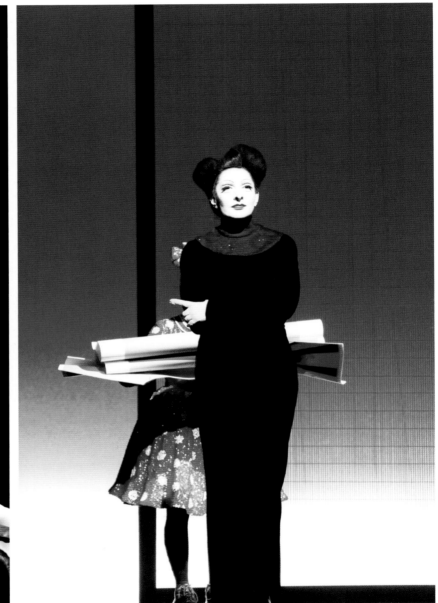

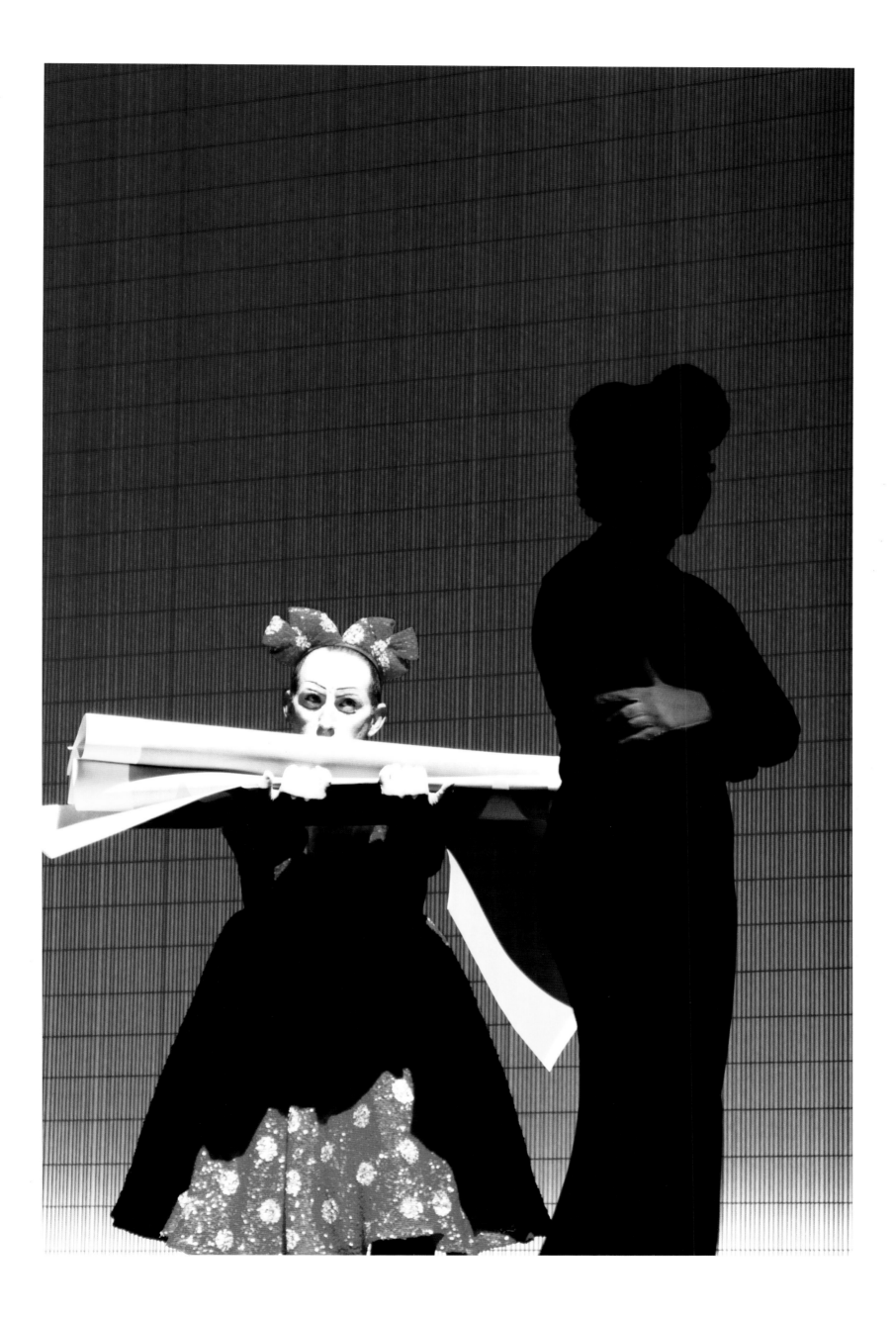

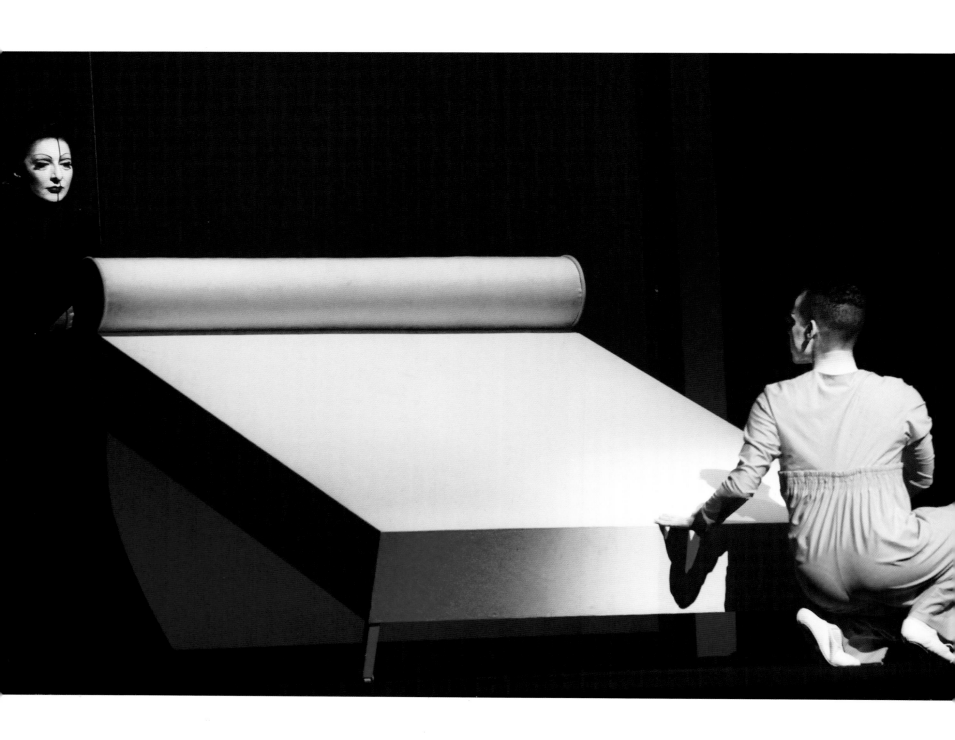

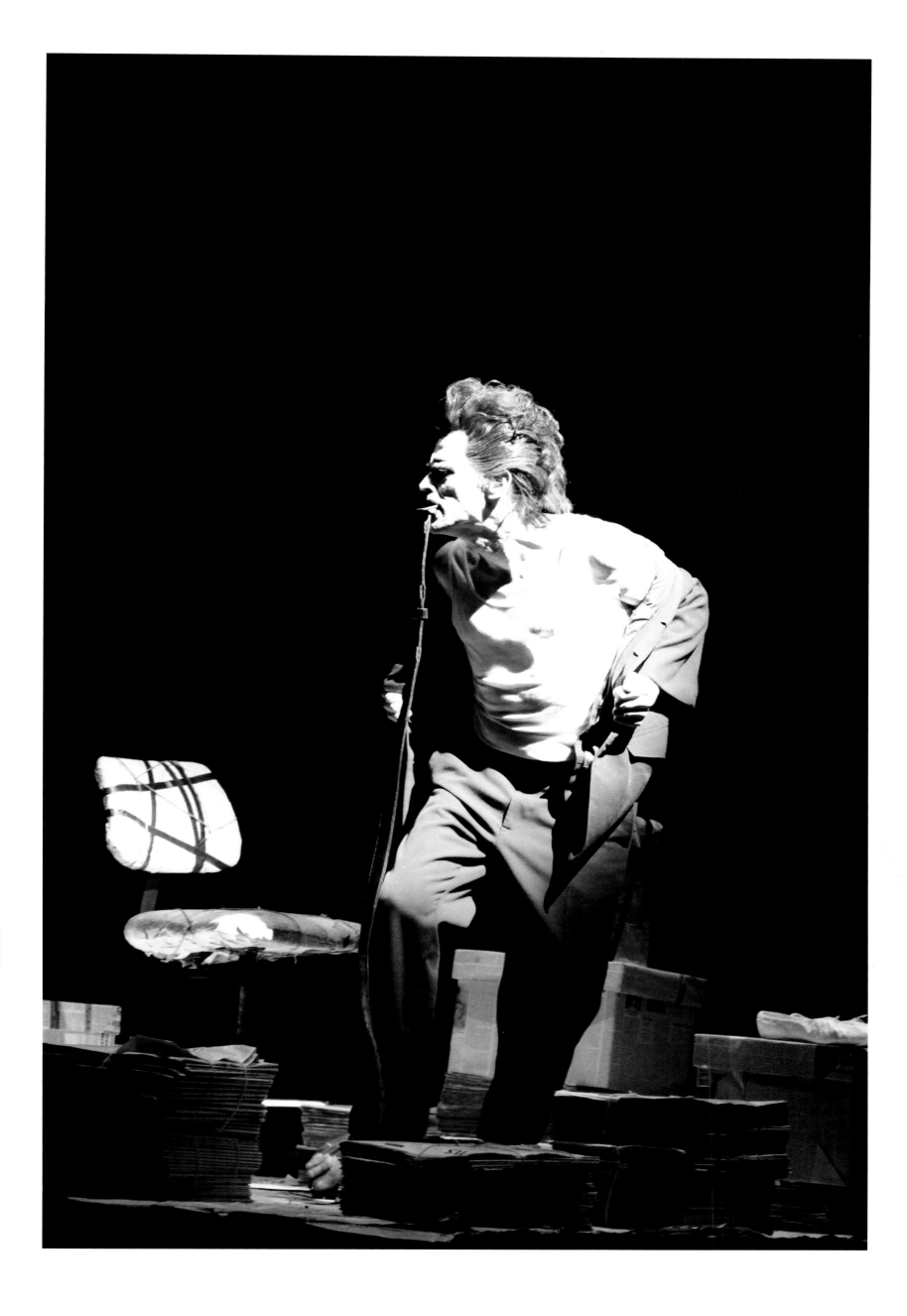

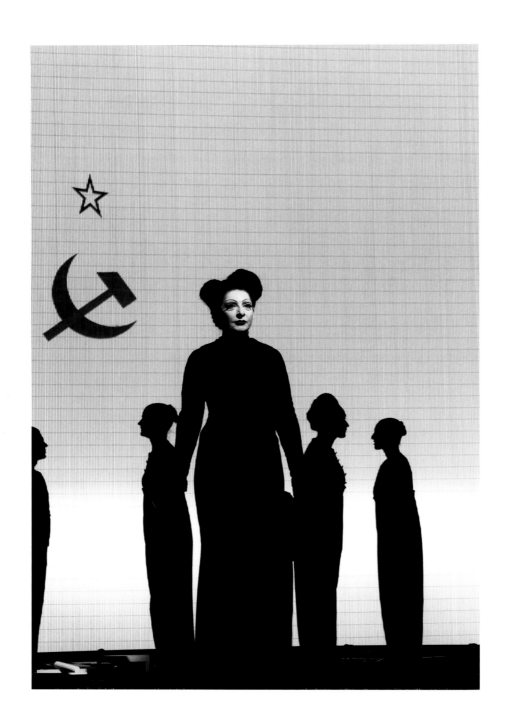

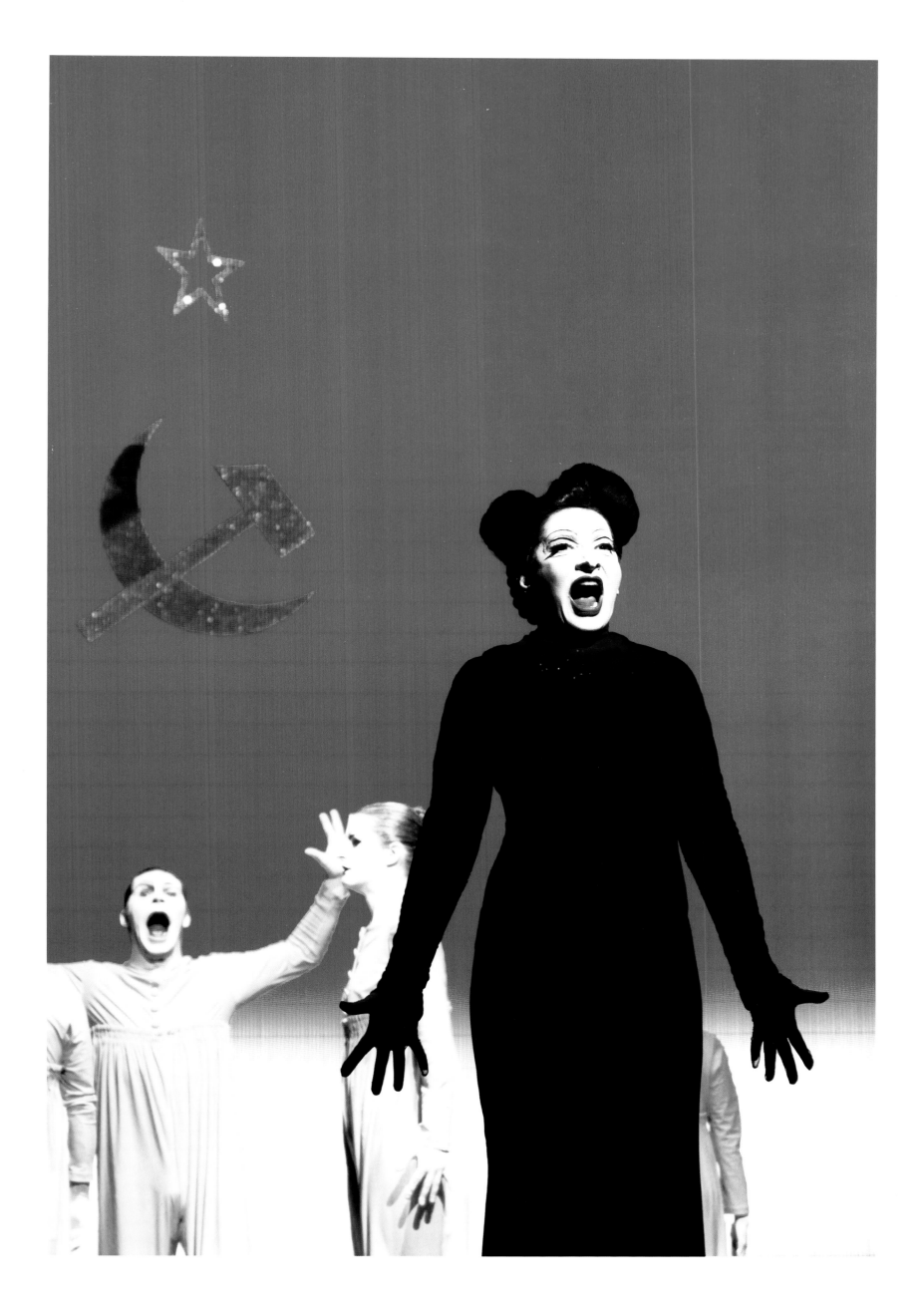

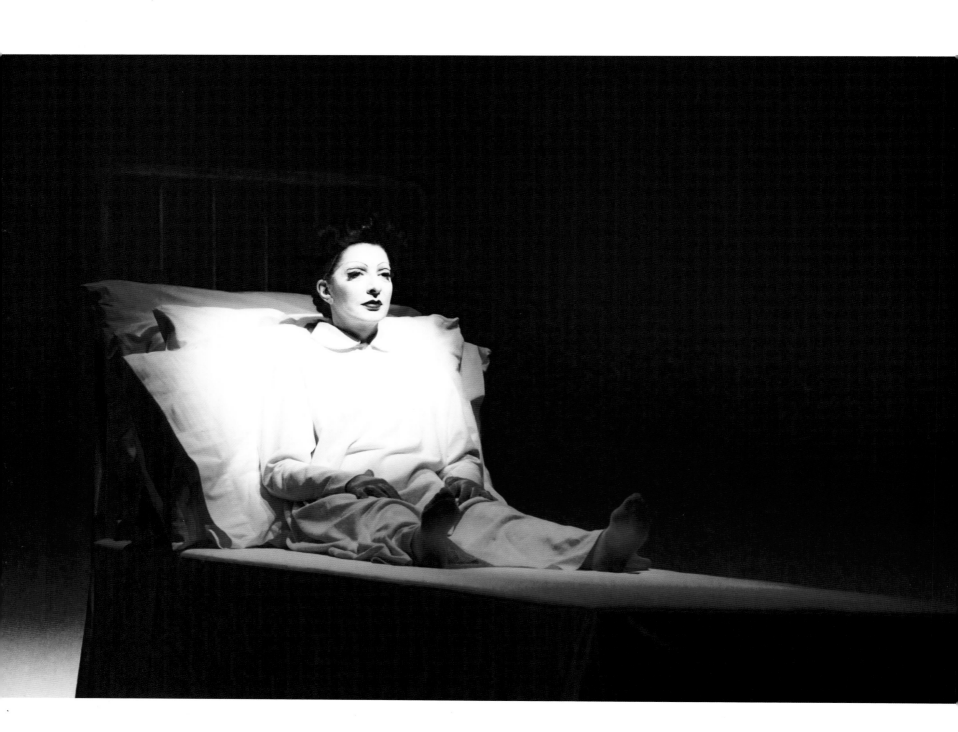

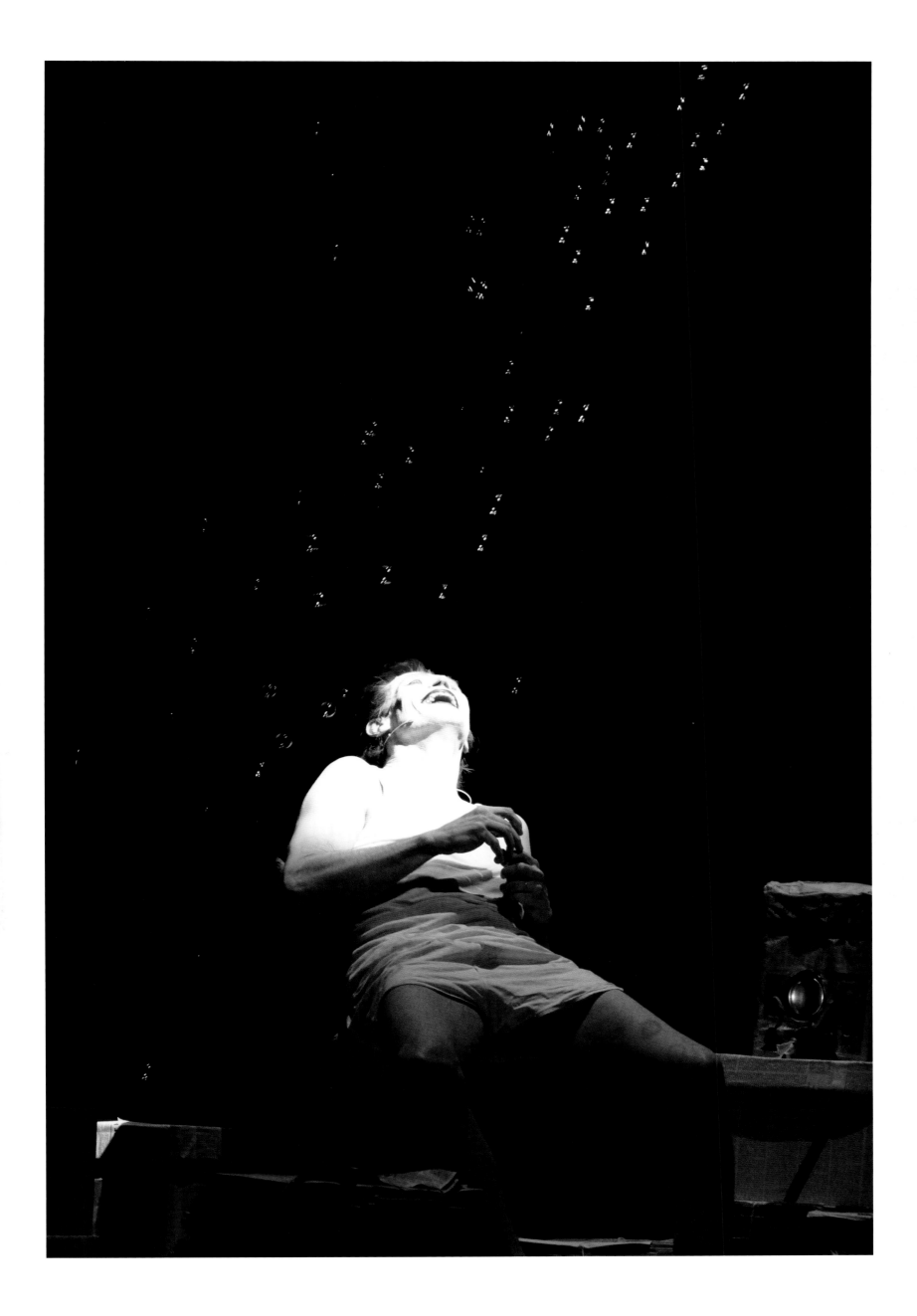

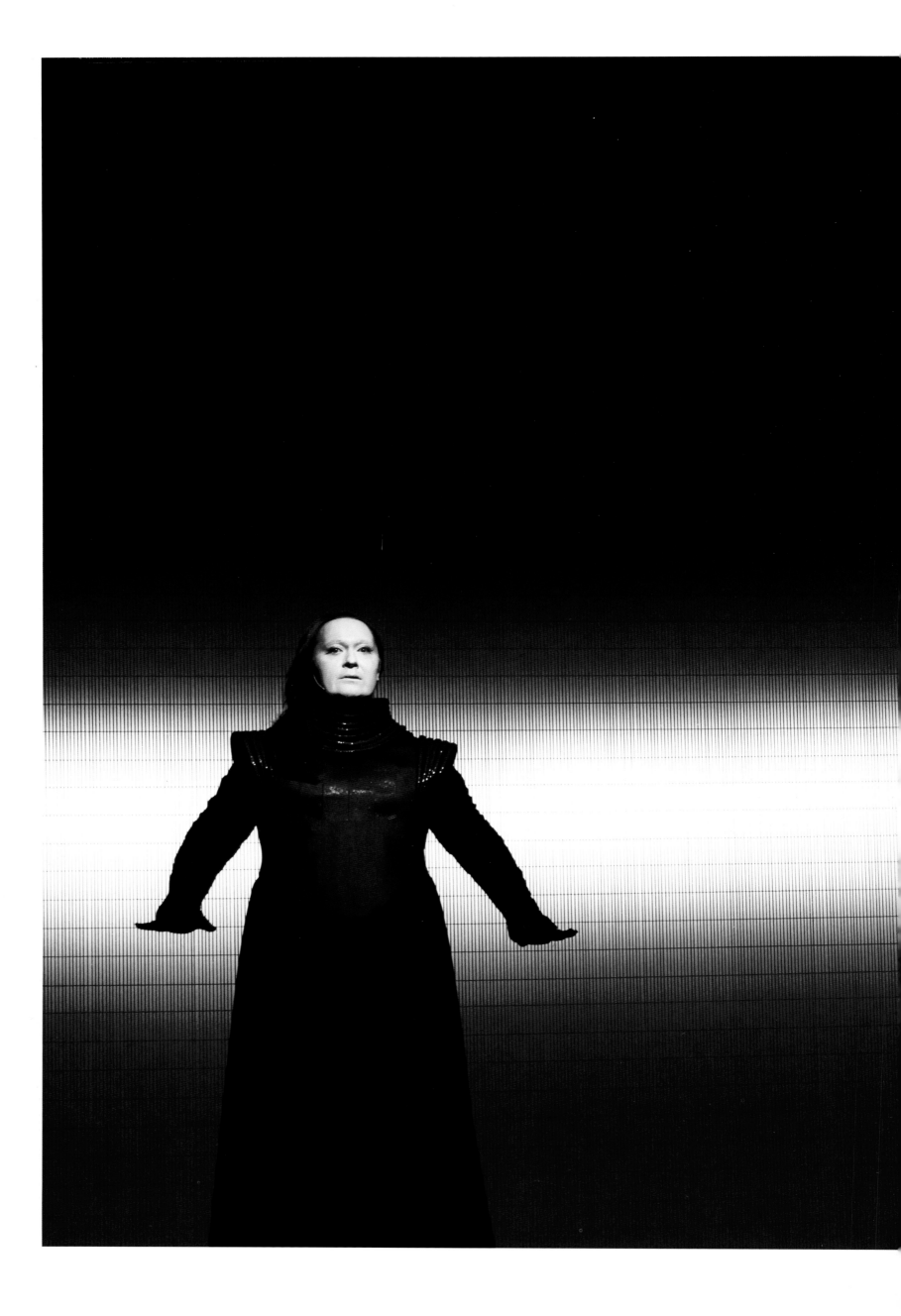

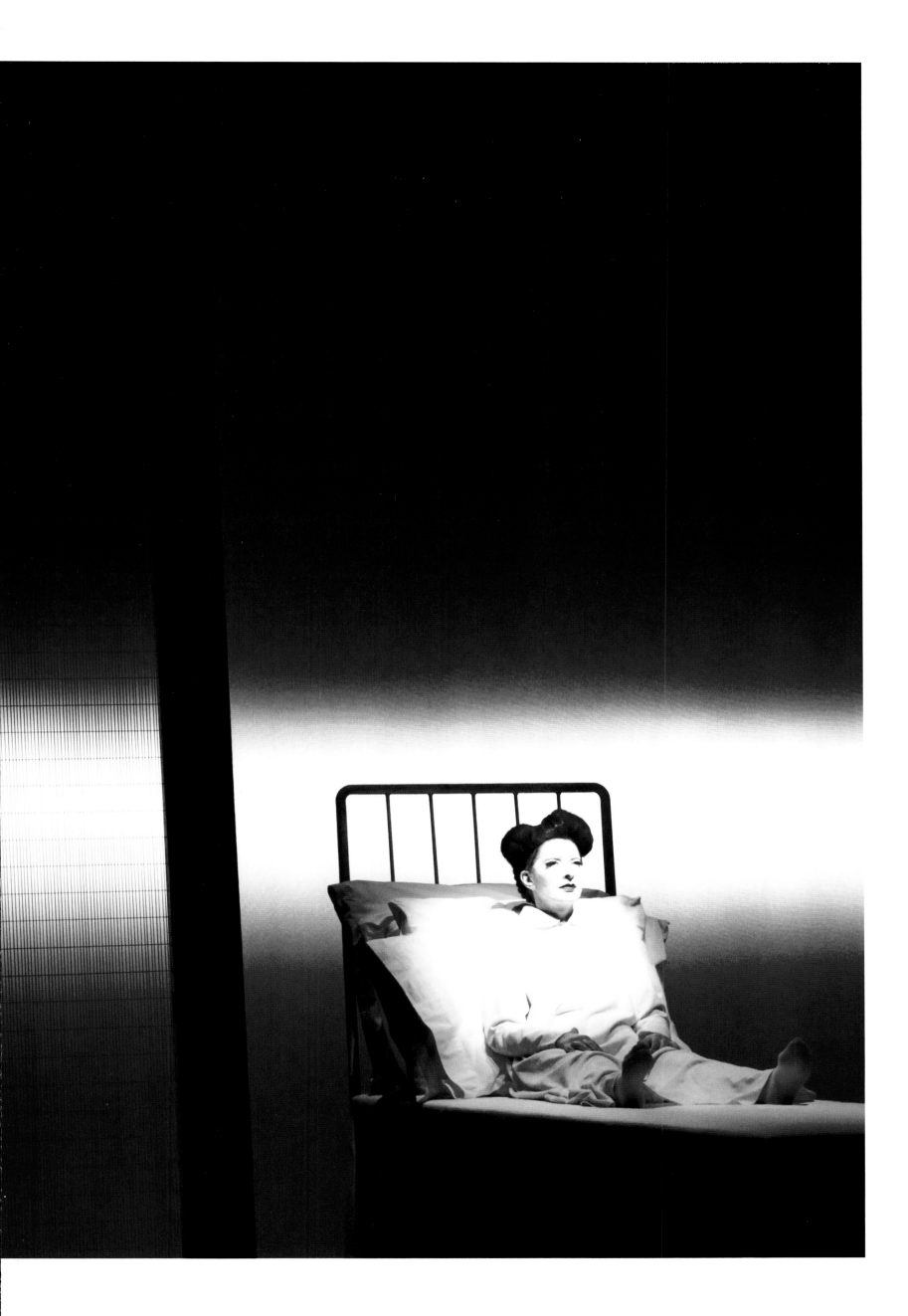

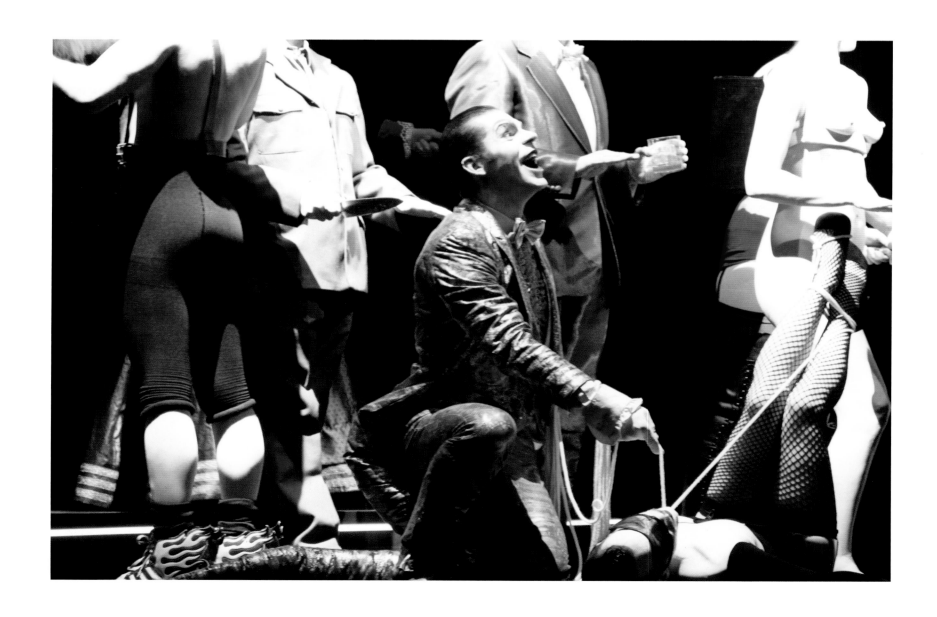

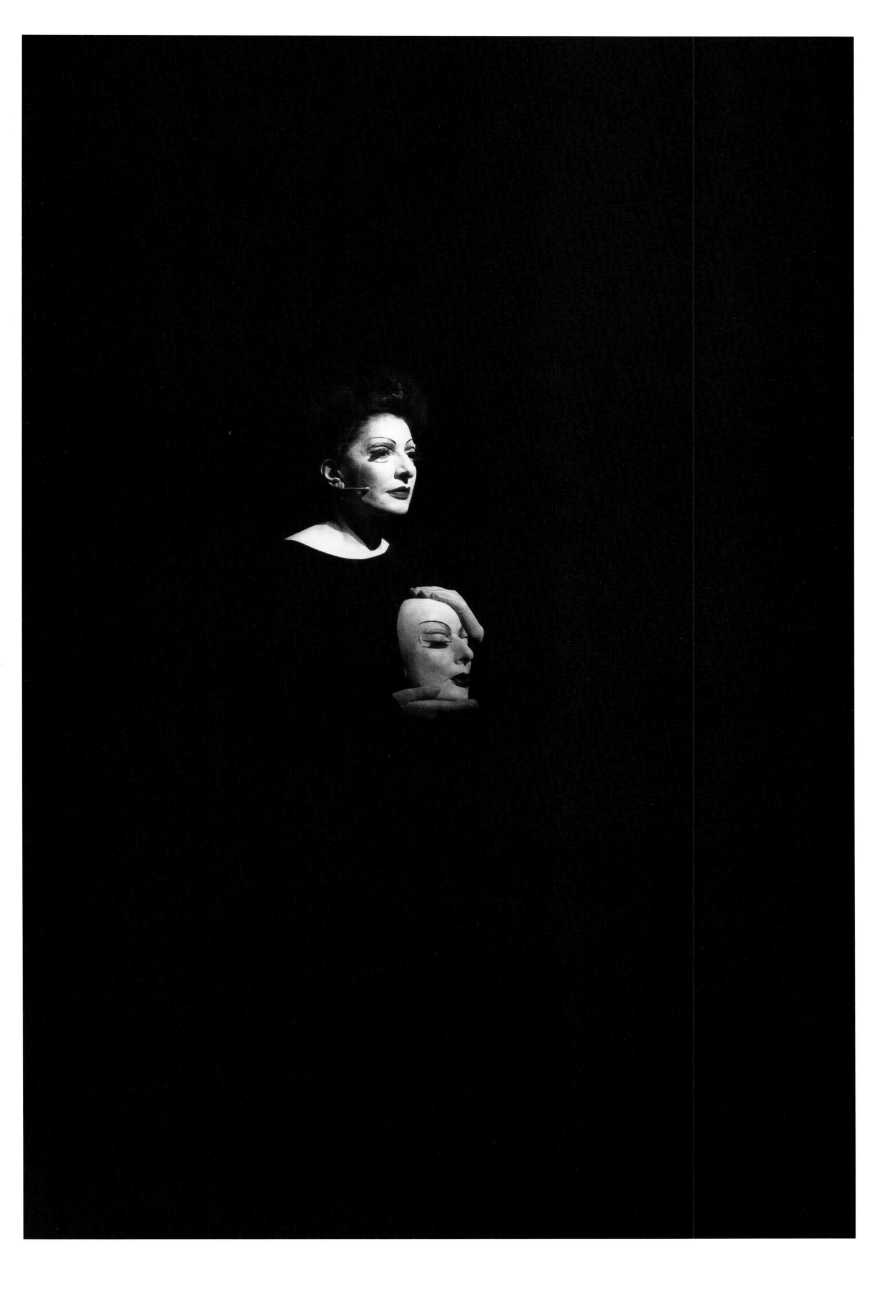

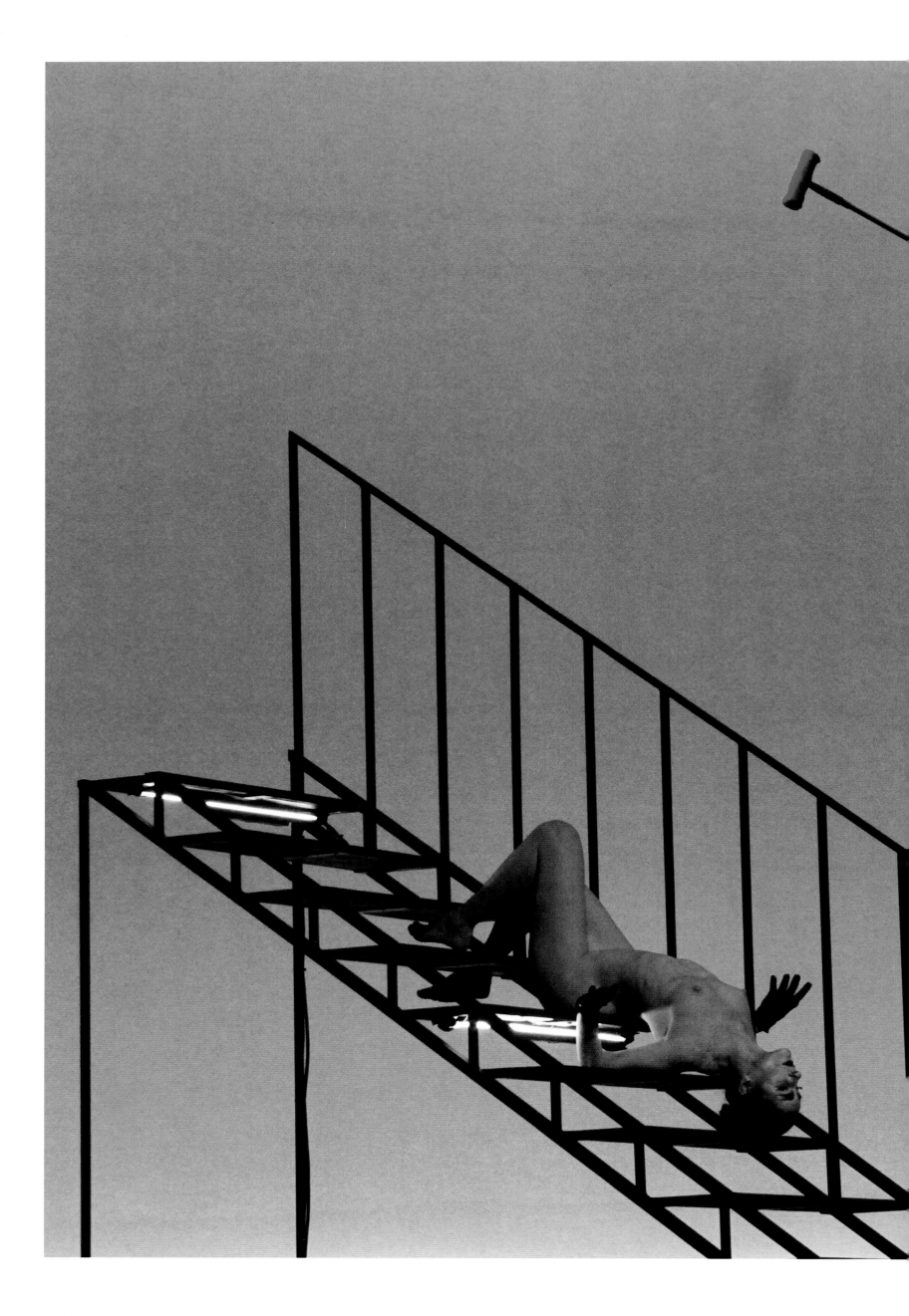

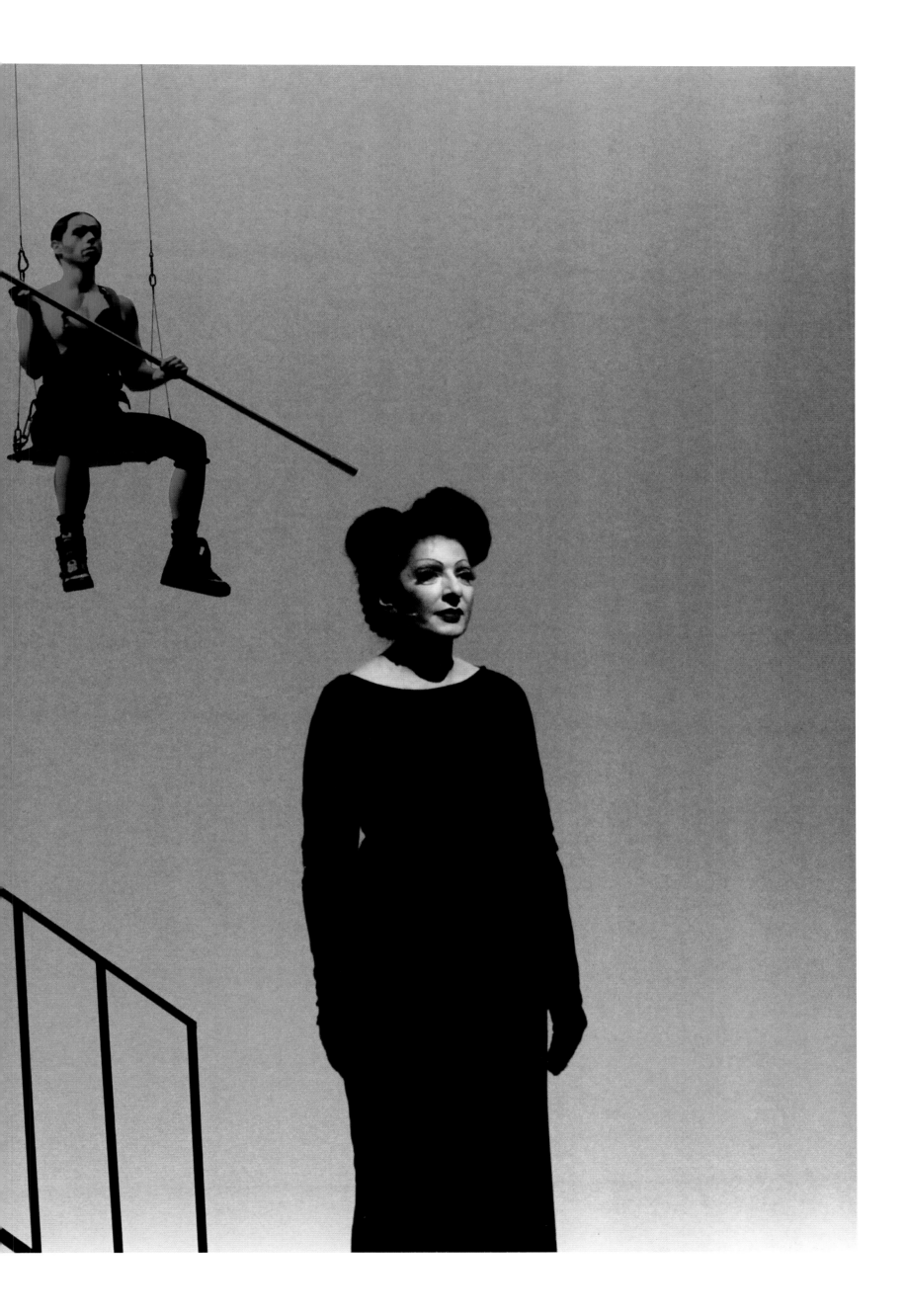

1974	Reading Dostoyevski, Marina Tsvetajeva, Rilke
	Drinking Turkish coffee and looking into the cup to see the future
	Singing sad Russian songs
	More fights with Mother
	Leaving home
1975	Meeting a man to work and live with
	Born on the same day November 30
	Strong attraction
1976	She writes to him: "Pour mon cher chien Russe."
	He replies: "Für meinen lieben kleinen Teufel."
1977	They tattoo the number 3 on their middle fingers
1978	On their birthday they share a sandwich covered with gold leaf
	They talk to each other in their dreams
1984	Domestic life Cleaning, washing, cooking
	He buys suitcases
1985	They stop making love
1986	He starts drinking
	Aerobics
	Unable to perform
	Instead they build black vases
	And sell them for 35.000 DM
1987	Everything is wrong
	Problems with their relationship
	She feels unwanted, Ugly, Fat
	Burning her possessions
	She can't let him go
1988	She stops liking his smell
1989	Growing her hair
	Buying her own house
	Need for change
	Need for laughter
	Need for melodrama
	Need for glamour

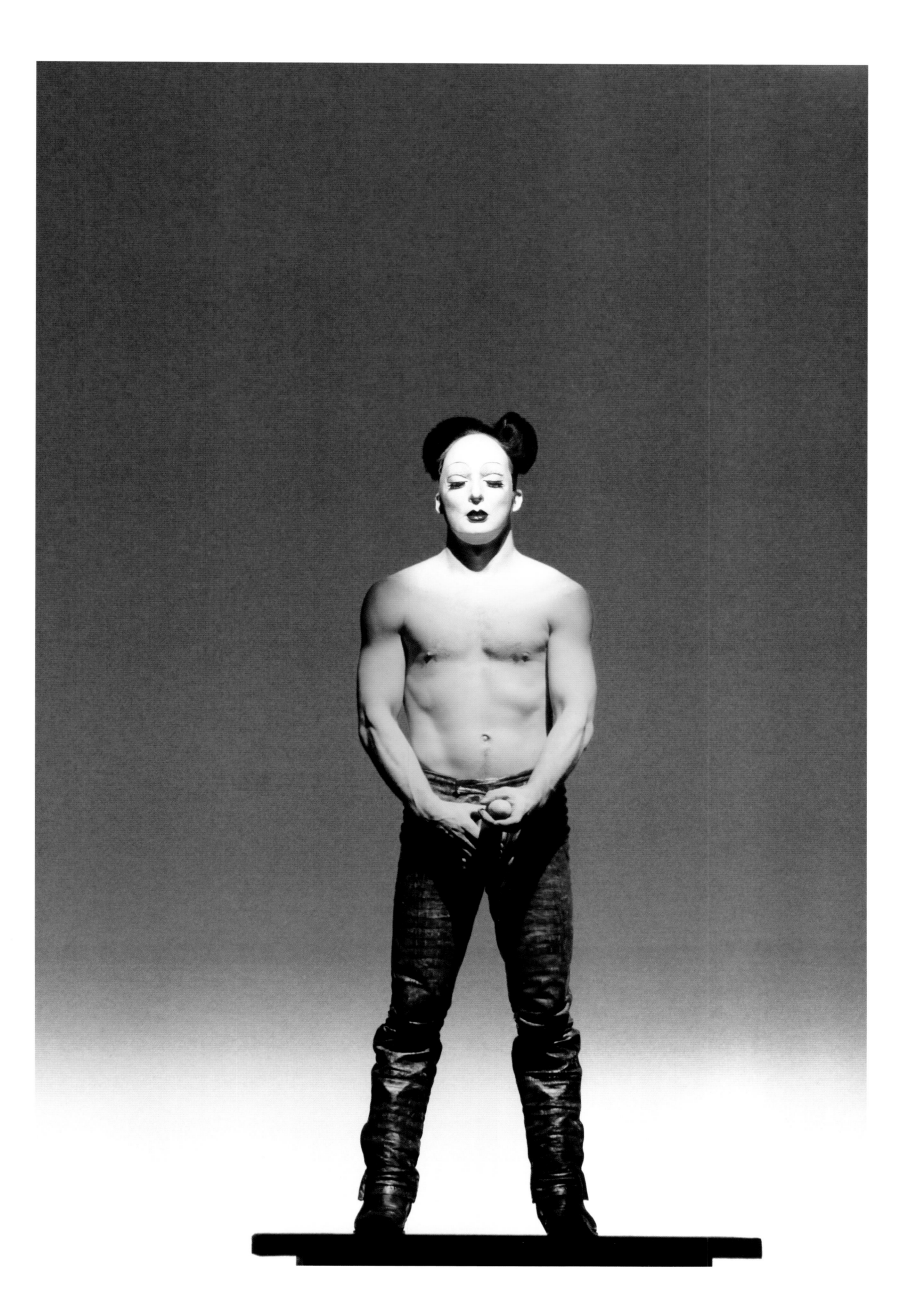

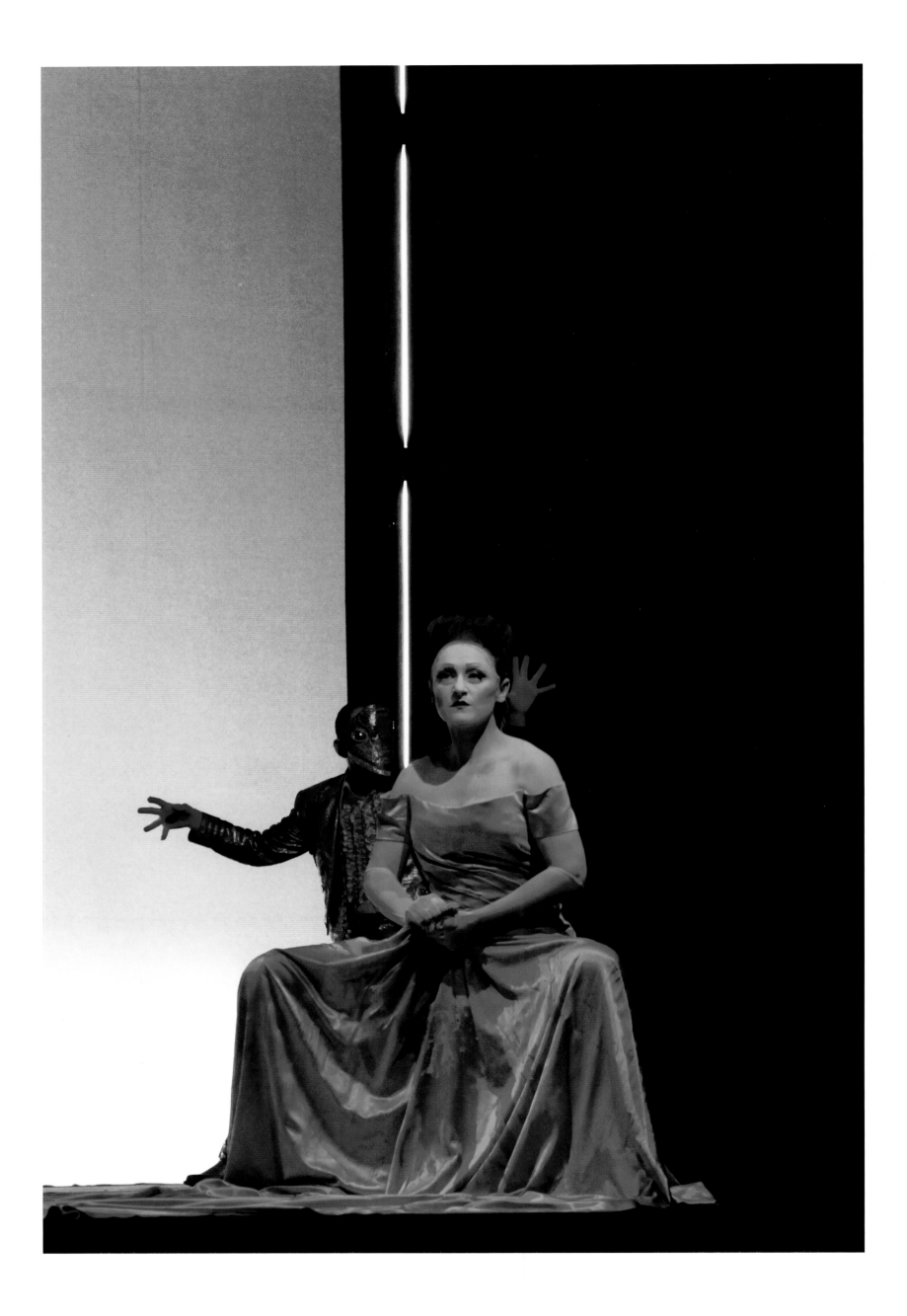

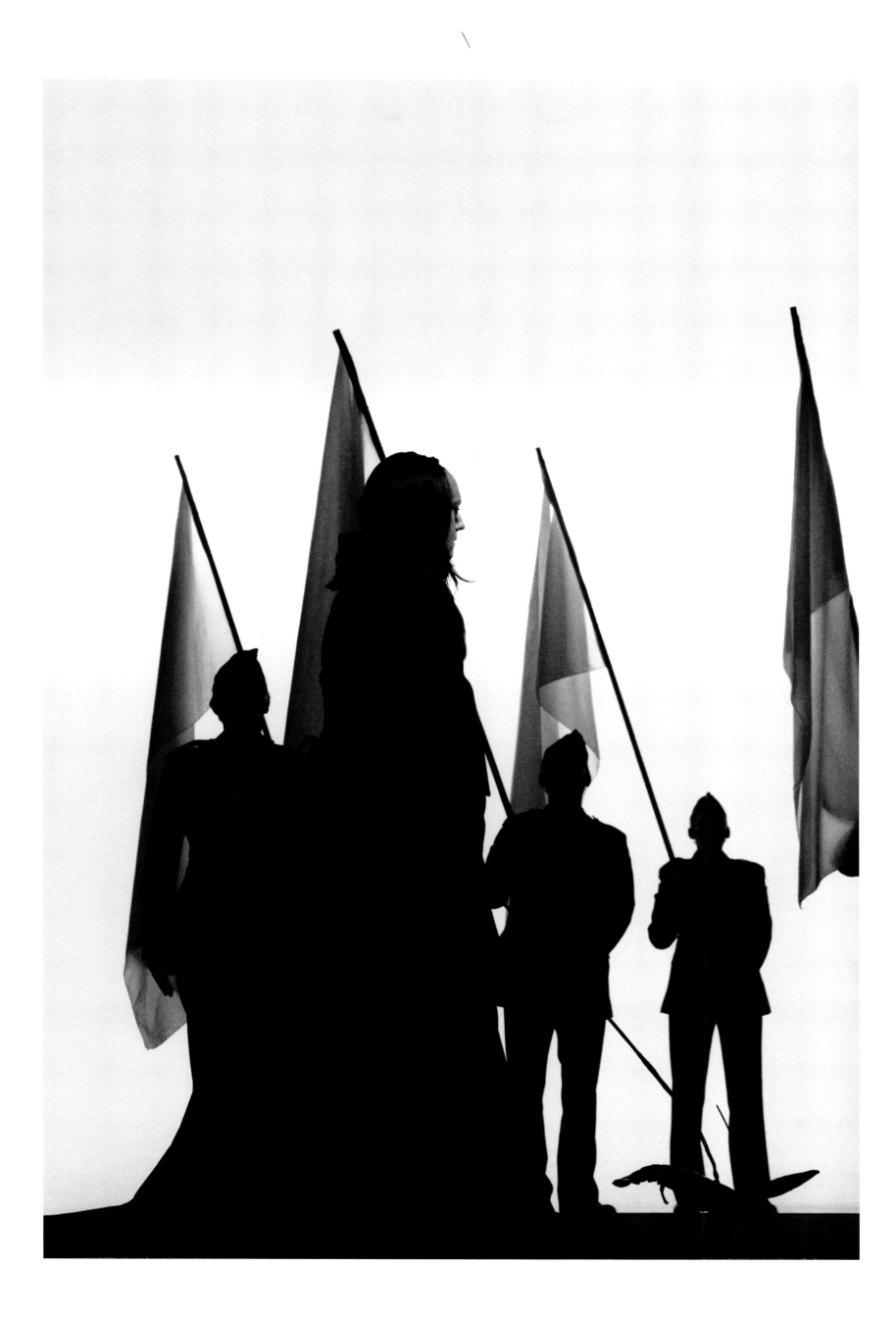

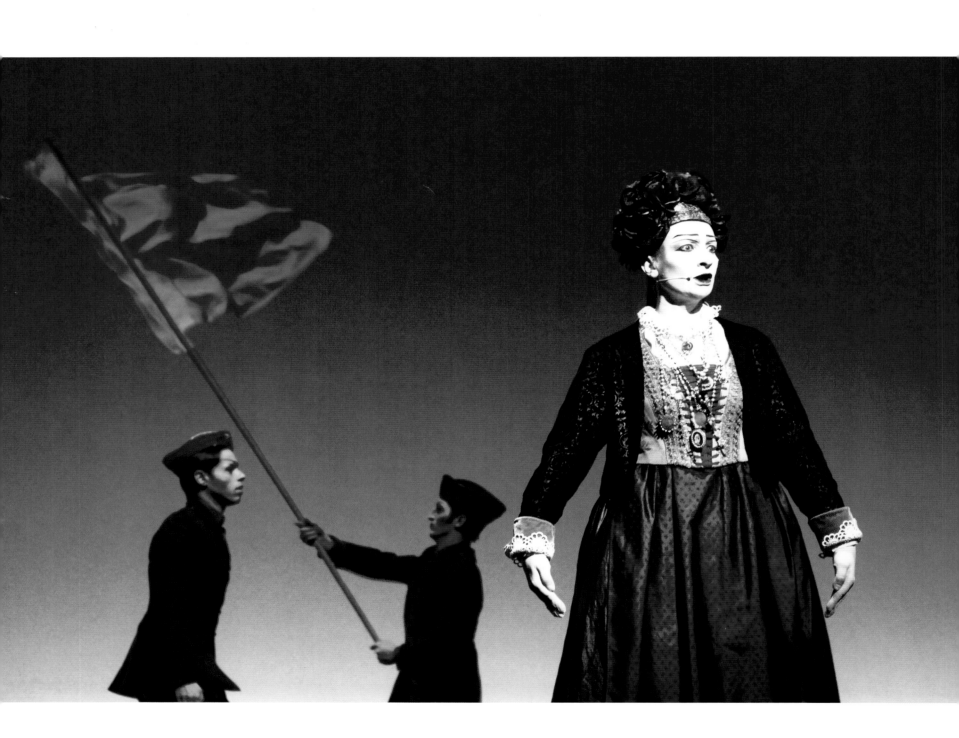

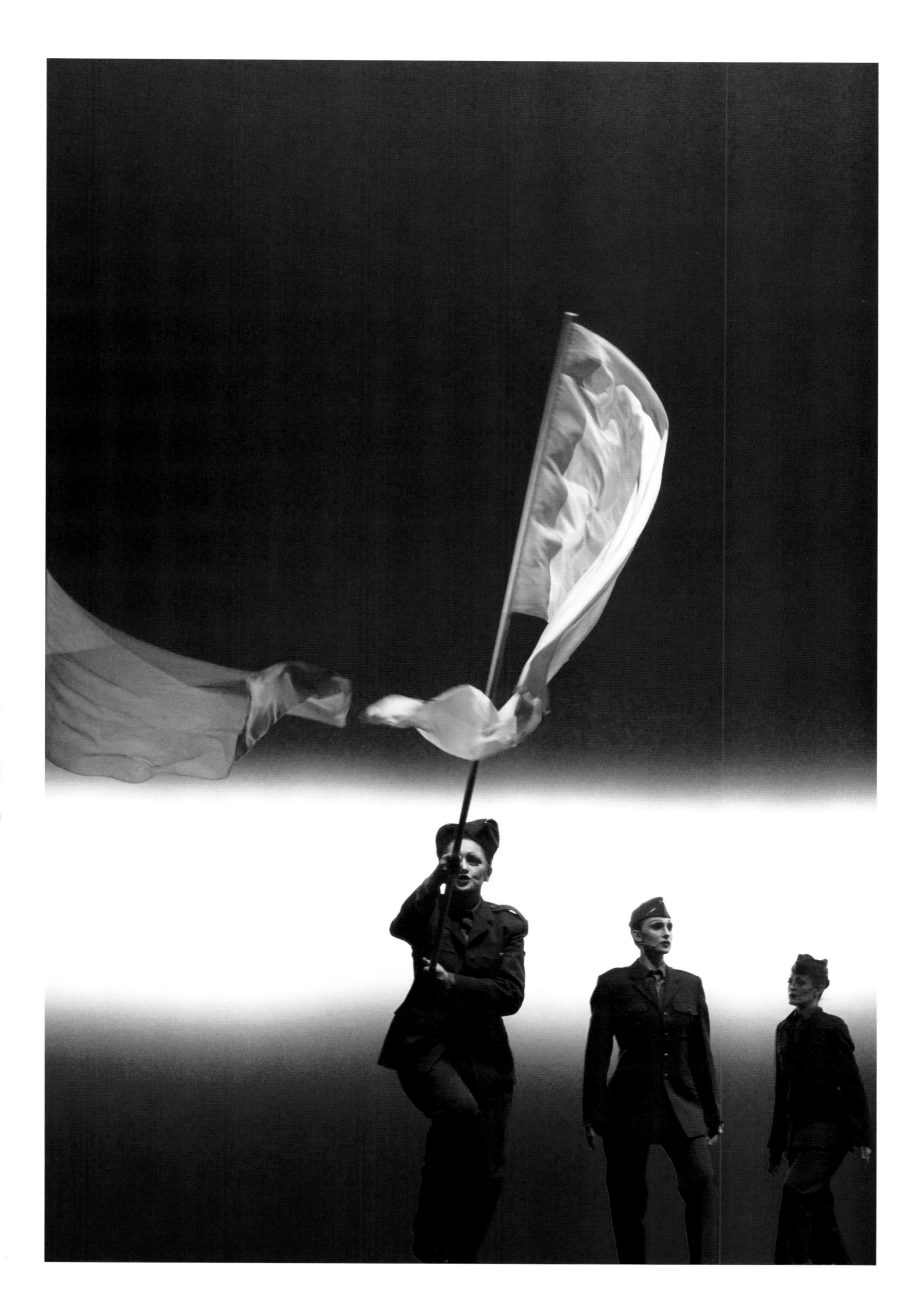

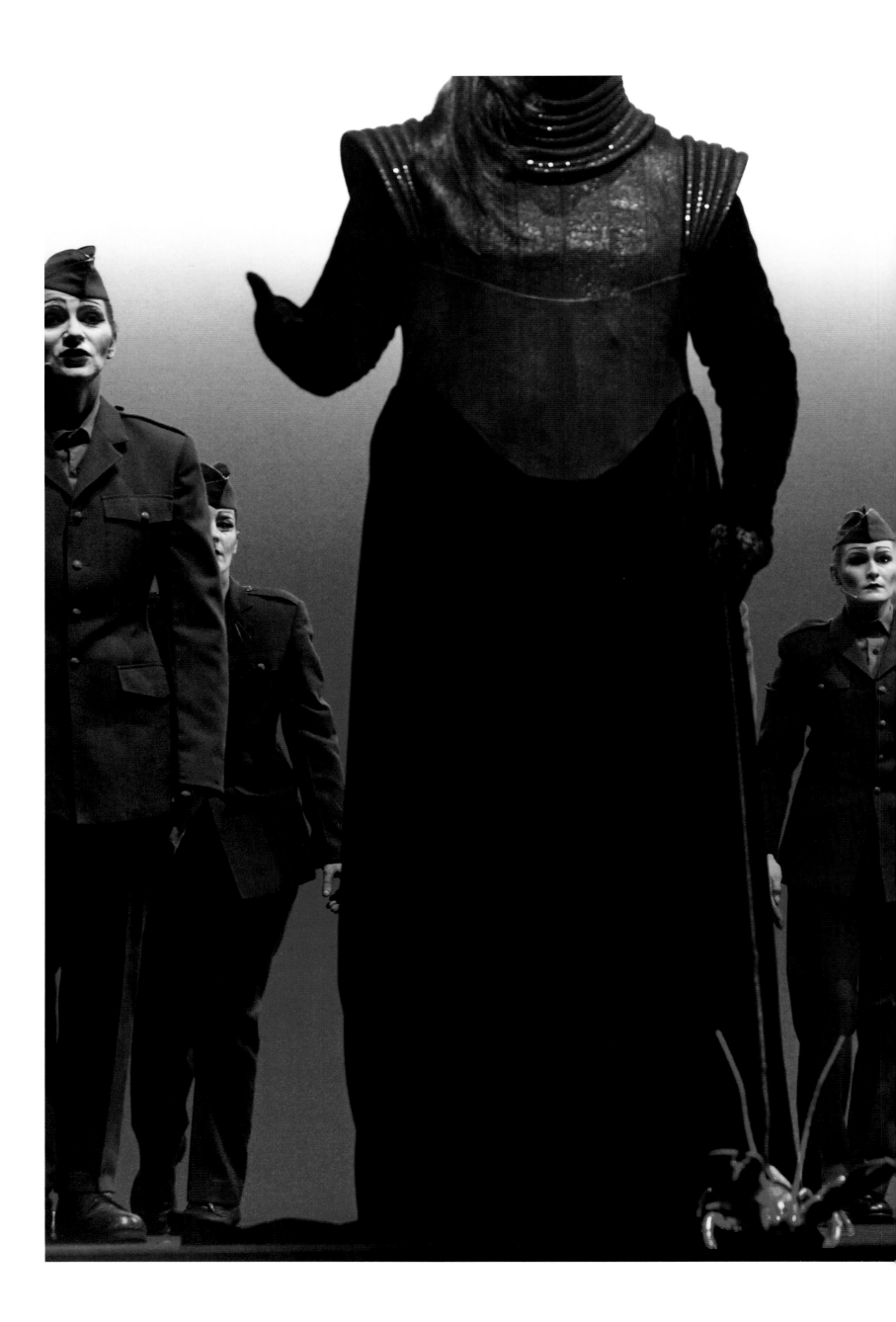

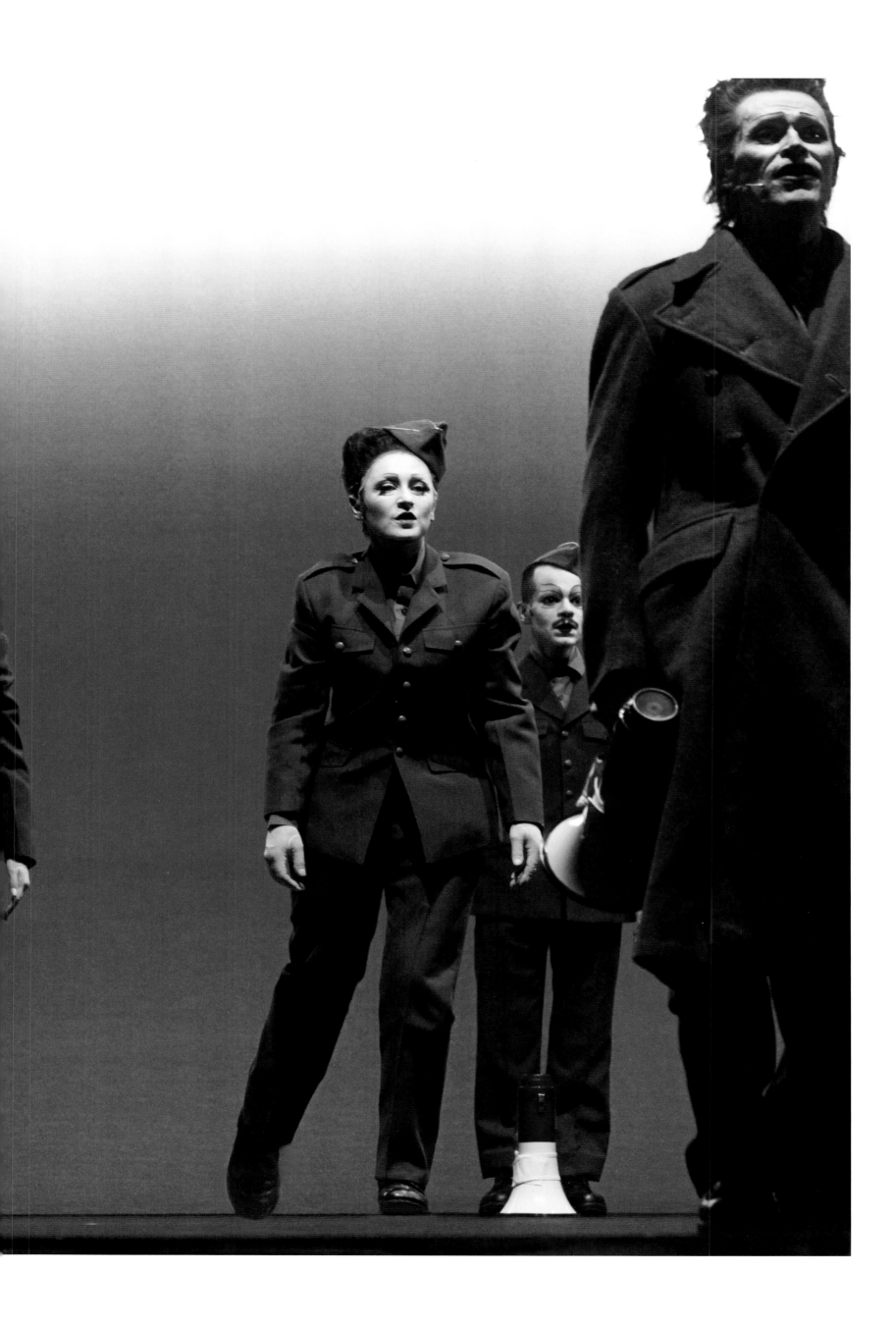

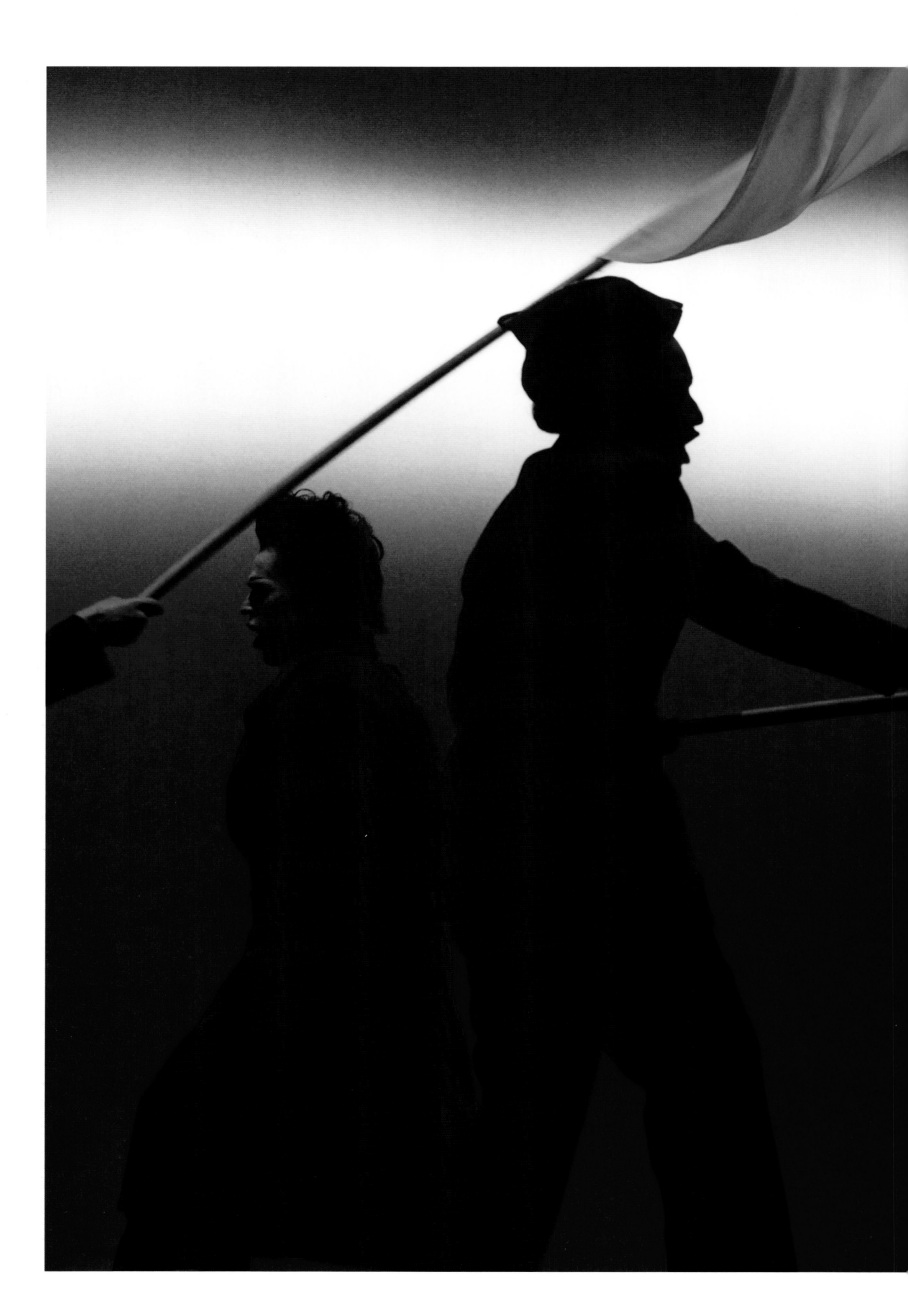

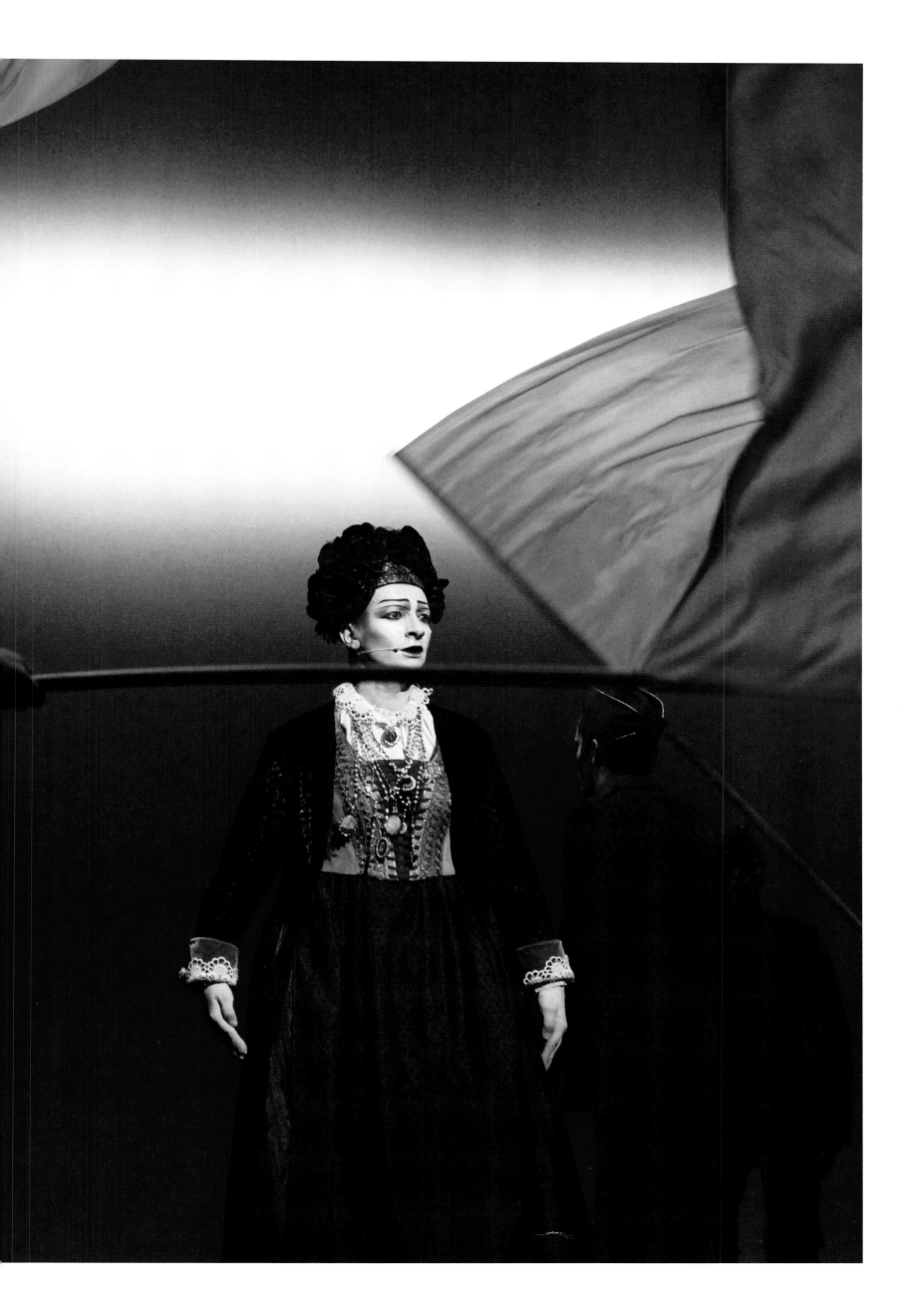

ACT 2

1994	More migraine attacks
	Overworked and overexposed
1996	Professorship in Braunschweig
	Teaching performance
1997	Meeting the man of her life
	Intense sense of destiny
	Losing her illusions about Montenegro
	Winning the Golden Lion in Venice
1998	Selling less and less
2000	Money problems
	Office problems
	Family problems
	Death of her father
	She stopped talking to her brother
2001	More and more in love
	Buying a loft in New York
2002	Living in the world of airports and hotel rooms
2003	Working with Tibetan monks again
2004	Resigning her professorship
	Hoping to have more and more of less and less
2005	Happiness, tranquility, her man is her home
	Building a house on Stromboli
	Love of volcanos and waterfalls
2006	He proposed marriage on a rainy day in front of Gourmet Garage in New York
	She said "Yes, Yes, Yes"
	Marriage
	Misunderstandings
	Death of her Mother, finally
	Brother Velimir comes one hour late for the funeral
	More and more misunderstandings

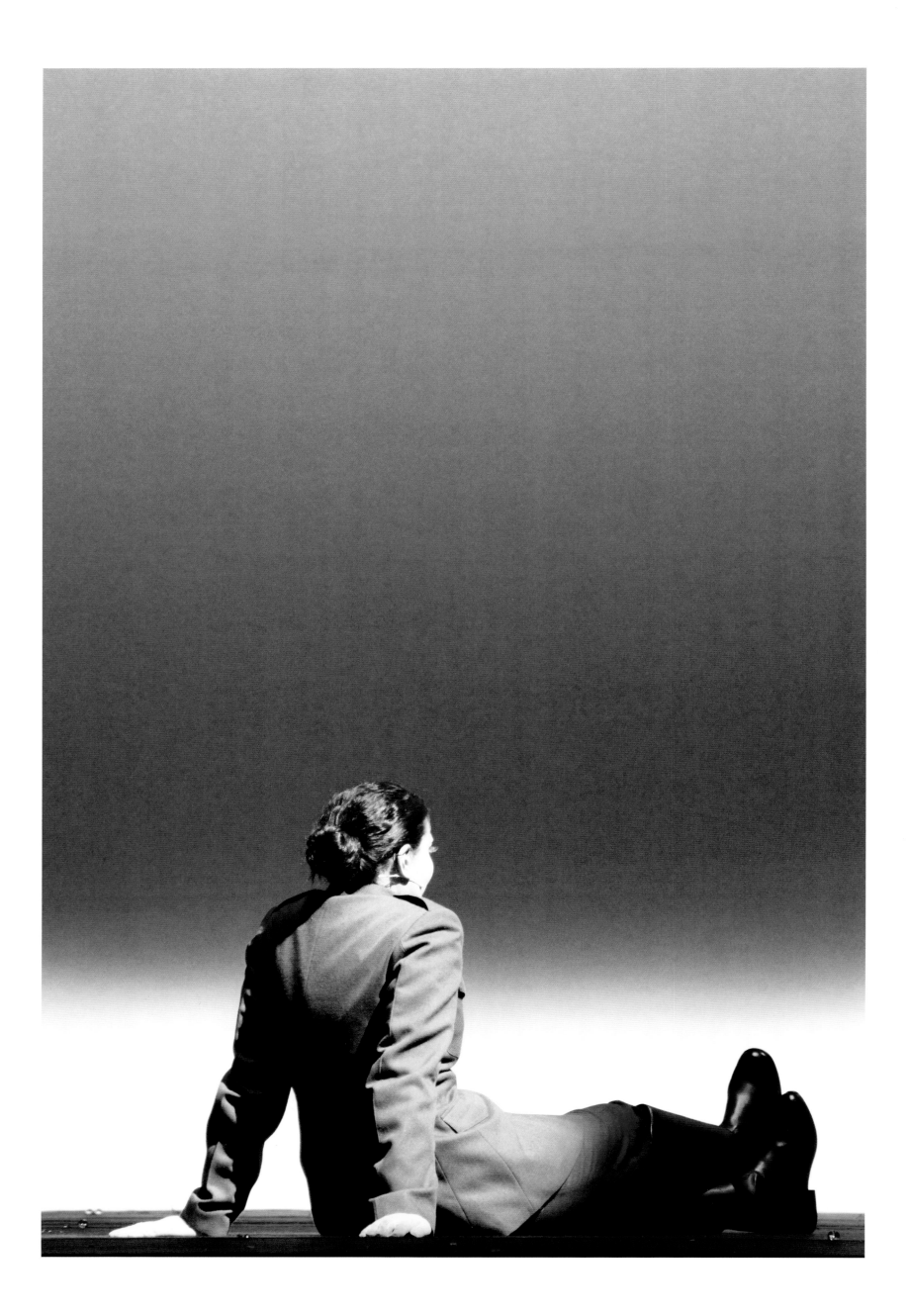

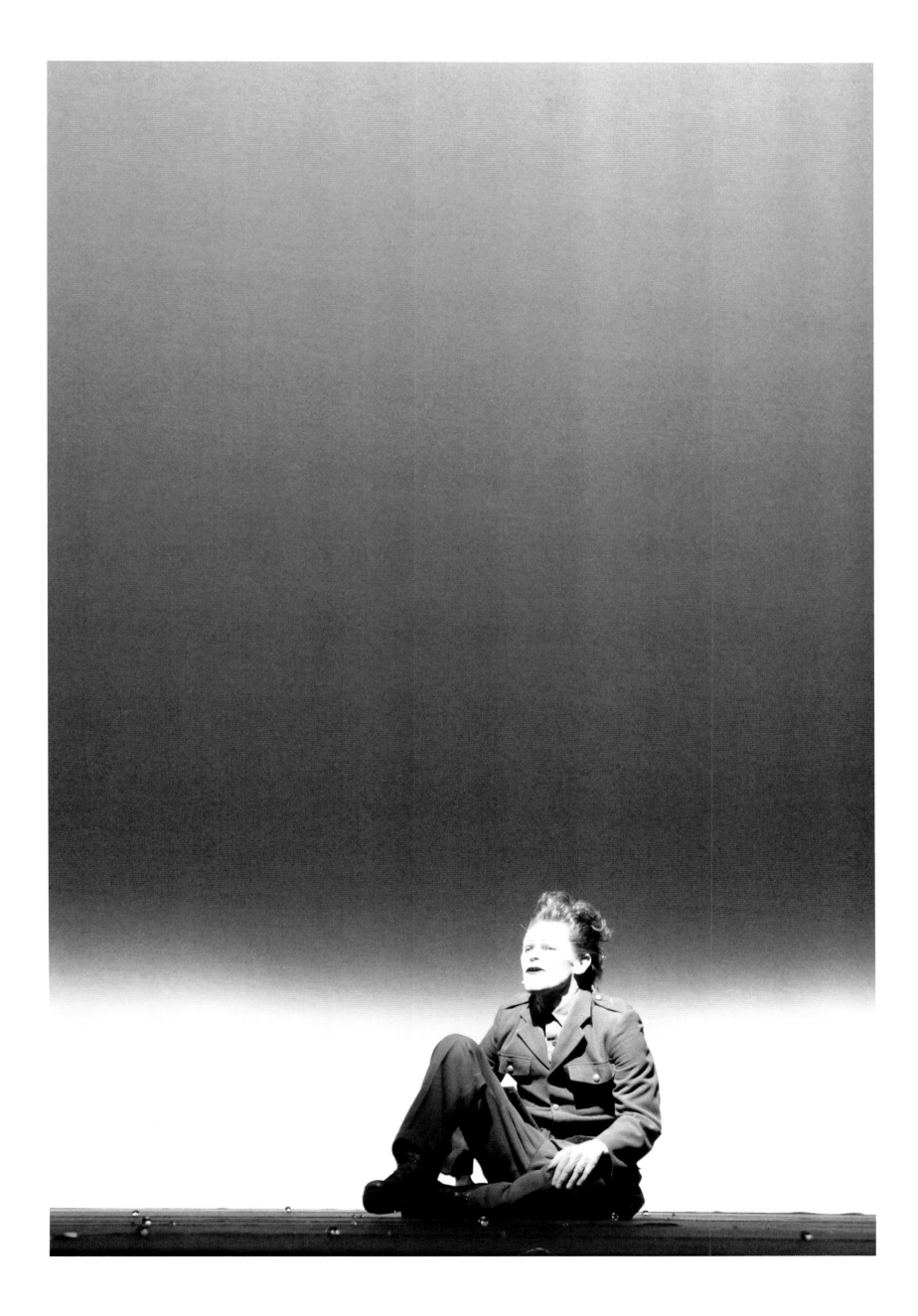

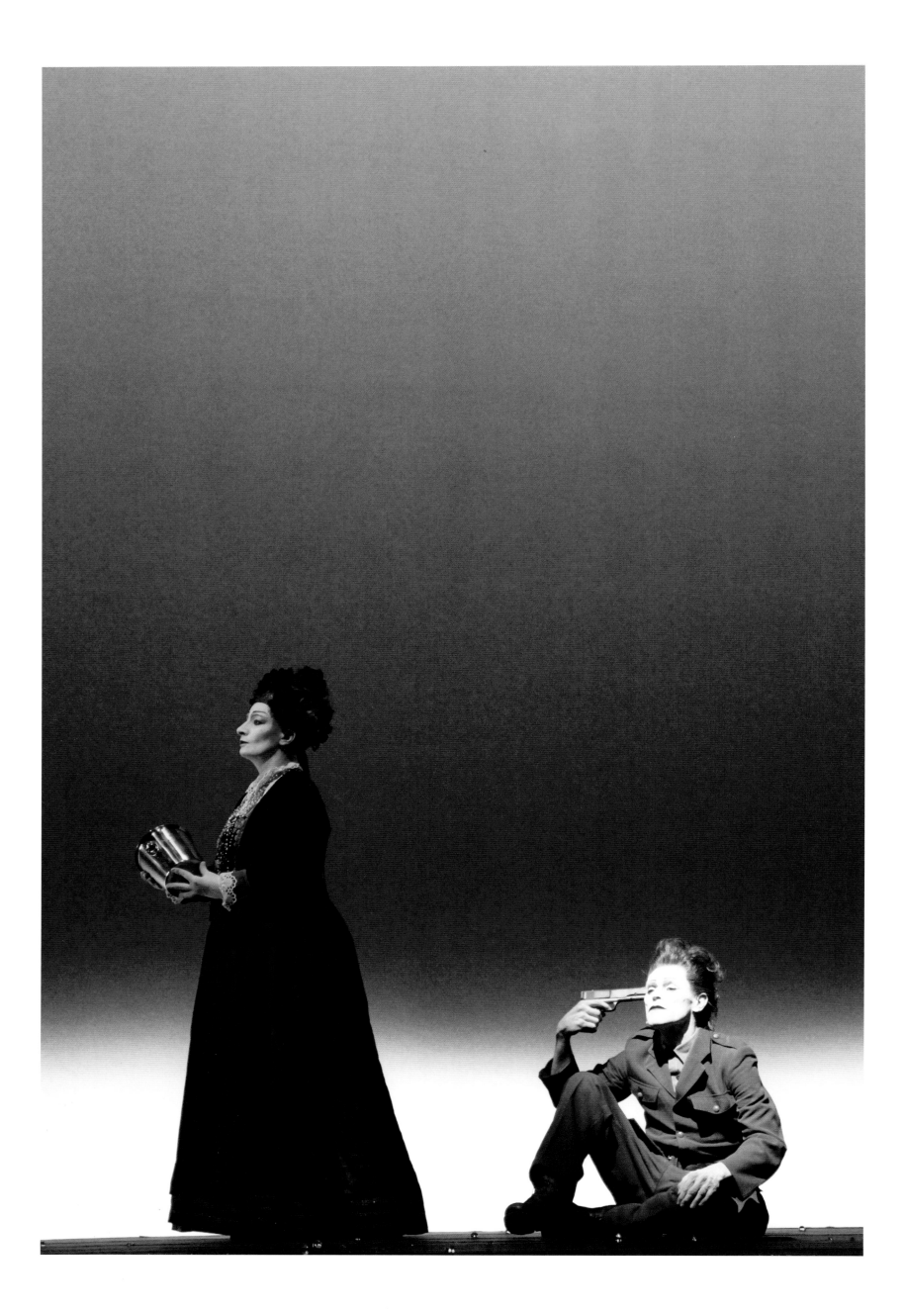

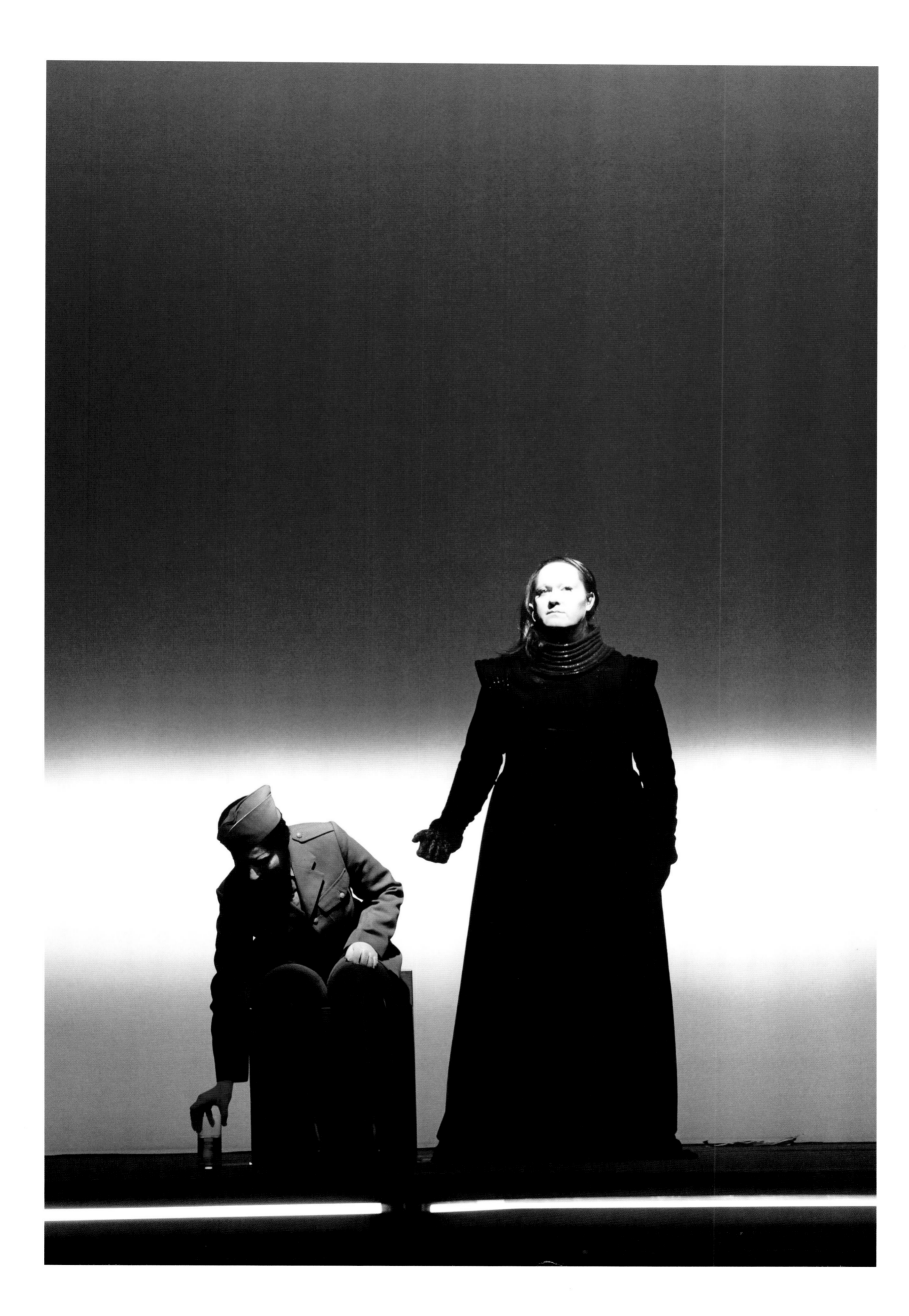

CUT THE WORLD

For so long I've obeyed that feminine decree

I've always contained your desire to hurt me

But when will I turn and cut the world?

When will I turn and cut the world?

My eyes are coral, absorbing your dreams

My heart is a record of dangerous scenes

My skin is a surface to push to extremes

But when will I turn and cut the world?

When will I turn and cut the world?

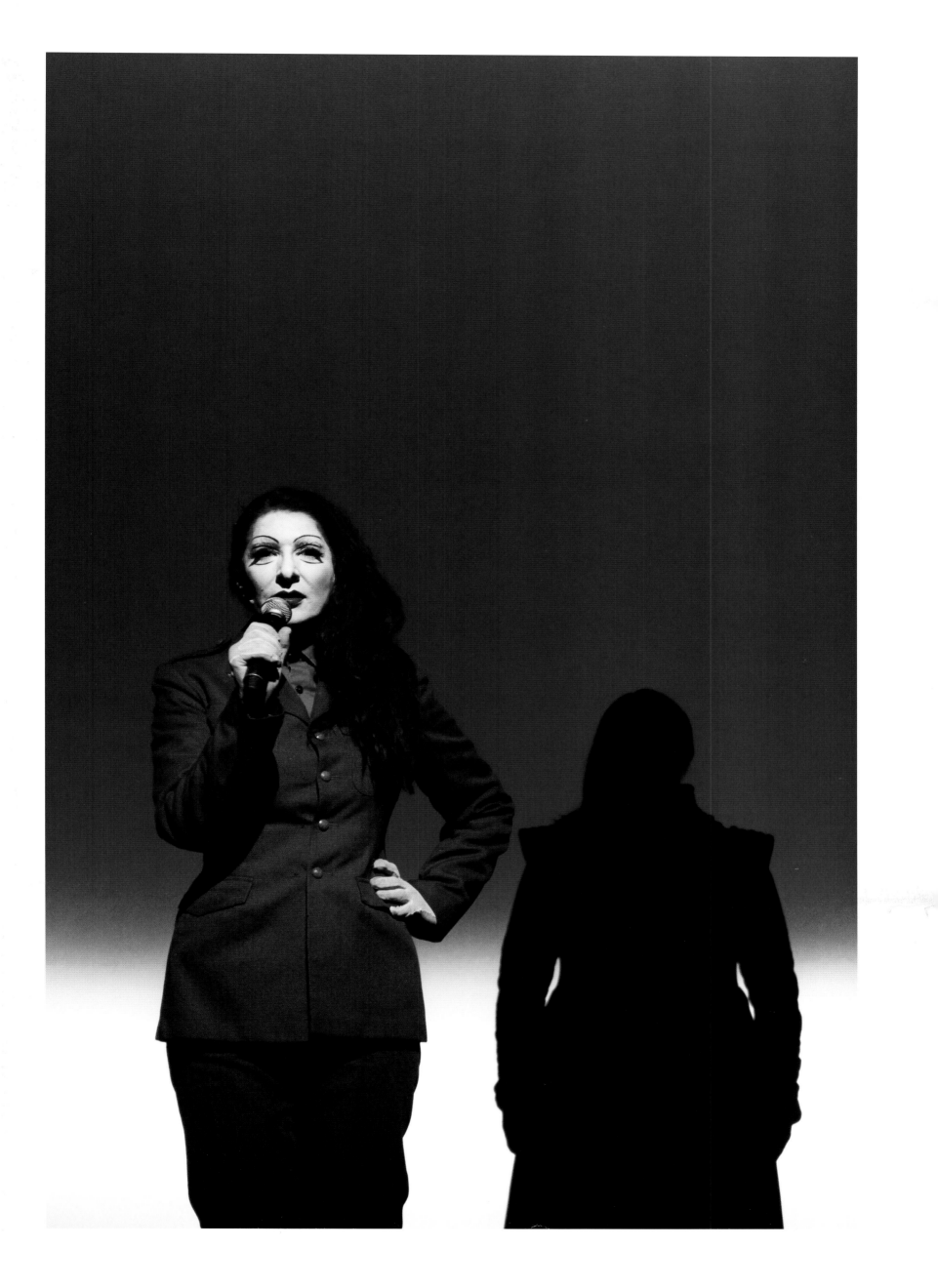

WILLEM'S SONG

Why must you cut yourself?

Do you know it hurts me

To see you suffer?

I never asked you to risk your life

On the altar

I don't want to see those colors

As they roll across your face

Why must you hurt yourself?

Are you hungry for my guilt?

Are you eating my guilt?

Or does this pain nourish you?

Every night I wait for you

Why must you suffer

Like Christ for his Father?

Like a lamb under a weeping willow tree

Like empty guts

Like a cow, folding in creases of her own blood?

Like a purse full of spite

Like a horse's bite

Like a bitter slice of metal in the stream?

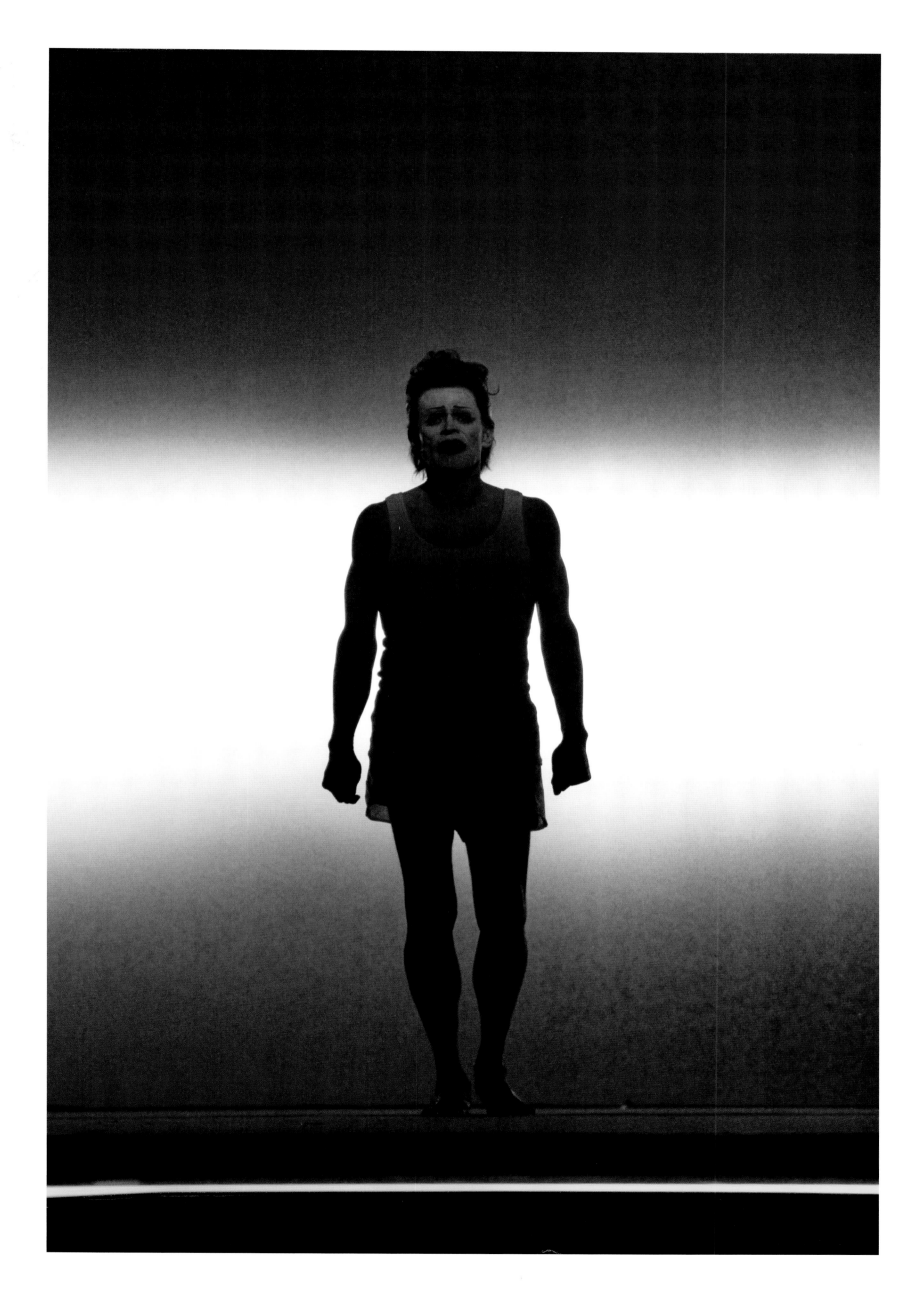

2007	Concerned about artistic career
	Intense social life
	Neglecting intimacy
2008	Trip to Laos He is leaving, said he needed time to be alone
	Endless phone calls
	Lies, lies, lies
	Humiliation
	Feeling abandoned, lonely, sad
	Crying in the taxis, on the street
	Crying at art openings
	Crying alone at home
	Depression
	She can't live without him
	It's too late
2009	She is waiting for a miracle
	He comes to Manchester to tell her that he chose another woman
	and brings her half of the money for a divorce
	Her heart is broken
	Psychoanalysis
2010	Retrospective at MoMA: "The Artist is Present" 736 hours sitting motionless
	He returns
	He is in the audience
	She doesn't see him
	Last day of the performance, when she stands up, in front of 17,00 people,
	he stood there looking at her
	She goes to him
	They embrace
	She loves his smell
	She loves his touch
	Their bodies connect
	Time stops
	Feels like an eternity

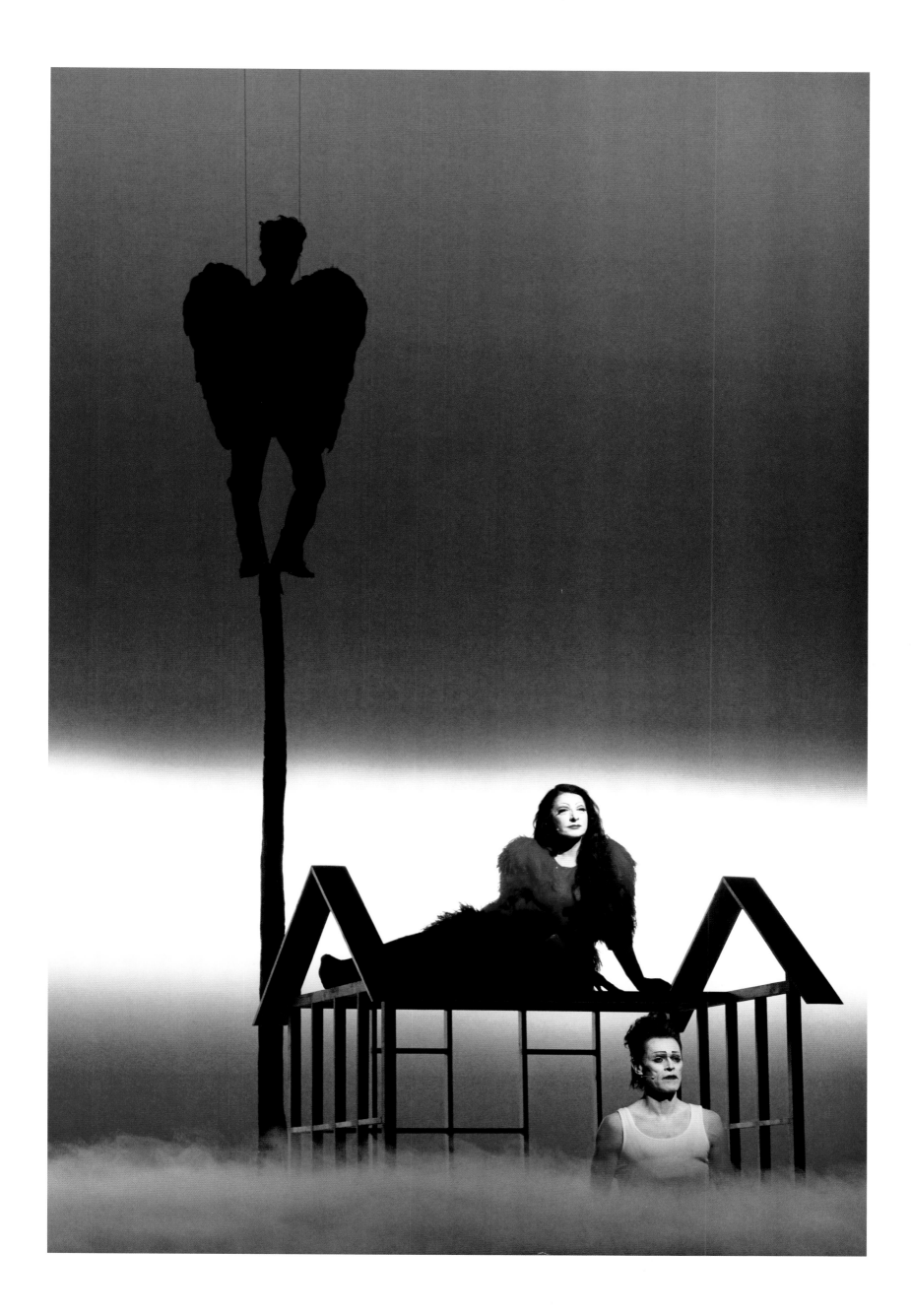

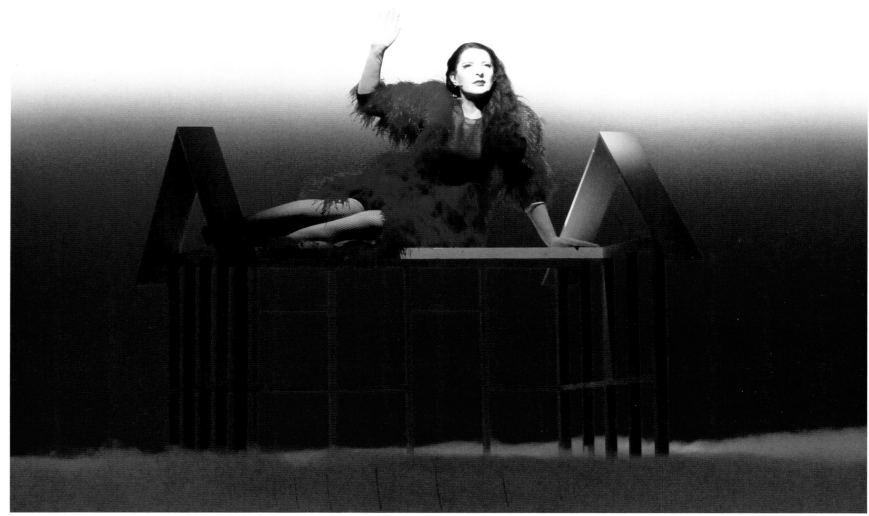

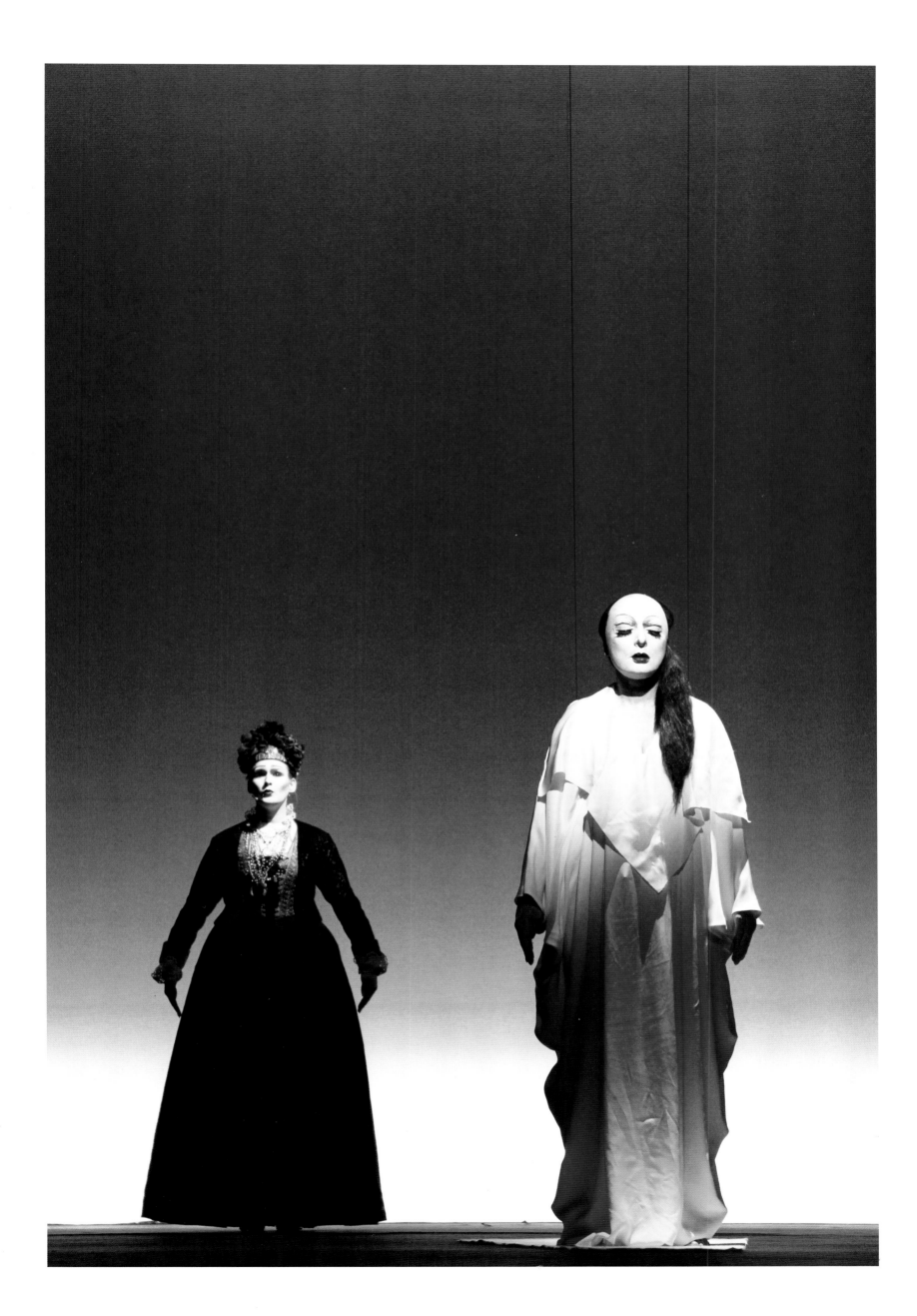

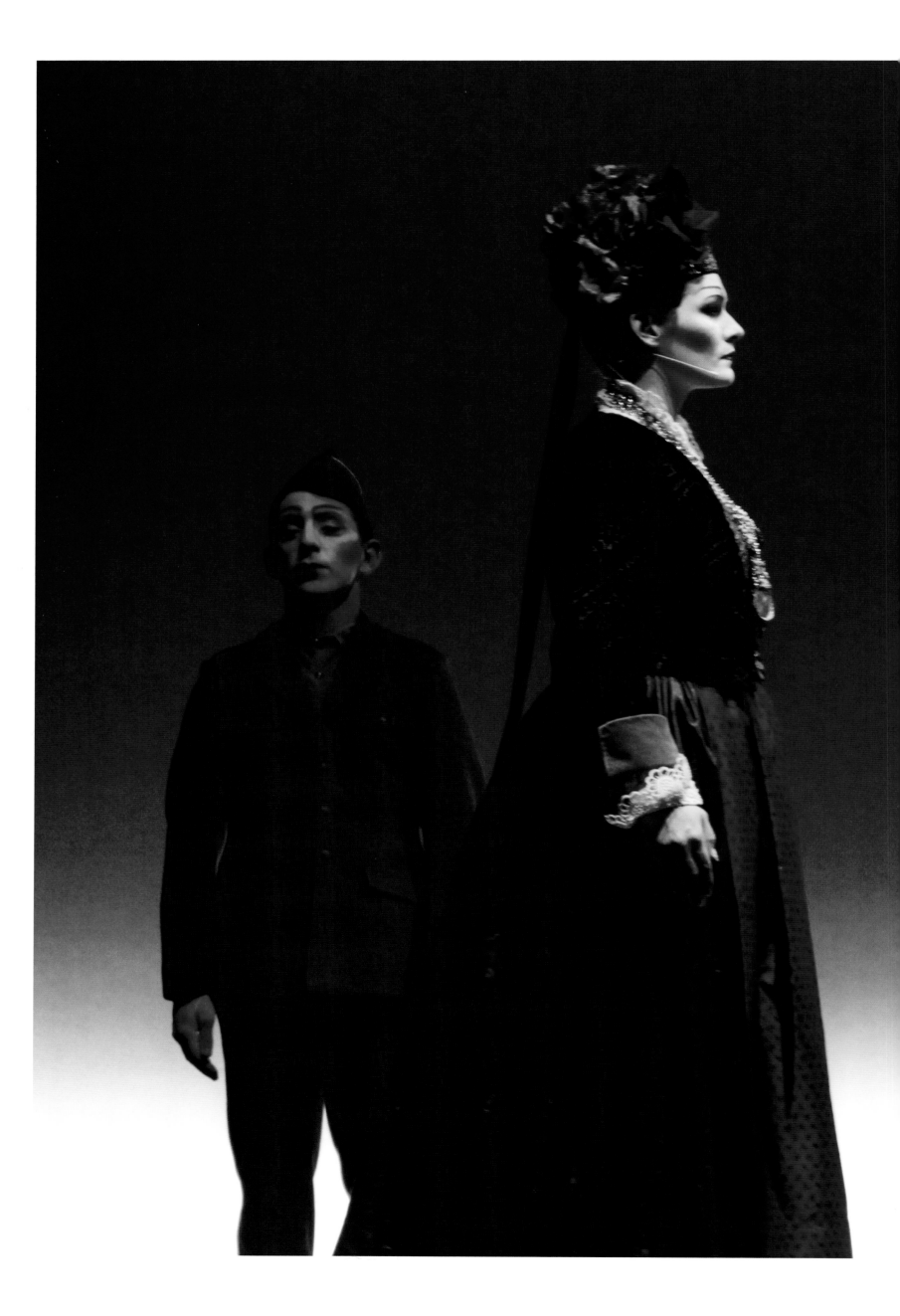

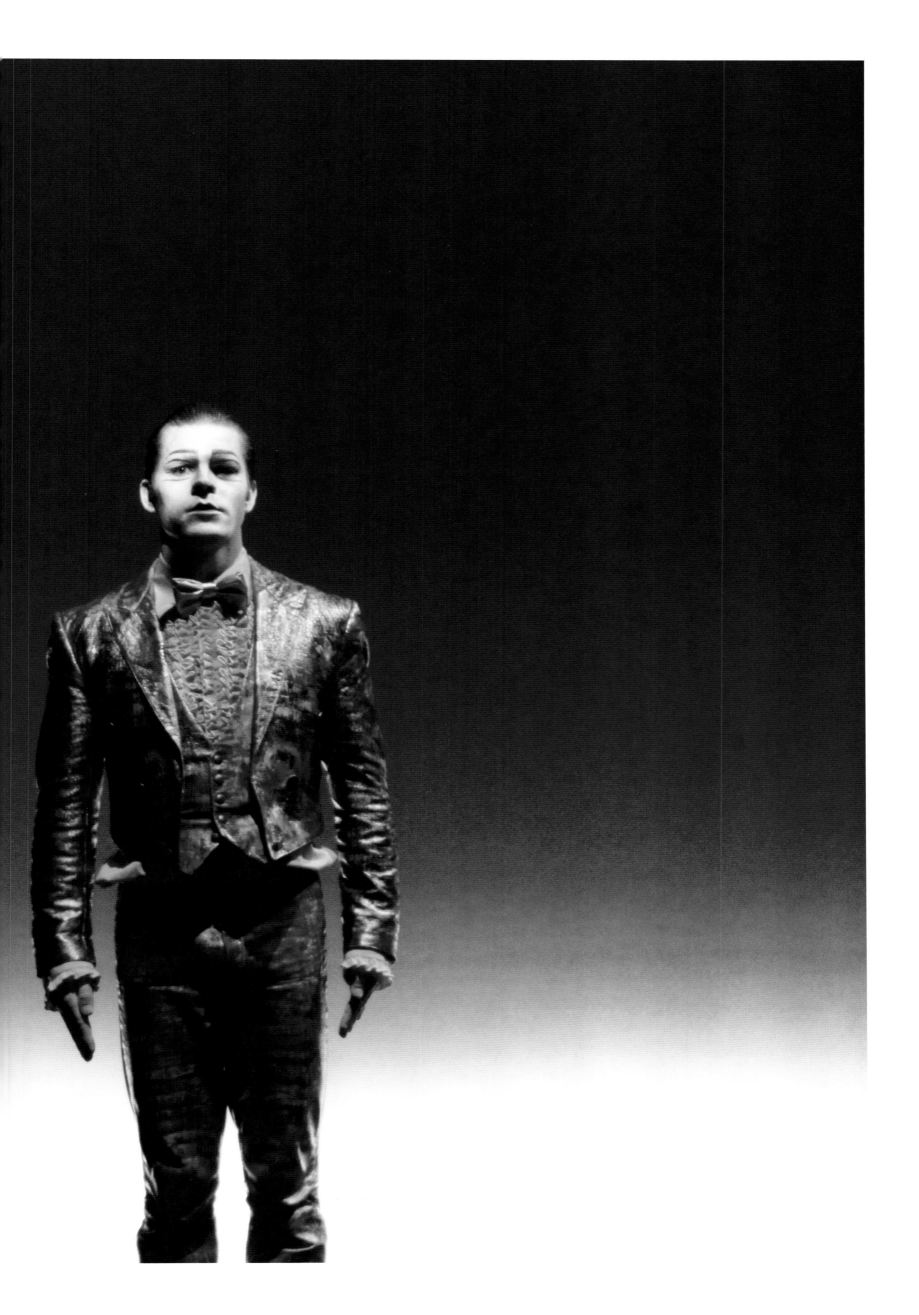

VOLCANO OF SNOW

I want white breath

I want everrest

I want sun's eyes

And rivers wind

Glittering to the sea

That's my destiny

I become a volcano of snow

I want crystal light

I want white night

And gold gilds

This dancing plane

My form, the immaculate

Constellation of whiteness

I become a volcano of snow

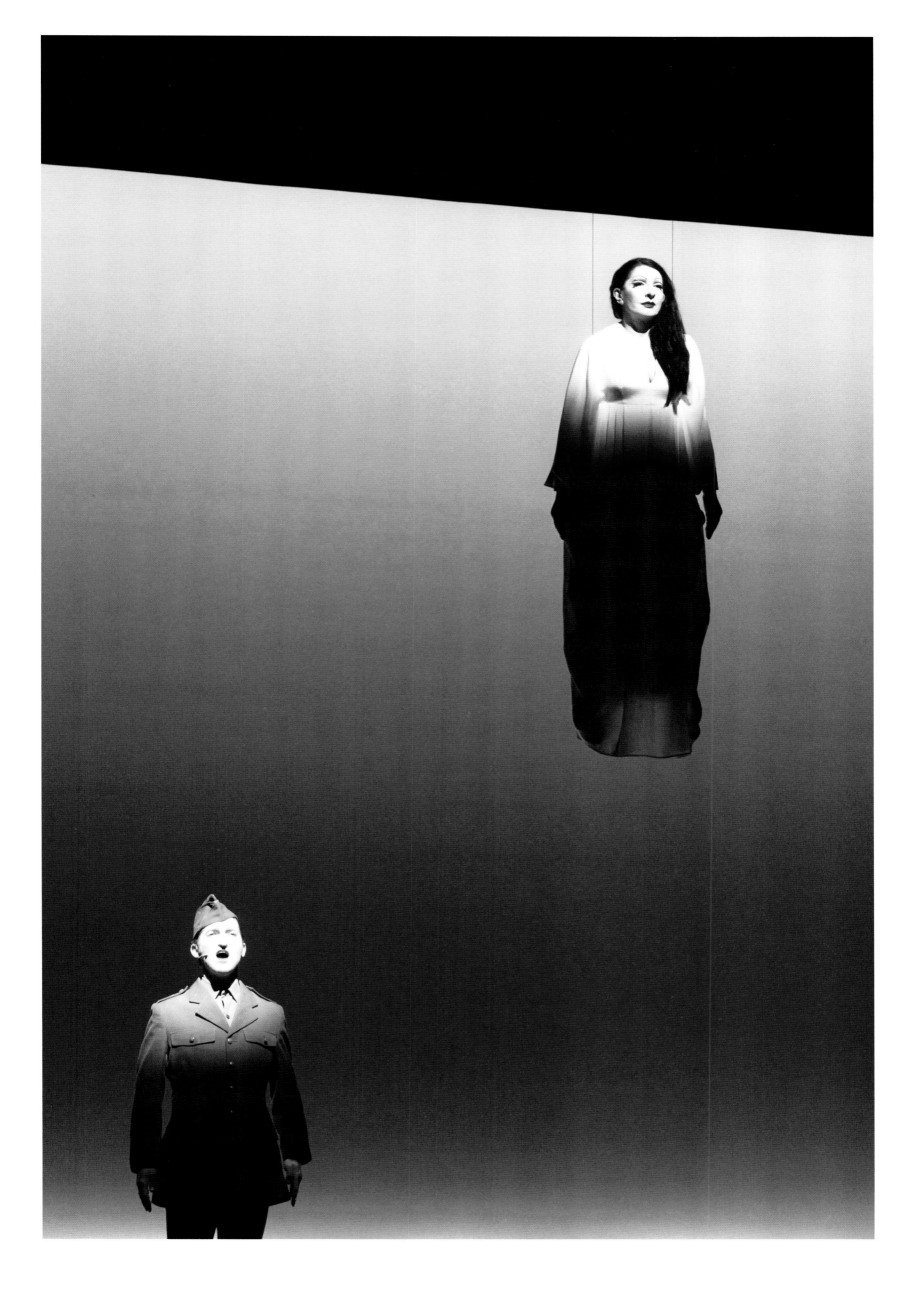

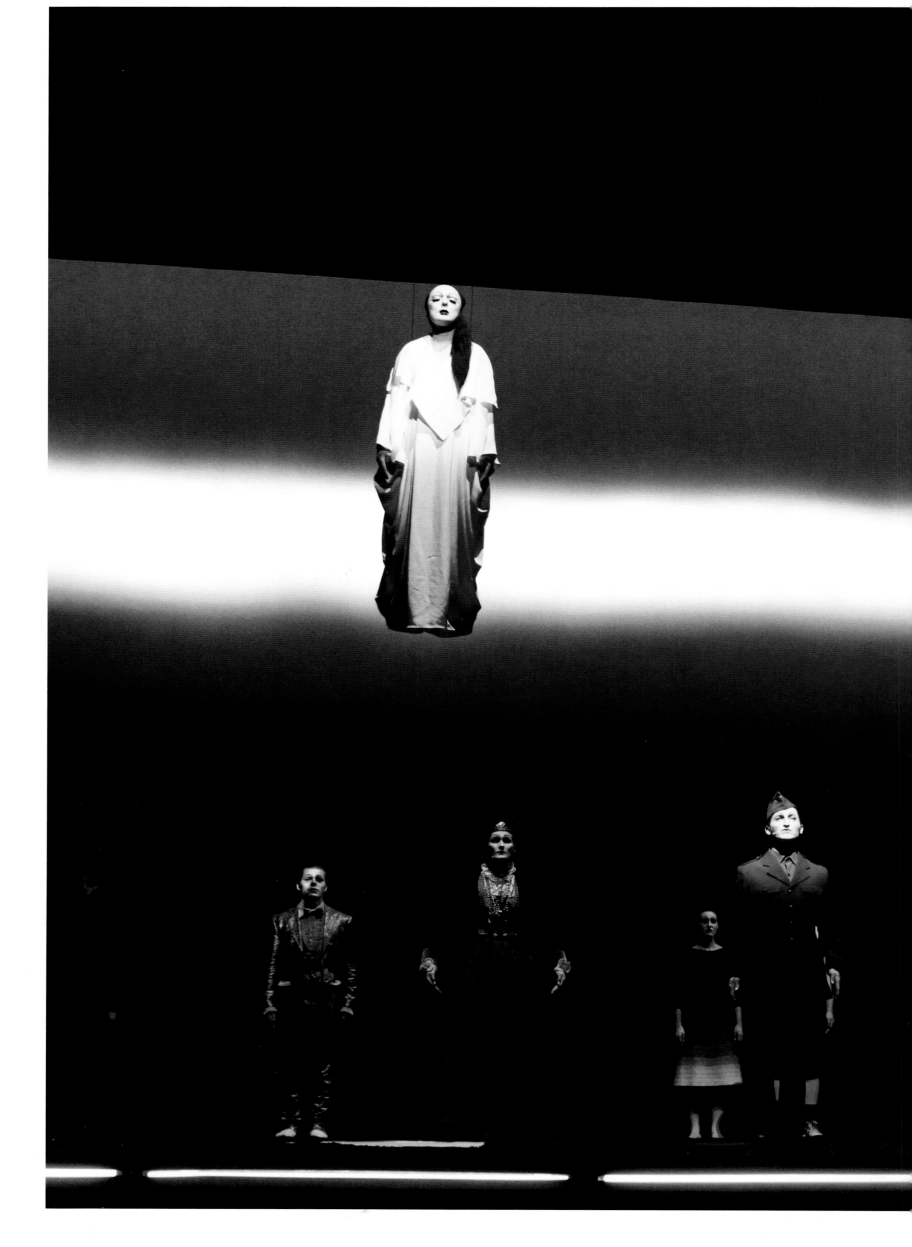

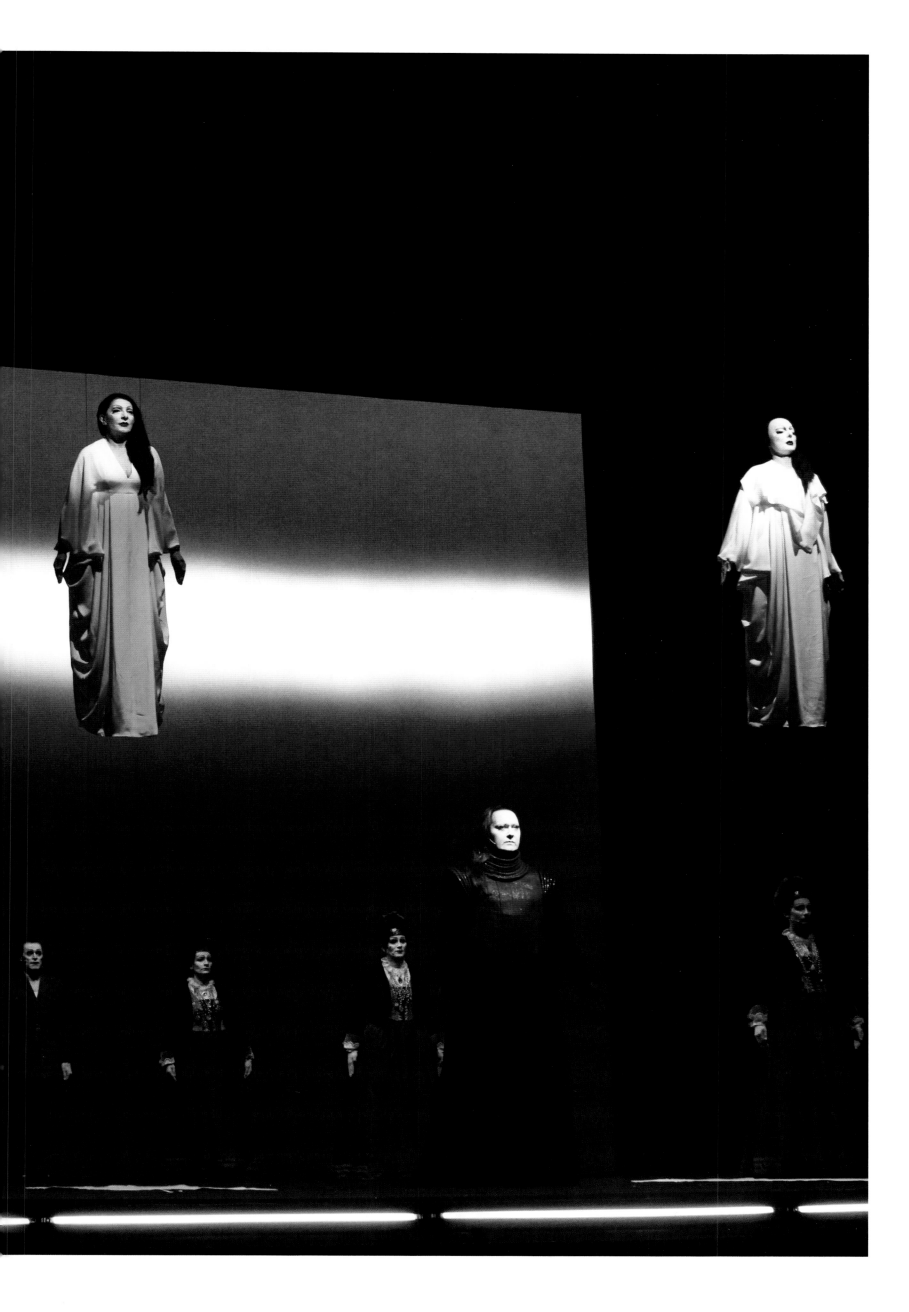

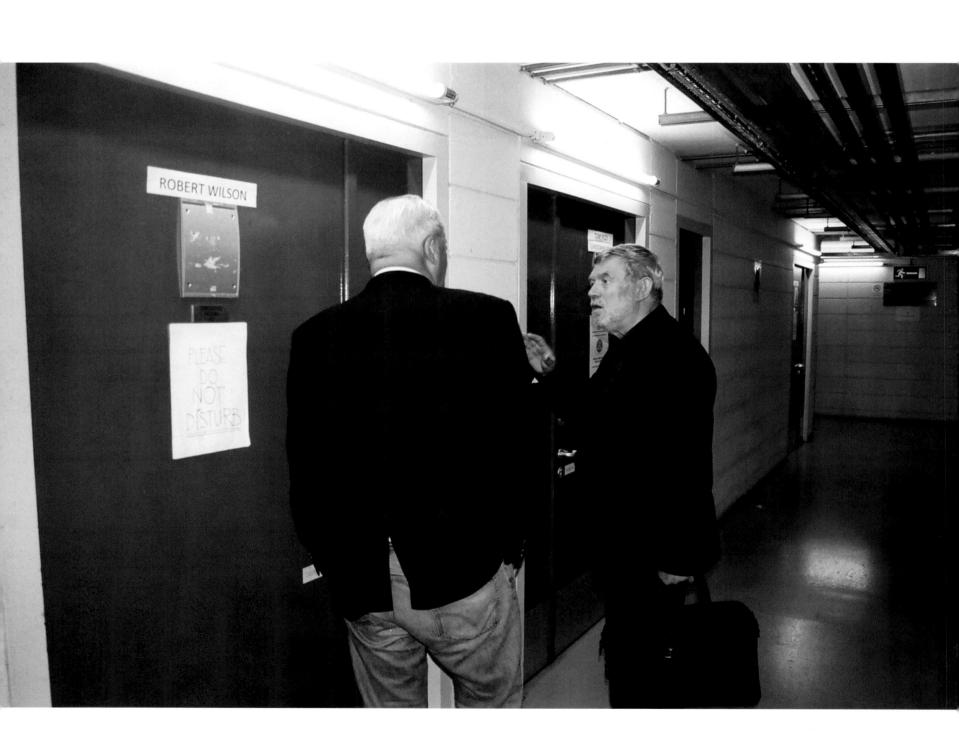

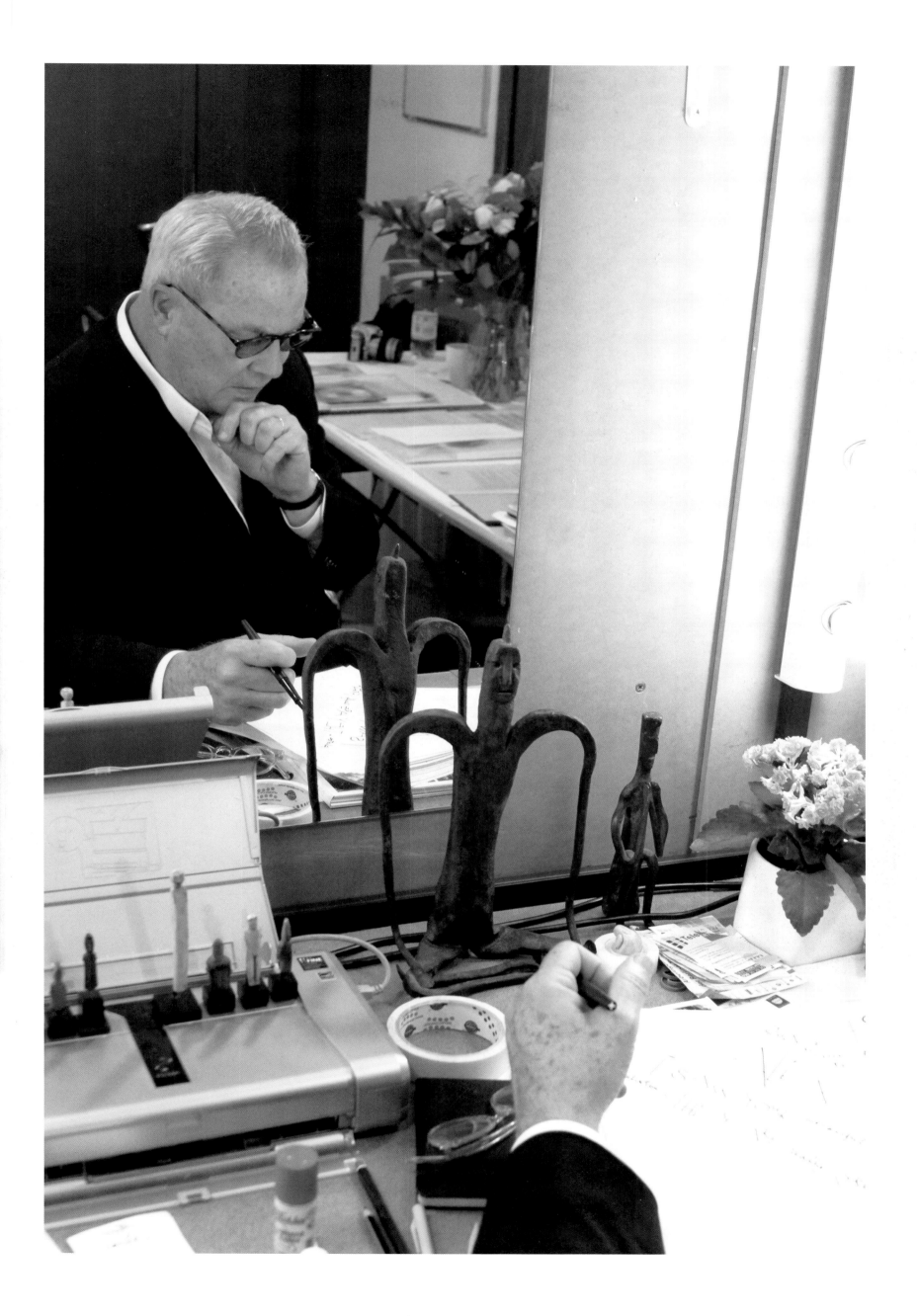

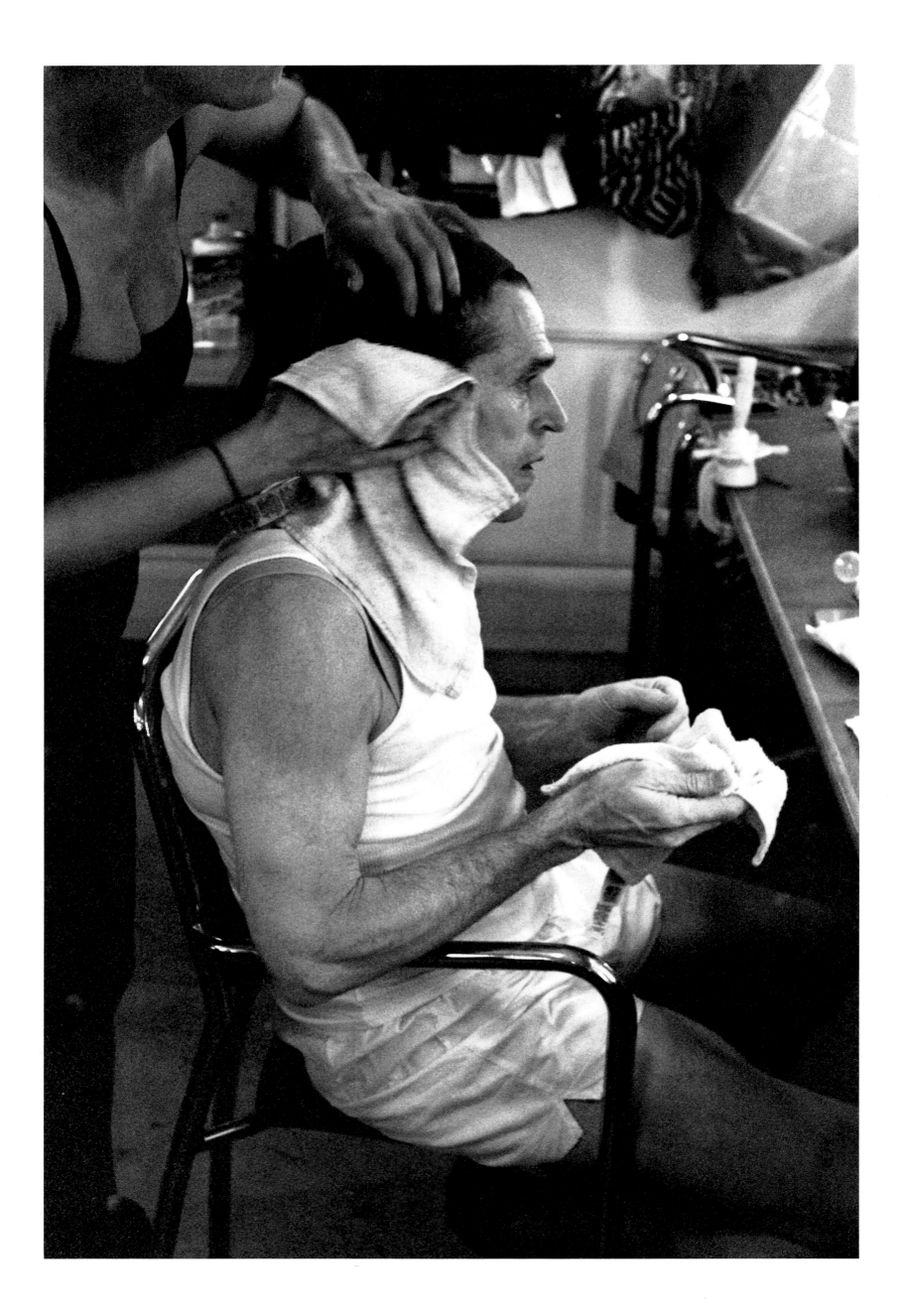

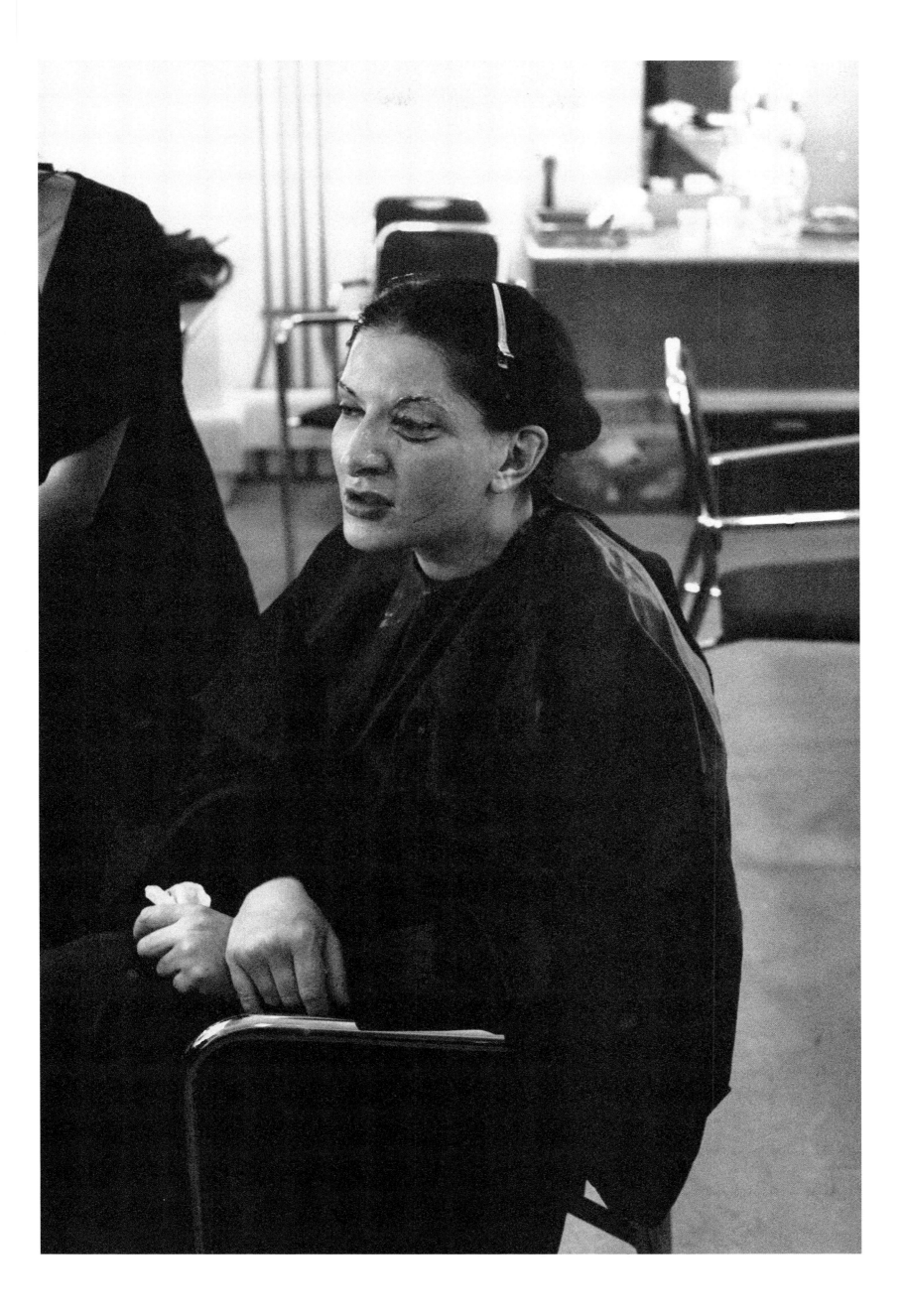

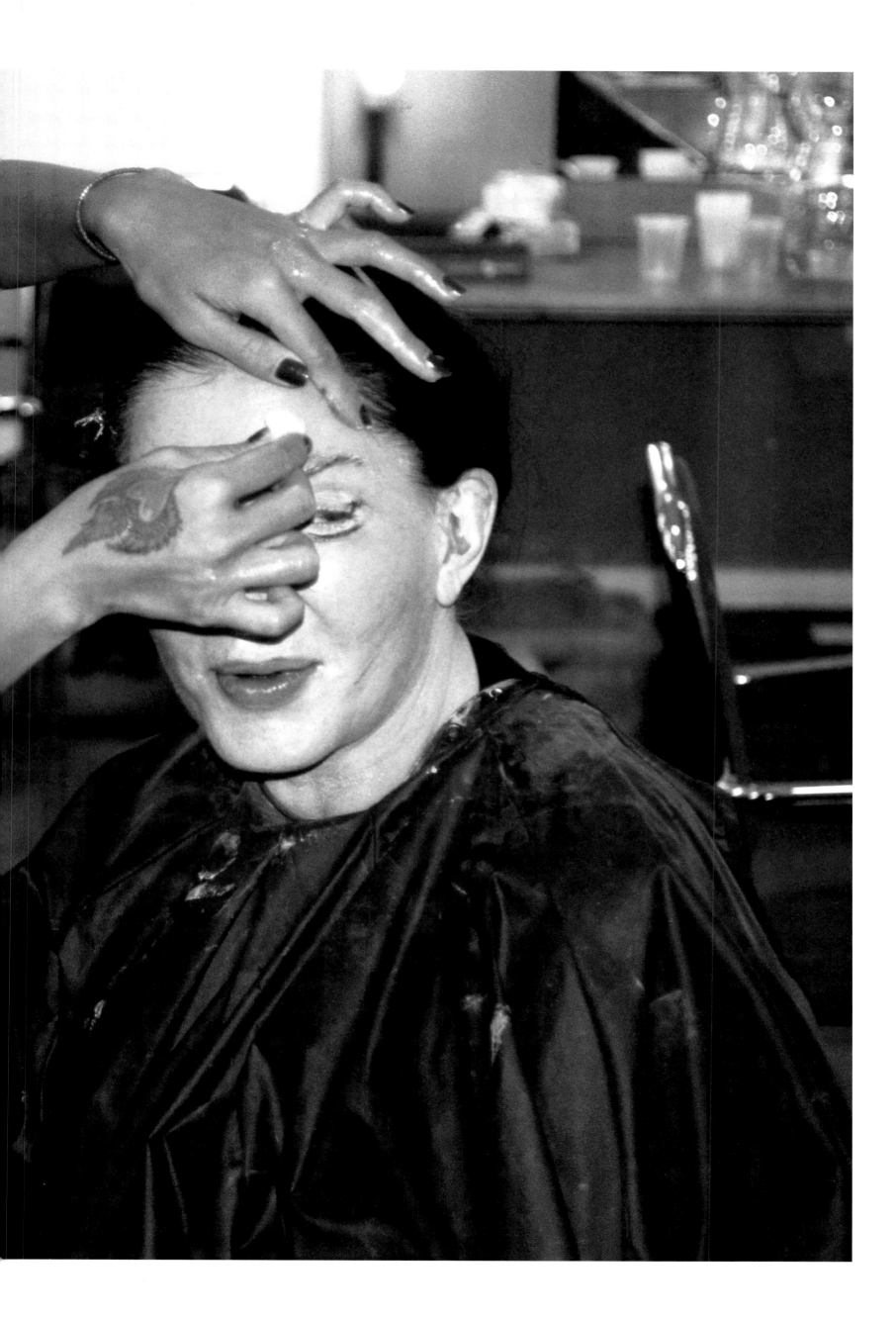

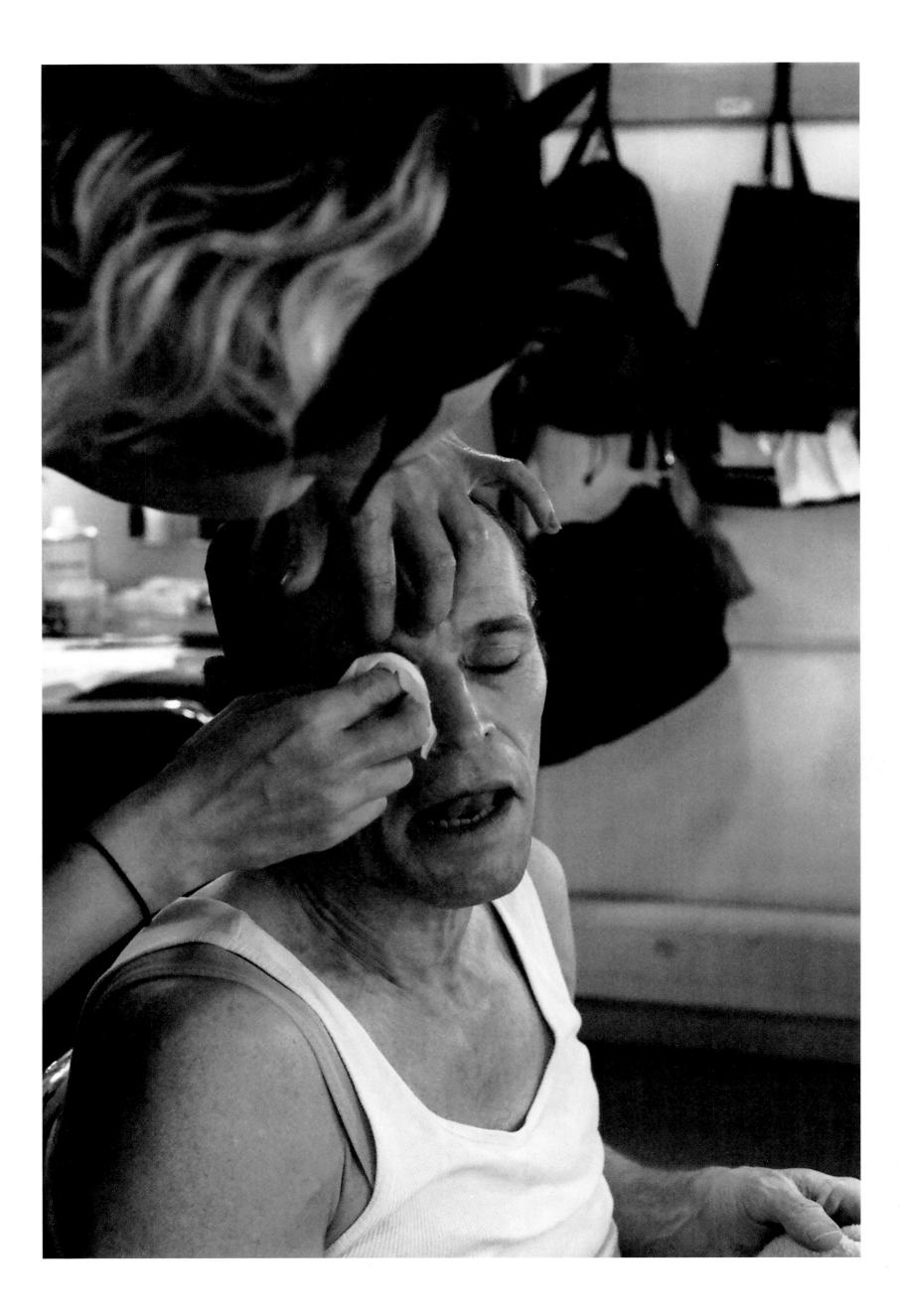

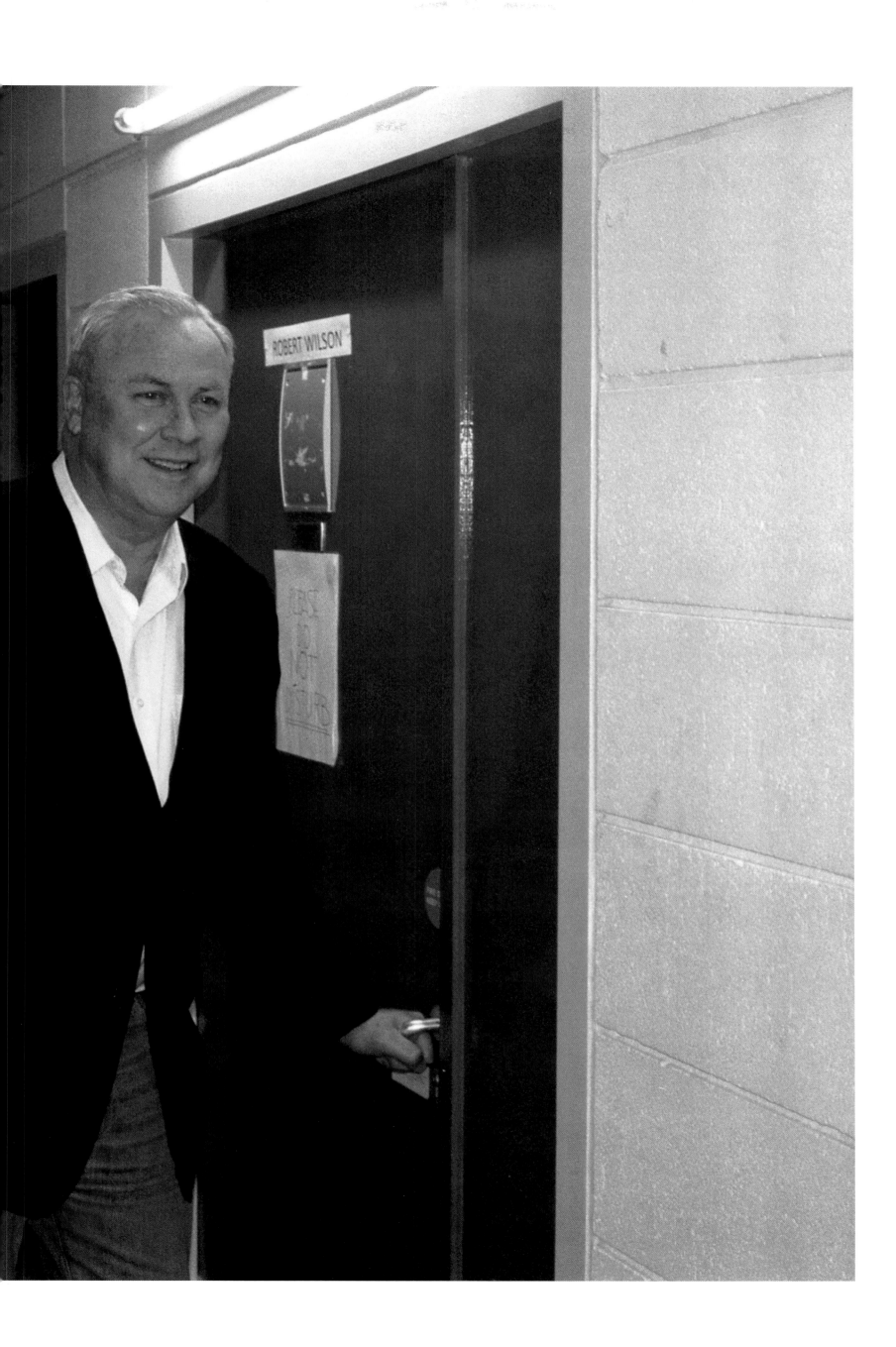

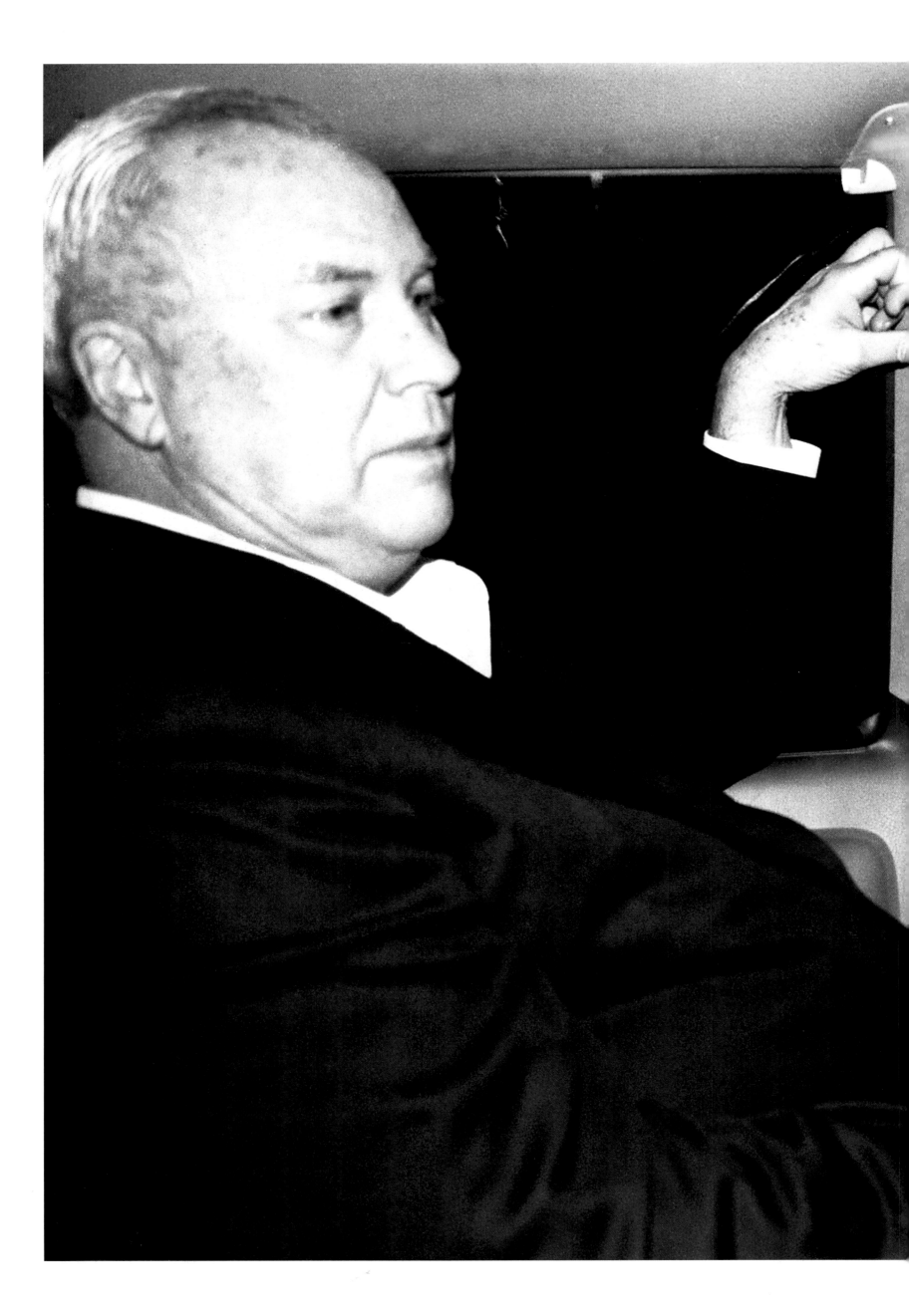

THE LIFE AND DEATH OF MARINA ABRAMOVIC

was an intense meeting of unlikely collaborators and traditions.
These photos were taken on the nerve wracking final rehearsal day.
There was so much left to do! I needed to rehearse cueing since I was responsible
for most of the text and transitions, Antony needed to rehearse the musicians,
Marina had to sing her song, costume changes had yet to be timed,
many things to practice, some of the show was not even finished!
Bob was perfectly calm. That day he took hours to adjust one light, one
gesture and rehearse the performers in the art of walking on the stage...
In the end, somehow he magically made the piece come together.
I always felt like we were animals or objects in a landscape Bob paints
with color and light. It was a transforming experience.

WILLEM DAFOE ROME DECEMBER 2011

THE LIFE AND DEATH OF MARINA ABRAMOVIC

ROBERT WILSON, MARINA ABRAMOVIC, ANTONY, WILLEM DAFOE

Robert Wilson	Concept, Direction, Set & Light Design
Marina Abramovic	Co-creator
Antony	Musical Director, Composer & Lyricist
William Basinski	Composer
Svetlana Spajic	Composer & Lyricist
Jacques Reynaud	Costume Designer
Ann-Christin Rommen	Associate Director
Wolfgang Wiens	Dramaturg
AJ Weissbard	Lighting Designer
Nick Sagar	Sound Designer
Joey Cheng	Make Up Designer
Tomaz Jeziorski	Video Designer
Dan Bora	Music Supervisor & Music Mix
Annick Lavallee-Benny	Set Design Assistant
Julia von Leliwa	Costume Design Assistant
Thomas Hescott	Assistant Director

PERFORMERS

Marina Abramovic

Ivan Civic

Amanda Doogan

Willem Dafoe

Andrew Gilchrist

Antony

Elke Luyten

Christopher Nell

Kira O'Reilly

Antony Rizzi

Carlos Soto

Svetlana Spajic

Svetlana Spajic Group (Minja Nikolic, Zorana Bantic, Dragana Tomic)

MUSICIANS

Doug Wieselman	Guitar/Clarinet/percussion
Gael Rakotondrabe	Piano/repetiteur/percussion
Matmos	Electronics/percussion
Oren Bloedow	Guitar/Bass

PRODUCTION TEAM

Sam Collins Production Manager

Sue Jane Stoker Company Stage Manager

Janine Bardsley Deputy Stage Manager

Louise Martin Deputy Stage Manager

Sally Townsend Assistant Stage Manager

Lynsey Peisinger Dance Captain/Prompter

Shanti Freed Costume Supervisor

Sarah Kate Heap Senior Wardrobe Assistant

Hayley Meaden Wardrobe Assistant

Laura O'Connor Wardrobe Assistant

Star Chen Make Up Supervisor/Assistant to Joey Cheng

Jayne Whittaker Make Up Supervisor

Rebecca Collins Make Up Assistant

Anne Heath Make Up Assistant

Natalia Leniartek Make Up Assistant

Patrycja Grimm Make Up Assistant

Jon Clarence Sound Operator

Amy Spencer Sound No. 2

Wee Cheng Low Lighting Programmer

Sam Floyd Chief LX

Emily Scale Followspots

Ben Wegg Followspots

Clive Eastwood Followspots

Hilary Eastwood Followspots

Stephen Beastley Stage LX

Danny Hones Chief of Stage

Alan Bradley Stage

Hannah Tierney Stage
John Mather Stage

Phil Buckley Stage

Neil Boardman Flys

Dave Stewart Flys

Richard Schnider Video Technician

Alan Henry Production Carpenter

Karen Jupp Artist Liason

Duncan Elliot Artist Liason to Antony

Shaun MacDonald Administrator to Antony

Aram Haus Assistant to Robert Wilson

Daniel Schulze Assistant to Robert Wilson

Bernhard Stippig Assistant to Robert Wilson

Omid Hashemi Intern/Additional Photography

Ginerva Mortola Intern/Props Assistant

FOR MANCHESTER INTERNATIONAL FESTIVAL

Alex Poots	Executive Producer
Tracey Low	Producer
Jo Walsh	Assistant Producer
Jack Thompson	Technical Director

FOR TEATRO REAL MADRID

Gerard Mortier
Romain Risset
Jesus Iglesius Noreiga

Commissioned by Manchester International Festival and Teatro Real Madrid with Theater Basel, Art Basel, Holland Festival, Salford City Council and deSingel, Antwerp.

Produced by Manchester International Festival , Teatro Real Madrid and The Lowry

Tim Hailand would like to extend his thanks and admiration to Robert Wilson for sharing his day, his work, and for creating the title page, to Marina for being Marina, to Antony for the use of his beautiful song lyrics, and to Willem Dafoe for his afterward. Special thanks to William Basinski, Svetlana Spajic, Minja Nikolic, Zorana Bantic, Dragana Tomic, Amanda Coogan, Andrew Gilchrist, Elke Luyten, Christopher Nell, Ivan Civic, Kira O'Reilly, Anthony Rizzi, Carlos Soto,Doug Wieselman, Gael Rakotondrabe, Matmos, Oren Bloedow, Bernhard Stippig, Jacques Reynaud, Ann-Christin Rommen, Wolfgang Wiens, AJ Weissbard, Nick Sagar, Joey Cheng, Tomaz Jeziorski, Dan Bora, Annick Lavallee-Benny, Julia von Leliwa, Thomas Hescott, Nichiren Daishonin, Carlos De Cruz, Damien Jalet, Rufus Wainwright, Jim Hodges, Frank Frattaroli, Alex Poots, Nadja Coyne, Tracey Low, Jo Walsh, Jack Thompson, Gerard Mortier, Romain Risset, Jesus Iglesius Noriega, Patrick J. Thomas, and to the entire Creative Team & Crew who help to create the magic. Very special thanks to Chris Pomeroy, Jil Derryberry, and Costume National for their support of this project.

This book is dedicated to Jorn Weisbrodt, without whom none of this would exist!

Lyrics to *Cut the World, Willem's Song,* and *Volcano of Snow* by Antony / courtesy of Rebis Music copyright 2012 (Kobalt/ASCAP)

Title page by Robert Wilson

Timeline compiled by Wolfgang Wiens based on notes by Marina Abramovic

THE PRODUCTION FEATURES THE WORK OF:

Carlos Soto	*Miss Every Evening* (performance 2006)
Ivan Civic	*Fabulous Marina* video (2006) performance, costume design (2011) Metal chest plate made by Kristine Estell (2010)
Kira O'Reilly	*Stair Falling* (performance 2009 - 2011)
Andrew Gilchrist	*Cocksure* (performance 2010)
Amanda Coogan	*Yellow 2008* (live performance) *Medea 2001* (live performance)

All photos by Tim Hailand copyright 2011

Printed in China by Jade Productions

Book edited and designed by Tim Hailand with Ji Hyun Moon

For further copies of this book and for other titles in the series: onedayinthelifeof.org

This first edition is strictly limited to 1500 copies worldwide

TIM HAILAND BY JIM HODGES 2011

Published by HAILAND BOOKS

PERFORMANCE AND THEATRE ONE CAN COMPARE TO BIG FAMILY
THEY ARE TIED BY LOVE AND HATE, AND THEY WILL ALWAYS NEED AND LOOK FOR EACH OTHER

MARINA ABRAMOVIC

A PORTION OF ALL BOOK SALES BENEFIT THE BYRD HOFFMAN WATERMILL FOUNDATION
www.watermillcenter.org